California Beach Houses

STYLE, INTERIORS, AND ARCHITECTURE

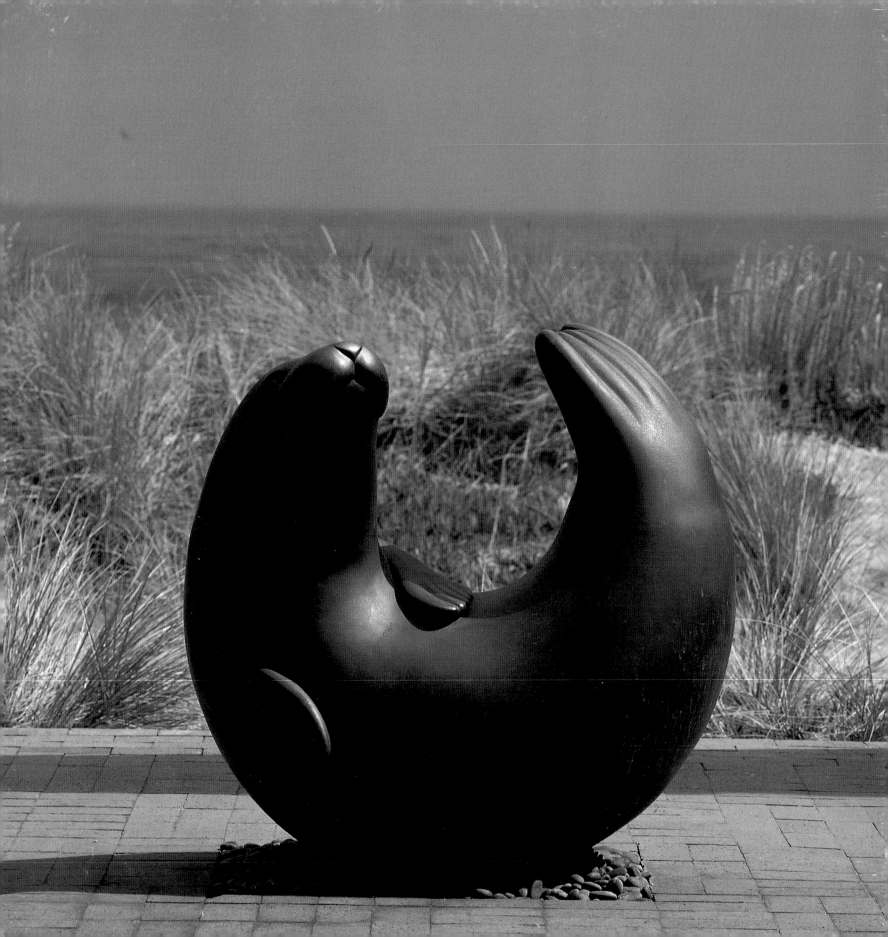

California Beach Houses

STYLE, INTERIORS, AND ARCHITECTURE

TEXT BY PILAR VILADAS

PHOTOGRAPHY BY MARK DARLEY

FOREWORD BY STANLEY ABERCROMBIE

CHRONICLE BOOKS

SAN FRANCISCO

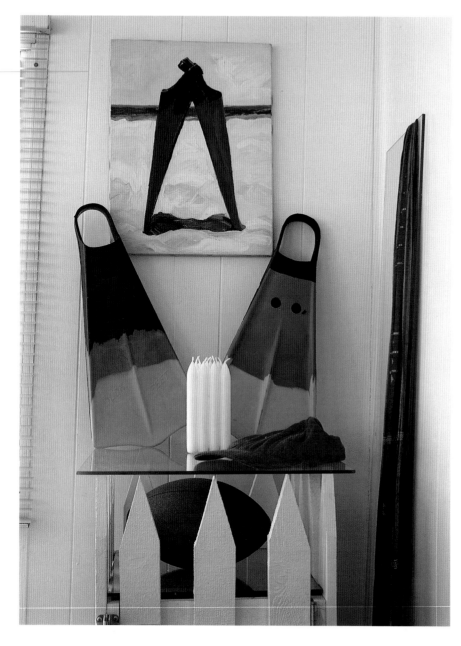

ABOVE: Pairs of swim fins, real and painted, adorn a picket-fence storage unit, designed by Brian Murphy, that keeps sports equipment organized in his Pacific Palisades trailer.

Text copyright ©1996 by Pilar Viladas.
Photographs copyright ©1996 by Mark Darley.

Printed in Hong Kong.

Book and cover design by Laura Lamar/MAX, San Francisco.

Film supplied by Just Film; processing by The New Lab, San Francisco.

Library of Congress Cataloging-in-Publication Data available.
ISBN: 0-8118-1218-9

Distributed in Canada by Raincoast Books,
8680 Cambie Street
Vancouver, B.C., V6P 6M9

10 9 8 7 6 5 4 3 2 1

Chronicle Books
275 Fifth Street
San Francisco, CA 94103

Chronicle Books© is registered in the US Patent and Trademark Office.

Acknowledgments

This book, like so many others, would not exist if not for the dozens of people who helped make it happen. To the designers and architects whose work is featured in these pages, our deepest thanks—we literally could not have done it without you. Similarly, we are grateful for the generous cooperation and unfailing hospitality that was shown to us at every turn by the owners of these houses. Our job would have been difficult indeed without the efforts of Devin Derby, Robert del Valle, Zane Payne, and Fro Vakili. To Fred Hill, our agent, and Laura Lamar, who designed this book, thanks don't even begin to convey our gratitude. To Nion McEvoy, Editor-in-Chief and Associate Publisher of Chronicle Books; to Charlotte Stone, Associate Editor; and to Chuck Robbins, copy editor for the book—our heartfelt thanks for your patience and encouragement. Paige Rense, editor of *Architectural Digest*, has provided invaluable support. Deborah Ross and Robbie Conal; Cherie Rodgers and Michael Nozik; and Jimmie Bly and Michael Ritchie made us feel at home even when we were on the road. And last—but far from least—we want to remember John Vaughan, whose vision gave this book its start, and whose generous spirit, we feel certain, was its guardian angel.

P.V.

M.D.

Dedications

To Henry Isaacs, who covers the waterfront like no one else.

P.V.

To my wife, Suzanne, and my children, James and Miranda.

M.D.

Contents

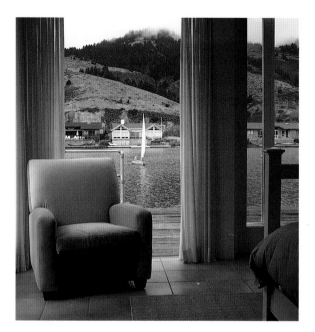

ABOVE: A boat glides past
Larry and G.G. Green's
bedroom in Stinson Beach.

RIGHT: Geometric forms
distinguish this house in
Capistrano Beach.

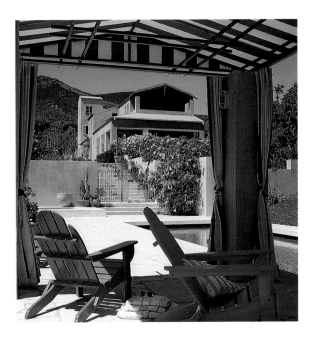

ABOVE: Brightly colored Adirondack chairs, grouped under a striped cabana, create an inviting spot next to the swimming pool at Buzz Yudell and Tina Beebe's Malibu house.

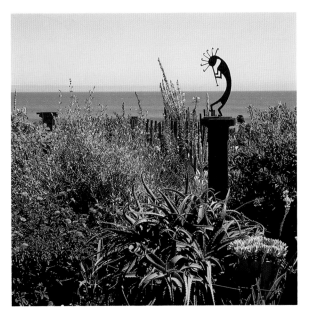

LEFT: Native plants grow abundantly in John Jones's Stinson Beach garden.

ABOVE LEFT: On Michael Smith's Santa Monica terrace, stripes enliven a black metal chair.

Foreword

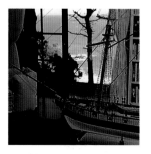

ABOVE: Against a view of the Pacific, one of the more imposing ship models in James Stockton's collection is proudly displayed in the library adjacent to his house on the North Coast.

Having recently transplanted myself from East Coast to West, I have arrived with the burdensome excess baggage of expectations and prejudices on every subject, beach houses among them. Back East, of course, escaping the city is a major obsession, and the escapes are many and varied: The Maine coast, Cape Cod, Newport, the Adirondack lakes, the Hamptons, Fire Island, the Jersey shore, to name a few. And each represents a distinctly different housing type.

California, however, has always brought to my uninformed mind a single beach house image: The house, dramatically cantilevered from a cliffside, is of redwood and glass (lots of glass). It has a broad deck, also cantilevered, also redwood, and certainly a hot tub. In the open kitchen area the young bronzed Californians make themselves sandwiches of soy bread and sprouts, then pluck mangos from a hand-thrown ceramic. On the beach far below, the volleyball game is starting.

I will not abandon my belief that this house exists. But Pilar Viladas and Mark Darley now show me that Paradise is not so monolithic, after all. Their selection of houses for this book is revealingly varied—grand houses and modest ones, complex and simple,

rustic and sleek, conservative and radical. There is, I feel justified in pointing out, some

redwood and some glass, but there are myriad other materials as well.

Yet, even in their diversity, these houses seem to share a common spirit, a

common freedom from any preconceived formulas. Unlike their East Coast counterparts,

straining to fit accepted images of Adirondack camp or Southampton cottage, these

house designs don't care a fig about image. Even when elaborately traditional (as some

of the most appealing ones are), such style has been chosen not to satisfy the dictates of

any actual tradition, and certainly not to please the neighbors, but simply because

that's what makes the owners and their guests most comfortable. Personal comfort and

pleasure is the shared theme here, along with appropriate attention to those glorious sites.

I don't live at the beach myself; not yet, anyway. I do covet many of the

houses shown here and could happily move right into several of them. But more enviable,

more valuable, and much more important than the houses themselves is that joyful

attitude they share. It makes me glad I came.

Stanley Abercrombie

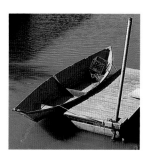

ABOVE: Traces of bright blue paint are still visible on the inside of an abandoned rowboat, weathered to the color of driftwood, on a Marin County salt marsh.

FOLLOWING PAGES: Iconic images of the California coast include a view of the boardwalk at Venice Beach, the luxurious seascape at Paradise Cove in Malibu, and the rugged contours of the North Coast.

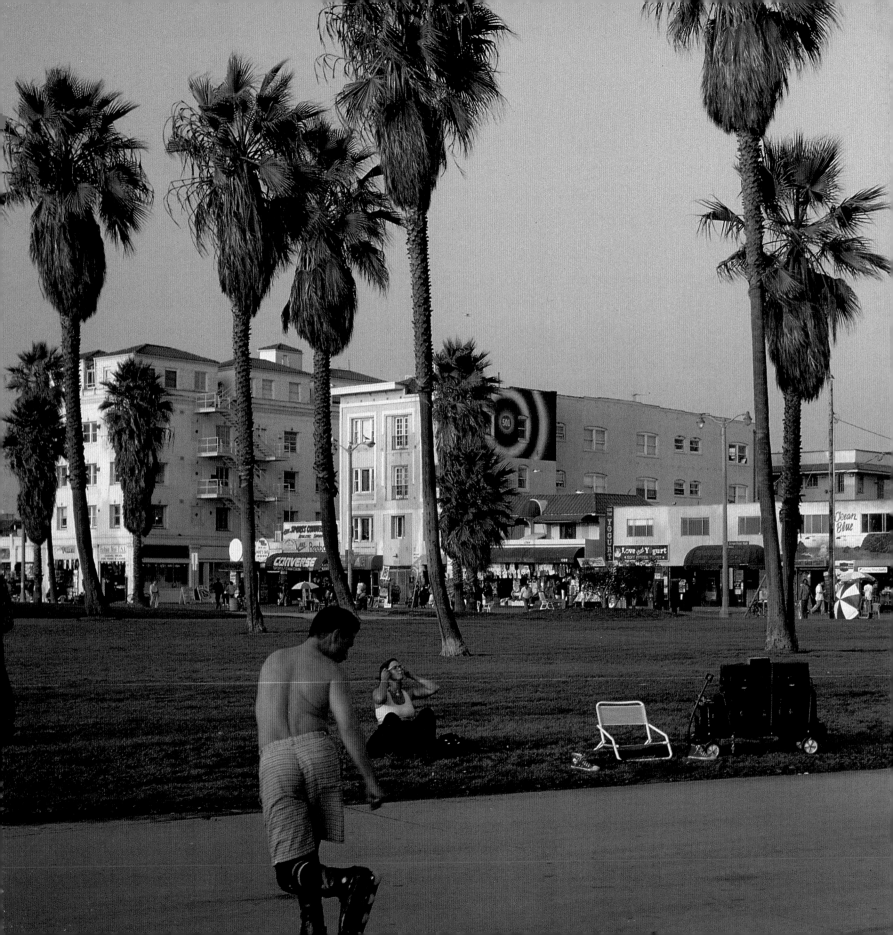

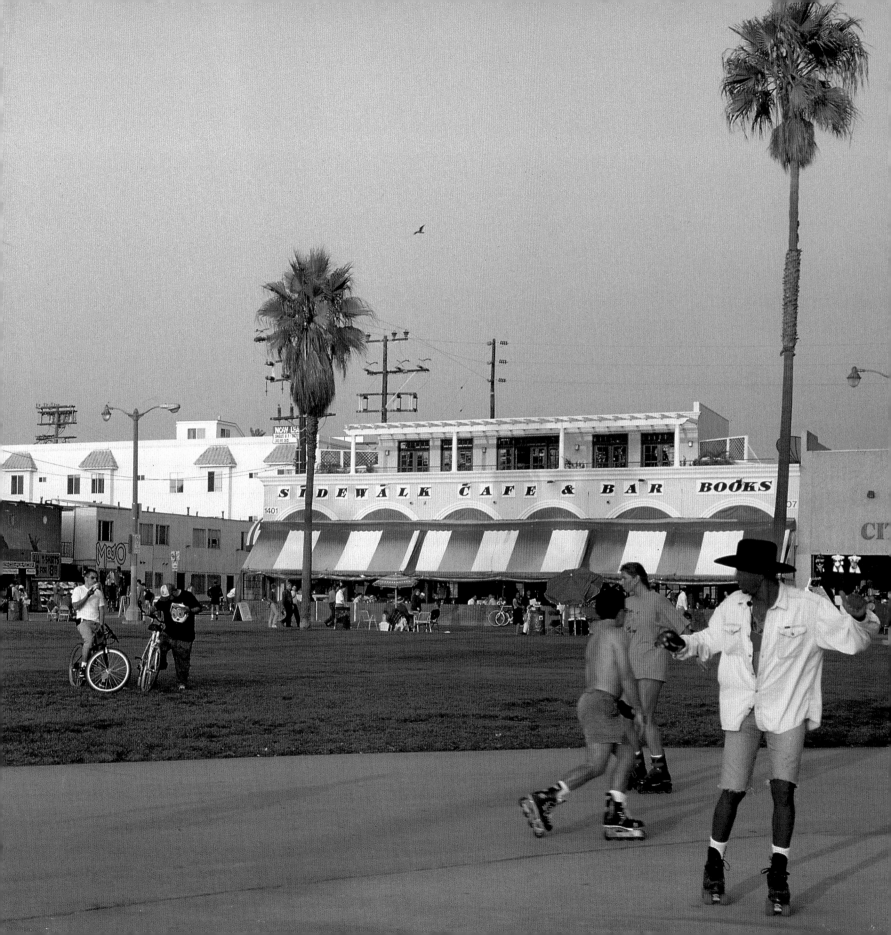

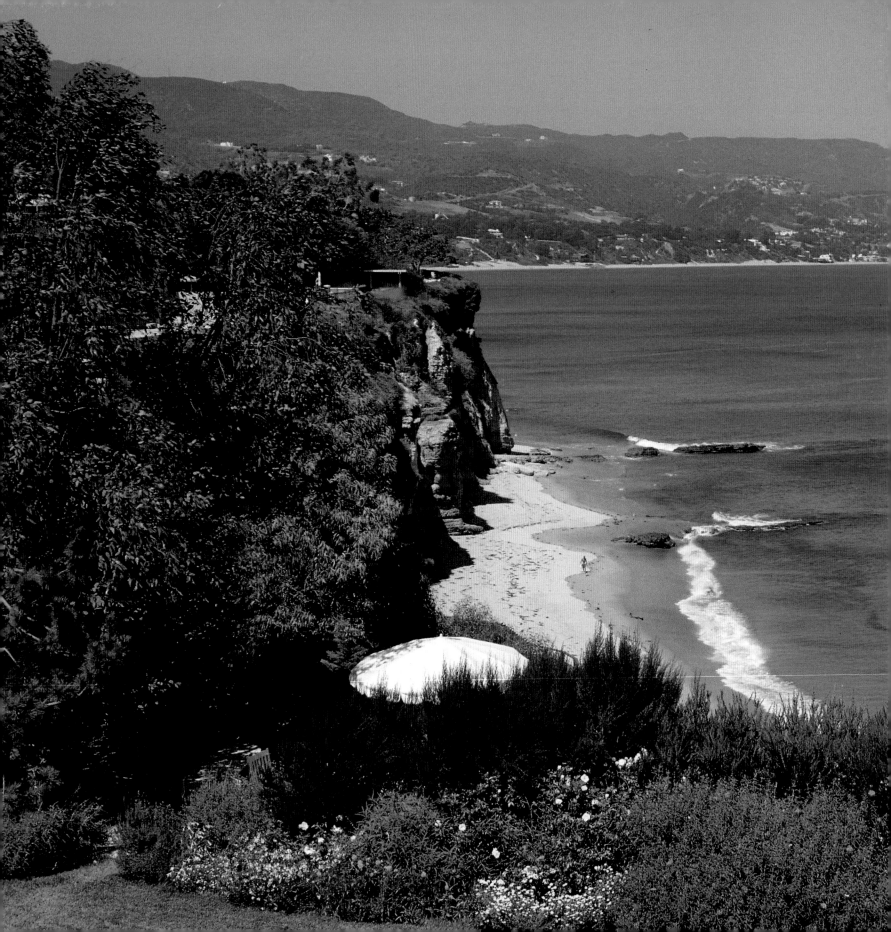

Introduction

ABOVE: The ten redwood cabins at the Steep Ravine Environmental Campsite, now a part of Mount Tamalpais State Park in Marin County, were originally built for Congressman William Kent and his family in the 1930s.

The first time it dawned on me that beach houses were different from other houses, I was, appropriately enough, in California. It was the early 1960s. My parents, siblings, and I were returning from a family trip to San Diego and stopped to visit friends who were vacationing in another southern beach community. Apart from the tide pools filled with exotic, colorful sea creatures, my most vivid memory of that day was of the house in which our friends were staying. It was neither large nor luxurious, but its rooms, bleached by the bright sun, looked radiant and smelled of brisk salt air. I was instantly seduced by the siren call of life by the sea.

That was just the beginning of my fascination with the California coast. As I would discover on another family trip, Monterey and Carmel, with their windswept cypress trees, tall cliffs, and offshore rocks crowded with barking seals, painted quite another picture of life by the sea. And just a few years ago, when I drove up Route 1 from Stinson Beach to Mendocino, I discovered the equally beautiful—yet very different—North Coast, where sheep grazed on tranquil meadows perched high above the pounding waves.

California's eleven hundred miles of coastline offer something for everyone. The south has wide, sandy beaches and a climate that seems almost perpetually balmy—the stuff of Beach Boys songs—while the central and northern parts of the coast are characterized by more rugged terrain and often violent winter storms. Among these vastly different settings, people live in houses that vary in size—from spare, modest, just-the-basics cottages to rambling, luxurious villas—and style—from New England shingles to contemporary steel and glass. Once considered suitable only for summer holidays, these beach houses are now, more often than not, lived in year-round by their owners. A house at the beach offers a refuge, a place where time moves according to Nature's rhythms, and the view is as big as the Pacific Ocean.

ABOVE: A row of potted cactus plants and a cascade of brilliantly colored bougainvillea brighten the man-made landscape at Brian Murphy's trailer in Pacific Palisades.

Pilar Viladas

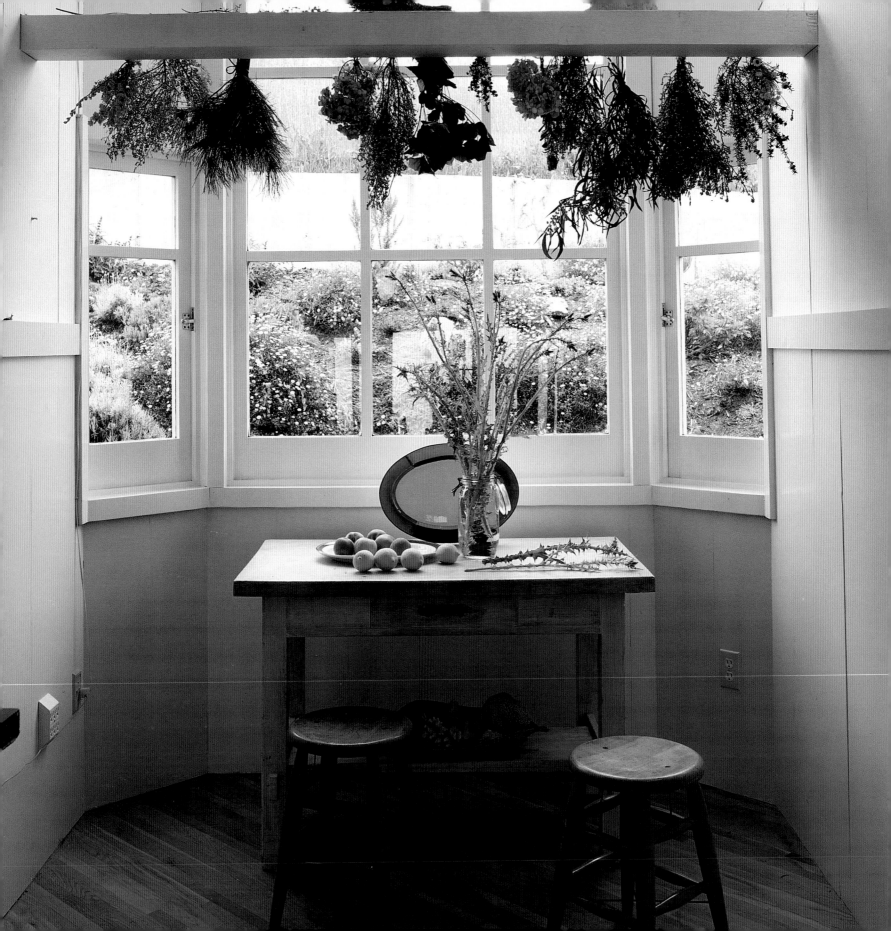

Beach Cottages

I know that it isn't most people's idea of the "quintessentially Californian" beach house, but I have always thought that my ideal beach house would be a cottage. True, it's a house type that was imported from New England in the 1930s, when a romanticized view of East Coast architecture began to vie for popularity with the reigning Spanish Colonial Revival style. But then, just about every style of California domestic architecture—with the possible exception of the state's trailblazing contemporary design—came from somewhere else. No matter that these small-scale, shingled, and clapboarded buildings originated in a place where big elms and maples shaded them and roses twined around their doors; they look just as inviting on the shores of Malibu or Stinson Beach, where there's nary an elm or maple to be seen (although there is an abundance of roses). There's a weatherbeaten charm to these houses, an unassuming quality that seems perfectly suited to the casual way in which people live by the sea. The idea of whitewashed rooms, filled with a few simple pieces of furniture and varied collections of treasured objects, and warmed by the sun streaming in through the windows, couldn't seem more appropriate. I'd happily live in any of the houses shown in this book, but I'd still dream of a cottage by the sea.

OPPOSITE: In this Muir Beach kitchen, a grandly scaled window contrasts with the intimate scale of the room, which is paneled in wood planks painted white.

FOLLOWING PAGES: On the deck of John Jones's Stinson Beach guest house, overlooking the Bolinas Lagoon, convolvulus creeps through the wooden planks, and bright yellow yarrow blooms behind the chairs.

When Jane Nathanson, a psychologist who is also the vice chair of the board of trustees of The Museum of Contemporary Art in Los Angeles, and her husband Marc, the CEO of Falcon Cable TV, first saw this house on the beach on Malibu, they knew it was the house for them. "Its New England charm is unusual for Malibu," says Jane. The Nathansons asked Waldo Fernandez, the Los Angeles decorator whose high-profile clientele also include actress Elizabeth Taylor and entertainment mogul Merv Griffin, to create a warm and casual weekend environment. "We wanted something very different from our house in Los Angeles, which is more formal," says Jane, referring to the couple's rambling, art-filled Spanish-style house, which was decorated by the late, legendary Kalef Alaton.

"We went for a clean, simple look," says Waldo, who describes his clients as "having definite ideas about what they want, so it was easy." Waldo bleached the wood floors to a pale tone, painted the walls white, and put white cotton slipcovers on the furniture. The only color is provided by accent fabrics and the art on the walls. The overall effect is, as Waldo describes it, "very open. It's a beach house—it shouldn't look elaborate." Jane Nathanson calls the house "easy, and semi-indestructible. It's cozy when there are just the two of us, but because our backyard is the ocean, it works for the whole family, too."

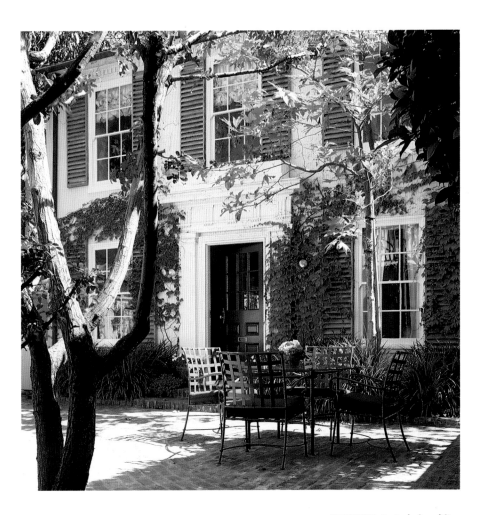

OPPOSITE: A study in white on white, a row of chaises sits on the deck overlooking the beach.

ABOVE: With its wood shutters and paneled door, the ivy-covered cottage has what its owners call "New England charm."

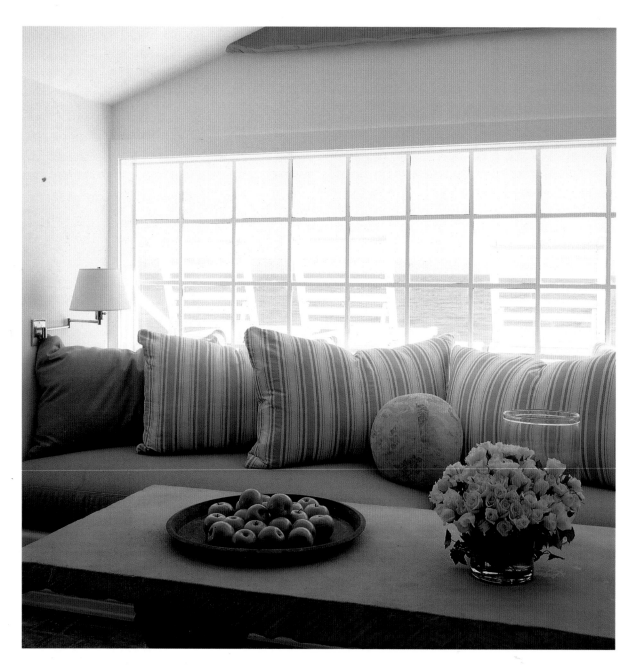

LEFT: In the beamed family room, Waldo Fernandez varied the house's all-white color scheme with a soft green fabric on the banquette and green-striped pillows. Waldo also created two separate seating areas to make the long room feel more intimate.

OPPOSITE: From the family room, the white of the chairs and the deck contrast vividly with the blue of the sky and water.

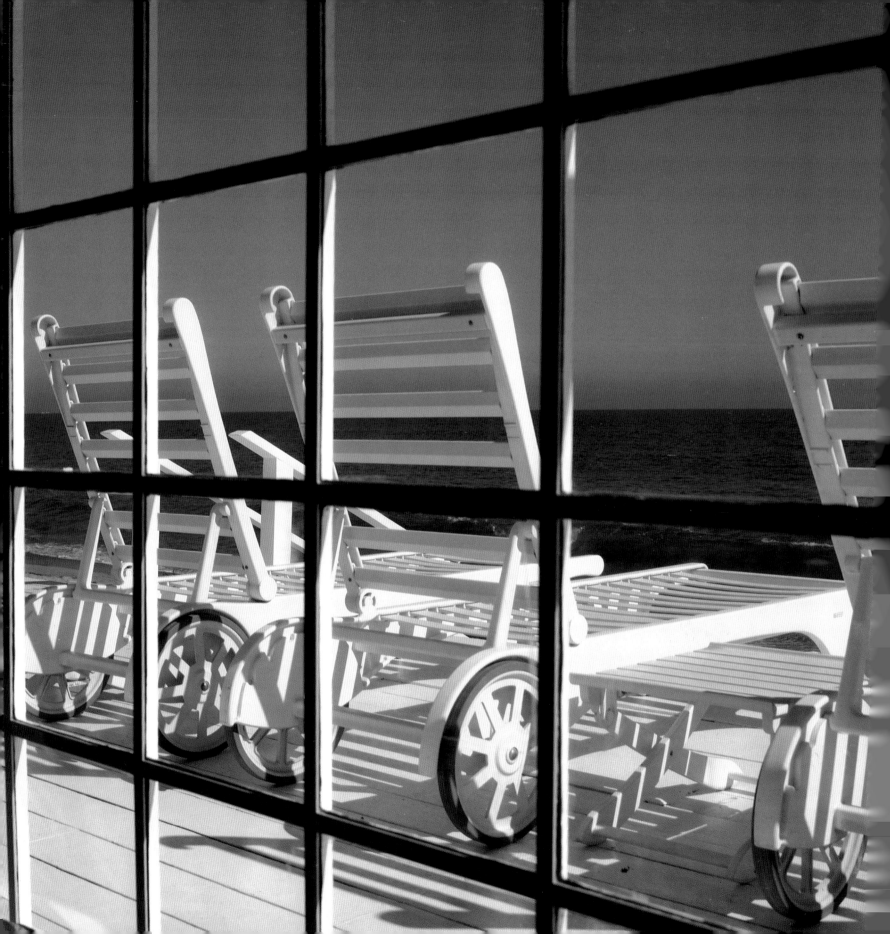

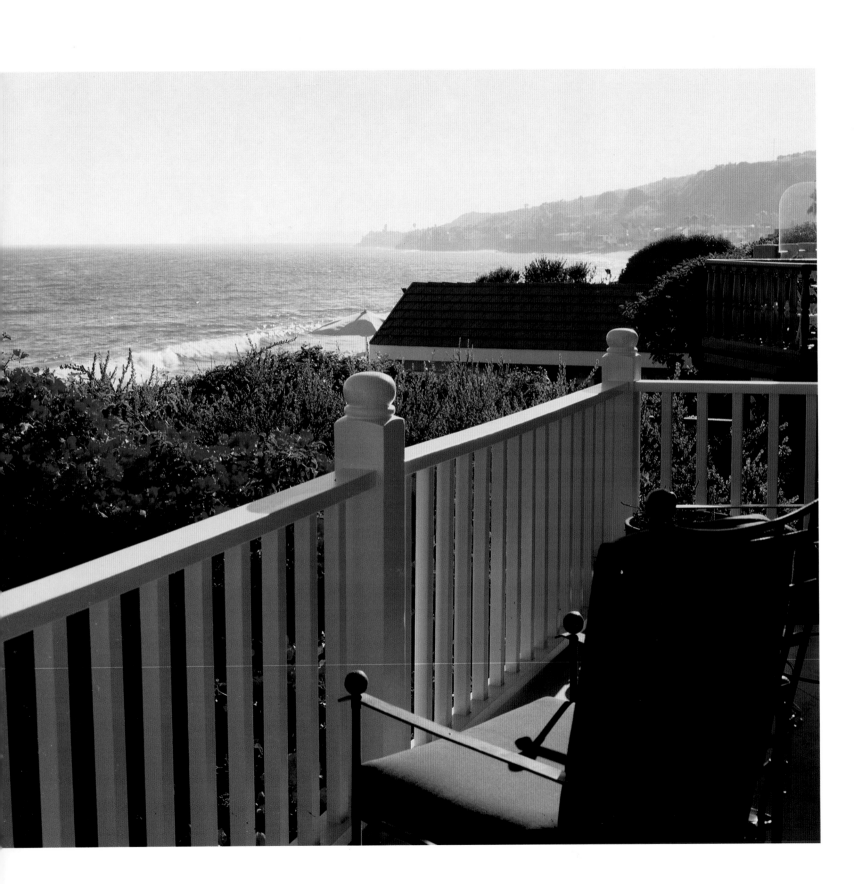

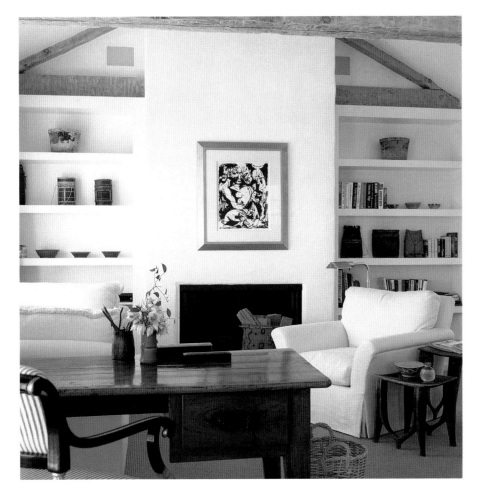

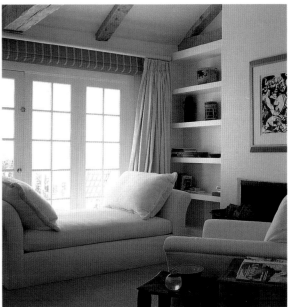

ABOVE: With an ocean view, a daybed in the master bedroom is the perfect spot for reading or an afternoon nap.

LEFT: The master bedroom, with its white walls, timbered ceiling, and elegantly austere bookshelves, is simply furnished: a reproduction Regency chair sits at an antique country table, and the sofa and daybed are covered in white cotton. A Jackson Pollock hangs above the fireplace.

OPPOSITE: Nestled behind a colorful growth of bougainvillea, the balcony off the master bedroom provides a sweeping view of the Pacific Ocean.

Bischoff House, Muir Beach

RIGHT: The front porch serves as the informal entrance to the house. A hammock adds to its unpretentious and easygoing charm.

BELOW: A view from the living room into the dining room illustrates the way in which the house's living spaces flow smoothly into one another, making the small house seem much larger than it is.

OPPOSITE: The view from the dining room into the living room shows one of the transverse dormers that bring light into the rooms. One of James Bischoff's paintings hangs to the right of the fireplace.

One of the things that draws people to the Bay Area is its natural beauty—and the fact that it is possible to live in a fairly rural-looking place that is still easily accessible to big cities. A case in point is this house in Muir Beach. Nestled into a lush hillside, with spectacular views of the Pacific, it seems far removed from the hustle and bustle of urban life, but in a twenty-minute drive, you can be on the San Francisco–side of the Golden Gate Bridge. That's part of what led James Bischoff to design a house here for himself and his family. (He and his wife, Linda Bischoff, have since divorced, and she continues to live in the house with the couple's two children.)

For Bischoff, who has worked in Northern California for much of his career, preserving the unique qualities of a building site is as important as the building itself. He set this house deep into the hillside, even going so far as to put the garage at the bottom of the hill, to keep the profile of the house as low as possible, thus not only preserving the hill, but the neighbors' views as well. You have to walk up to the house from the garage, but Bischoff wouldn't have it any other way. "Other people might have put a driveway up to the house," he says. "But it would have ruined the hill."

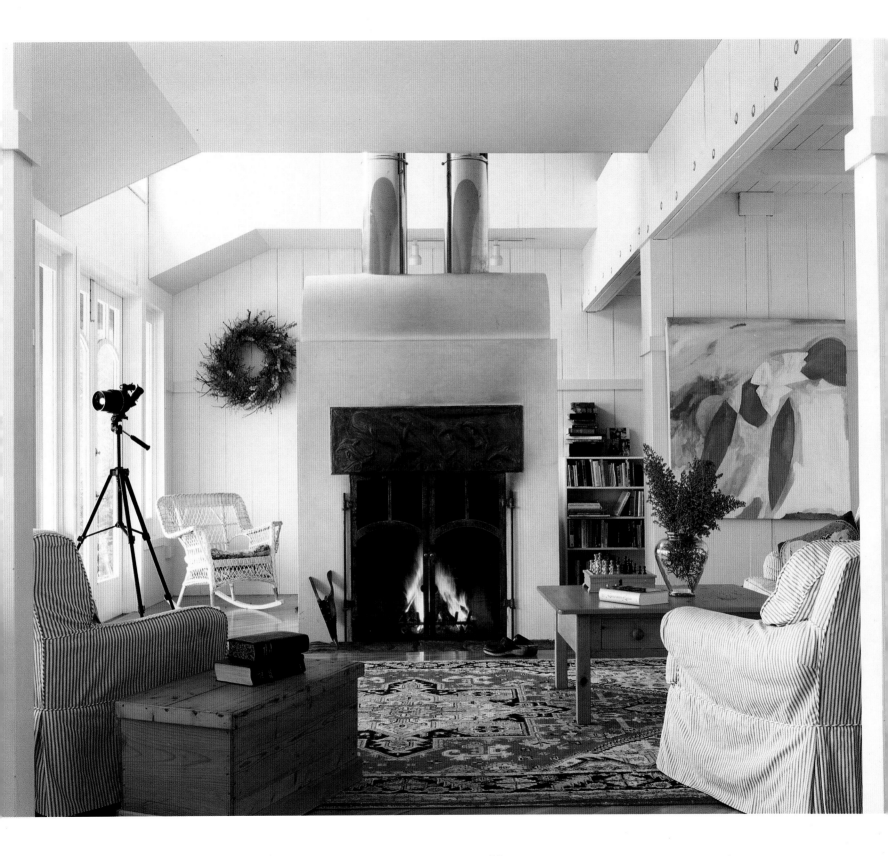

RIGHT: In the kitchen, Bischoff designed what looks like a cross between a Palladian window and a bay window; its splayed sides project extra light into the room. The window offers a glimpse at the oval retaining wall that is set into the hillside behind the house. The kitchen has concrete countertops cast by Bischoff in molds lined with glass, which produces a smooth finish.

OPPOSITE: The dining room opens into the kitchen beyond. A doorway at the right of the passage leads to the children's rooms.

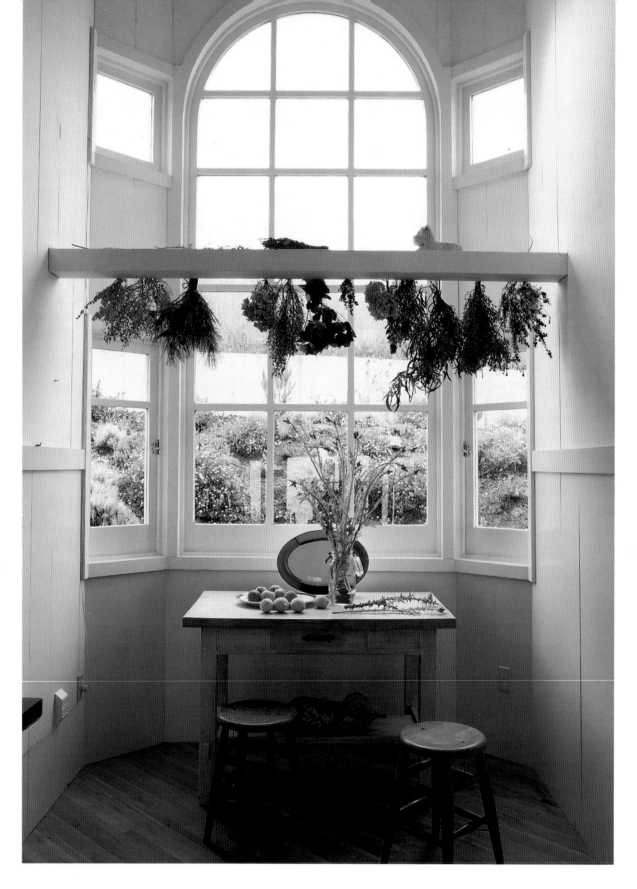

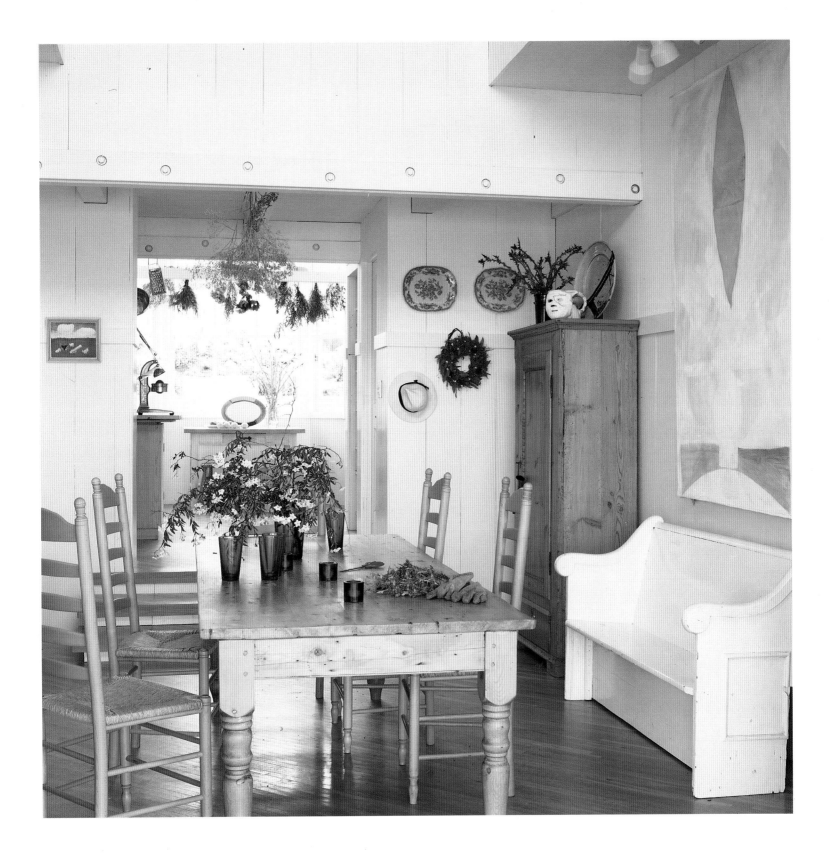

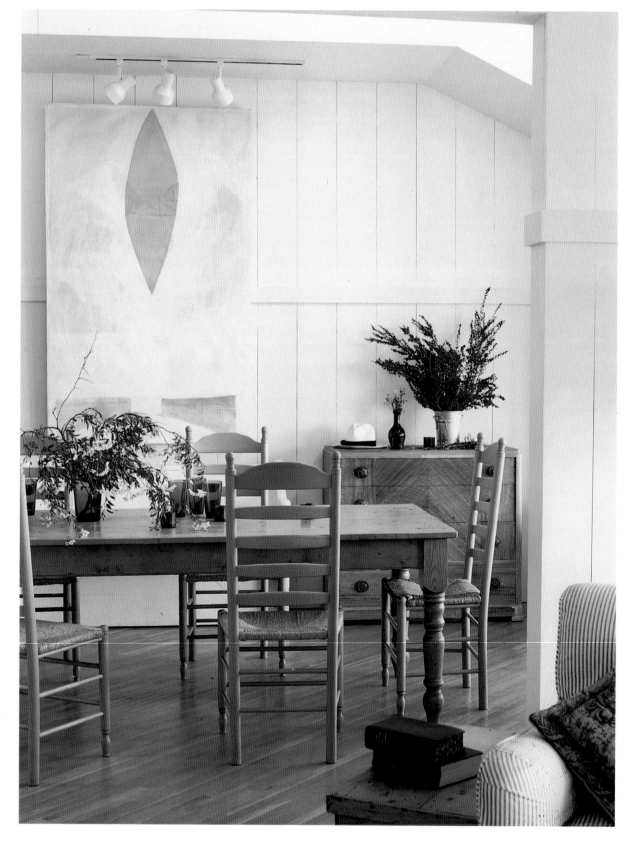

RIGHT: Another of Bischoff's paintings hangs in the dining room. Interior walls are wide-plank wood boards; here, they are painted a creamy white below and a brighter white above, a "picture rail" molding that allows boards of uneven lengths to meet behind it, thus eliminating the need for baseboards.

The house's formal entrance is on the hill side, but most people enter through the porch on the view side. Bischoff designed the house with deep overhangs to protect the interiors from the summer sun, while still allowing the low winter sun in to warm the rooms. The house itself, which measures just under two thousand square feet, is essentially a thirty-by-sixty-foot box with two transverse dormers running through it. These dormers allow more light into the rooms downstairs as well as the loft spaces upstairs, which are open so that the children can do their homework and still feel a part of the family life that goes on in the rooms below. Similarly, the low wall that separates the kitchen from the living area has a semicircle cut in it to allow a view of the ocean from the kitchen counter. With the living areas' cream and white walls, and the row of French doors that open onto the porch, the entire house feels both cozy and open. In fact, says Bischoff, "The whole thing is just like a porch." What better way to live by the sea?

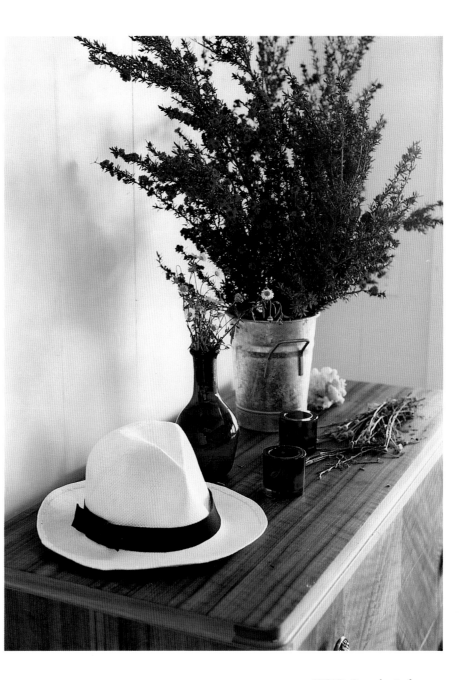

ABOVE: On a chest of drawers in a corner of the dining room, a still life of summer hat, blue glass, and flowers evokes the windswept pleasures of the beaches in Marin County.

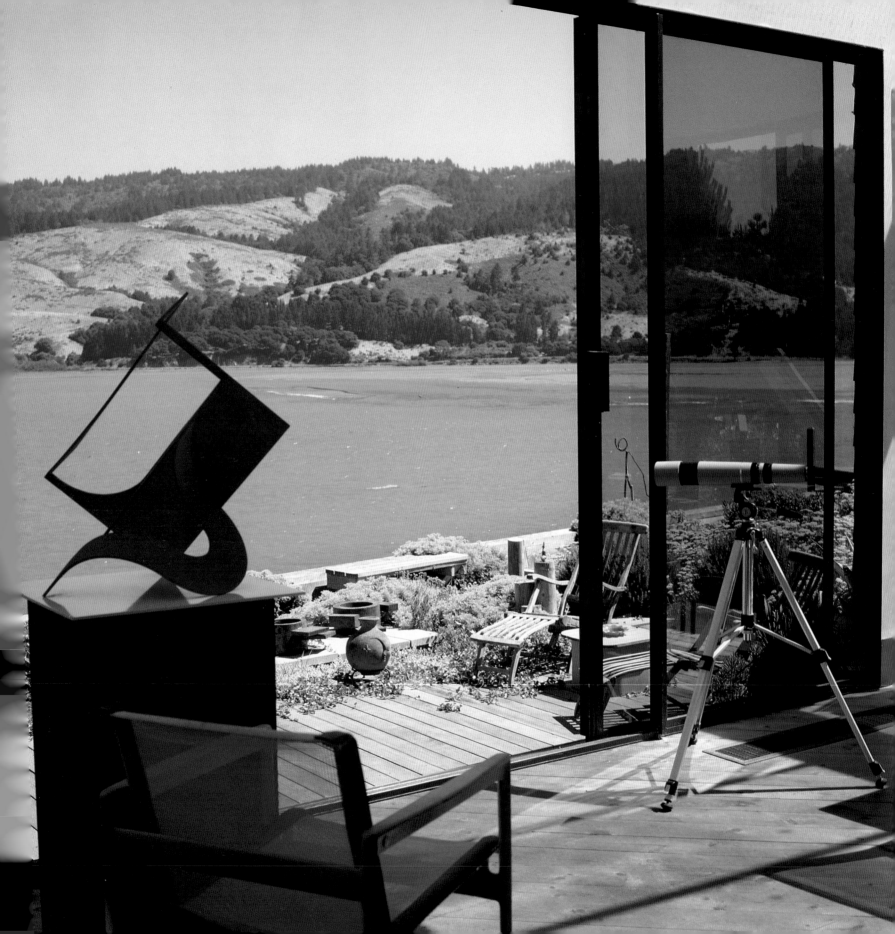

When John Jones built this redwood-shingled house more than two decades ago, he envisioned it solely as a weekend house for himself, his wife, Charlotte, and their three children. But Jones grew so attached to the peaceful pace and privacy offered at Seadrift—a community located on the north end of the sand spit in Stinson Beach, between the Pacific Ocean and Bolinas Lagoon—that the weekend house became a year-round house. Families change, too; there are now quite a few grandchildren, who love to visit. Fortunately, the house, which was designed by Jones's brother-in-law, architect Daniel Volkmann of Bull Field Volkmann & Stockwell (Volkmann has since retired and the firm is now called Bull Stockwell Allen & Ripley), has five bedrooms. And across the street, what was once a studio has now become a guest house.

The house is filled with Jones's collections of paintings, sculpture, ceramics, and furniture created by artists from California and elsewhere. Jones buys for love, not for investment; and he willingly lends his holdings to any museum that asks. "It's only fair to the artists," he explains. His wide-ranging acquisitions coexist peacefully in rooms that are comfortable and welcoming. "It's a pleasure," he says, "to live around things that you harmonize with." Jones's other passion is gardening, and although he insists that his gardens "just sort of created themselves," it is clear that their unfussy beauty—like that of the houses—is the product of a disciplined eye and plenty of loving care.

ABOVE: A Windsor chair and a fan-back chair, both made by Dennis Young, stand in front of an old ship's mess table made of ash. Above it hangs a collage by Bay Area artist Roy Gober.

LEFT: French scarlet poppies make a splash of color at the entrance to the guest house.

OPPOSITE: A sculpture by Fletcher Benton and a chair designed by Richard Schultz frame the view from the guest house out to Bolinas Lagoon.

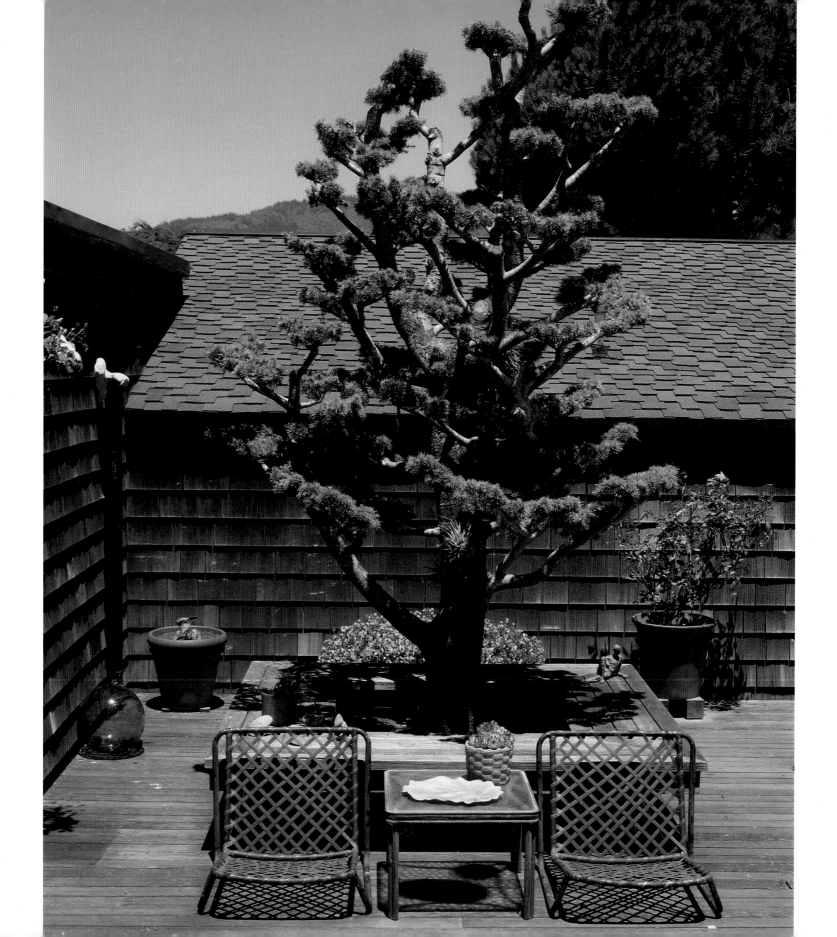

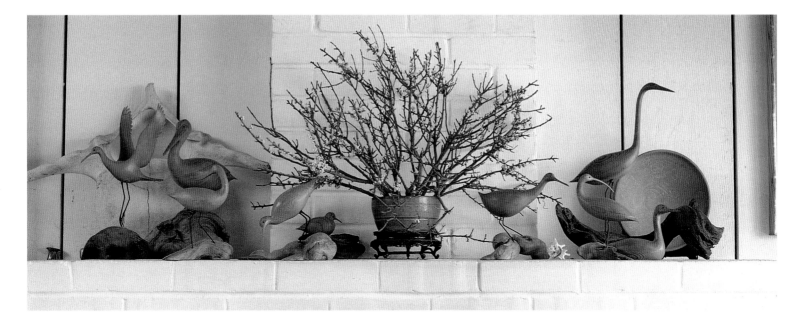

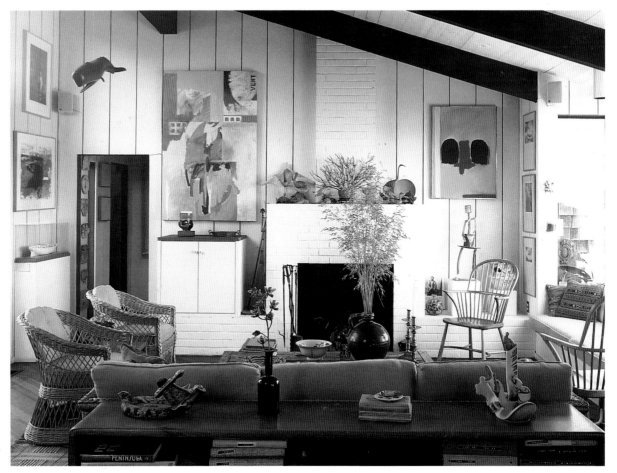

OPPOSITE: The weather at Stinson Beach can often be quite windy, so many houses have enclosed courtyards for protection. The courtyard of the main house is dominated by an Atlantic cedar tree.

ABOVE: Atop the fireplace, a group of wooden birds by noted Bay Area sculptor Wheatley Allen surrounds a rare, blue-glazed Ming bowl that is filled with bayberry branches.

RIGHT: The living room is filled with John Jones's art collection. To the right of the fireplace hangs a painting by the late Spanish artist Jose Guerrero; a painting by Michael Phleger hangs to the left.

Cormack House, Sea Ranch

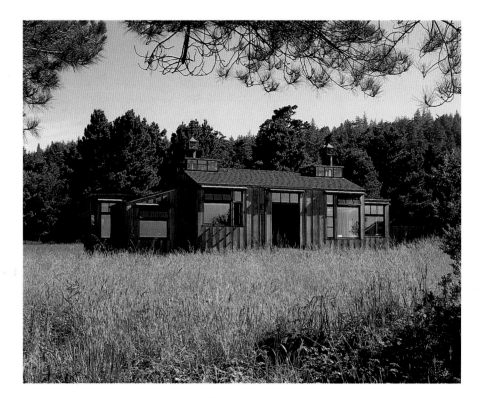

ABOVE: The house, with its board-on-board redwood siding and green-painted trim, is topped by two custom-made copper "lanterns" that bring light into the main room.

OPPOSITE: In the living area, a corner window seat offers a cozy spot near the fireplace from which to admire the quiet beauty of Sea Ranch's surroundings.

At Sea Ranch, the award-winning development on California's north coast, the prevailing architectural style—which is controlled by definite design guidelines—offers a largely modernist take on the shed-roof buildings that are native to the area. But Ann and Rob Cormack's house is different. While it conforms to the rules that ensure that all Sea Ranch houses blend unobtrusively into their breathtaking surroundings, this house possesses a timeless quality all its own. For James Bischoff, who designed the house as a partner in the architectural firm of Callister, Gately, Heckmann & Bischoff (he now has his own office), architecture's experiential aspect is more important than its formal one, and he set about determining what kind of house would make the Cormacks—friends of many years— feel truly at home. "They didn't care about curb appeal," recalls Bischoff. What did they care about? "We were after order," explains Ann, "a calming symmetry, but the house had to be open, with a lot of light." Rob, who studied architecture in college, admired the heavy-timber aesthetic of Northwest Coast log lodges, with their massive, exposed structures. Bischoff gave them all that, and then some—in a mere sixteen hundred square feet. The spacious living-dining-cooking room doesn't segregate the kitchen from the family or houseguests. The three bedrooms are wrapped around the back corners of this space in a way the Cormacks call "brilliant." Community and privacy are available in equal amounts, and Bischoff's elegant use of wood and copper make the interiors as inviting as the exteriors.

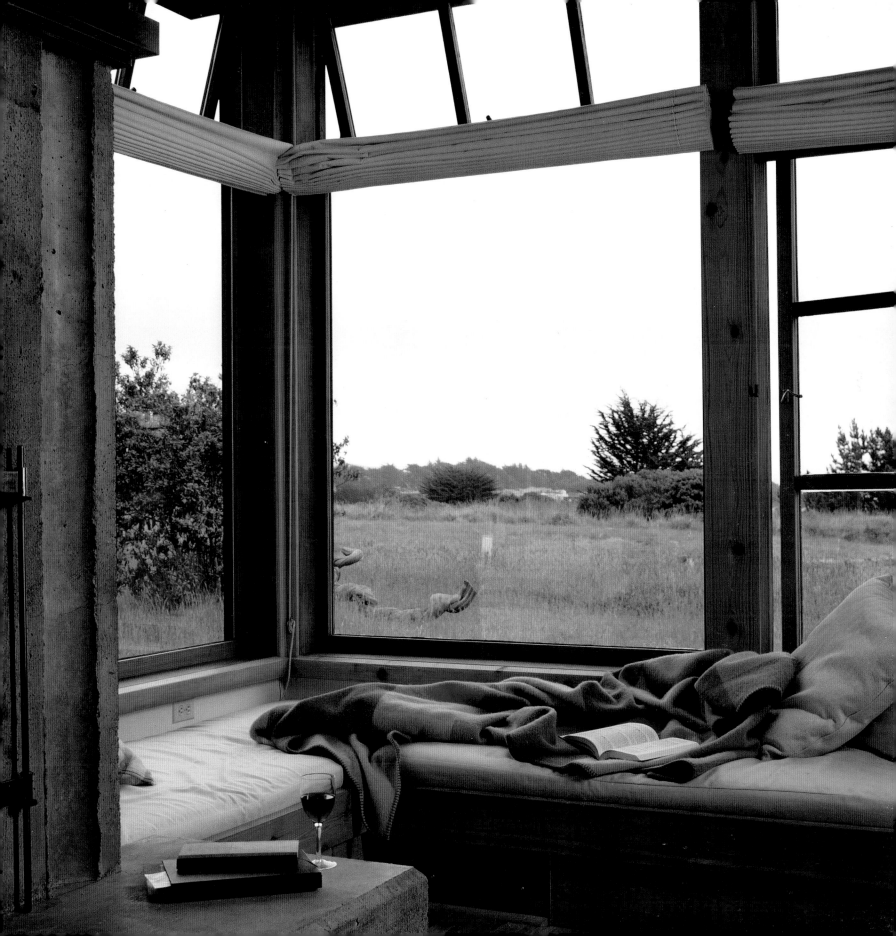

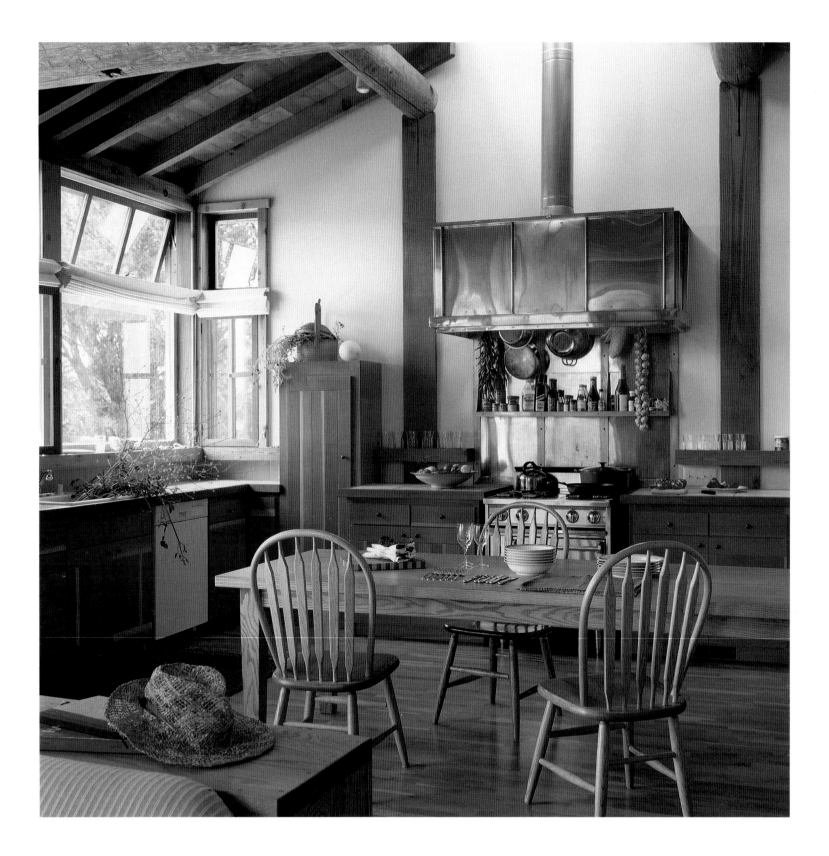

OPPOSITE: Massive Douglas fir columns and beams, redwood rafters, and vertical-grain Douglas fir cabinets create a sense of warmth and solidity in the dining-kitchen area, while the clerestory "lantern" above the stove floods the room with light.

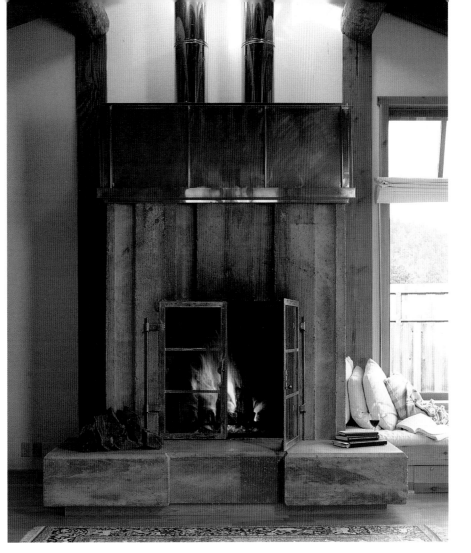

LEFT: The Cormacks wanted the concrete fireplace to be the color of ocean stones, so Bischoff mixed the concrete himself, and added splashes of bright colors.

BELOW: Although the budget for the house was a modest one, Bischoff gets plenty of mileage out of the judicious use of fine materials, such as the copper of the range hood and the teak edging on the cabinets. Both the Cormacks and Bischoff credit contractor Gregg Warner with especially meticulous craftsmanship.

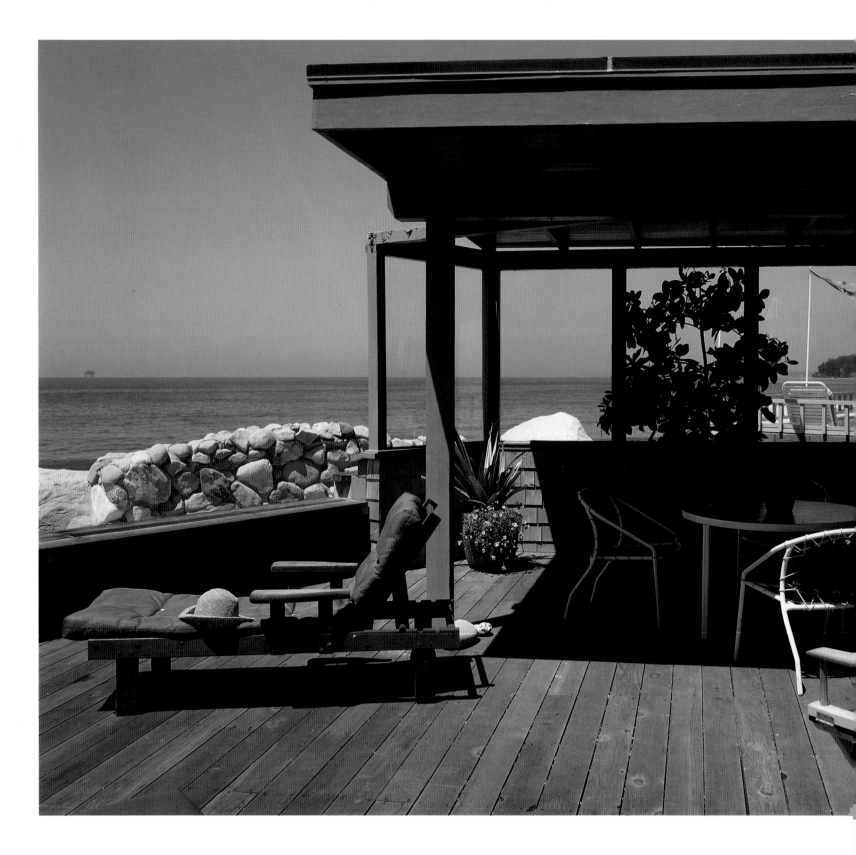

When Pasadena residents Edward and Joyce Engs started shopping for a weekend house near Santa Barbara, they knew exactly what they wanted: "A real beach house," says Joyce Engs, "not a fancy place. We wanted something we could lock up and leave." They found just the house, in the form of a beachfront cottage in Carpinteria that began life as a naval barracks at Port Hueneme, and which was moved up the coast many years ago and used, as were other cottages in the neighborhood, as summer houses for people from Montecito. The house has seen its share of adventures: the infamous 1983 storm that battered the entire California coast swept water and boulders right through the house, and destroyed its porch. "Rumor has it that a wave went over the house," says Edward Engs. "The water was waist-deep in the road." Since then, the weather has been kinder, and the house has been enlarged to include a second-floor master bedroom-with-a-view, designed by the Engs's Los Angeles-based son Edward, who is known as Ned. The house is filled, says Joyce, with "things that I've had for a long time," such as her collections of shell-covered boxes and mirrors, and paintings of ocean scenes by local artists. "You don't need a lot of furniture," she continues. "You just want pieces that are useful, and that have a little personality."

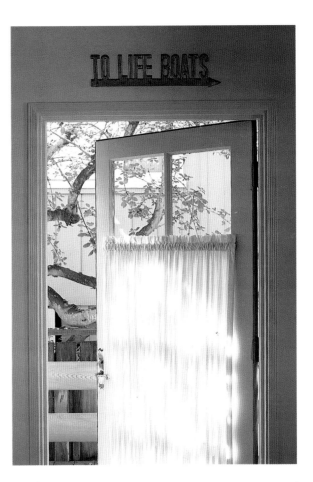

OPPOSITE: The deck offers both sunny and shady spots from which to enjoy the sun and the ocean views.

ABOVE: An old sign that ocean travelers hoped they would never need to follow now has a second life as a whimsical adornment above a side door in the house.

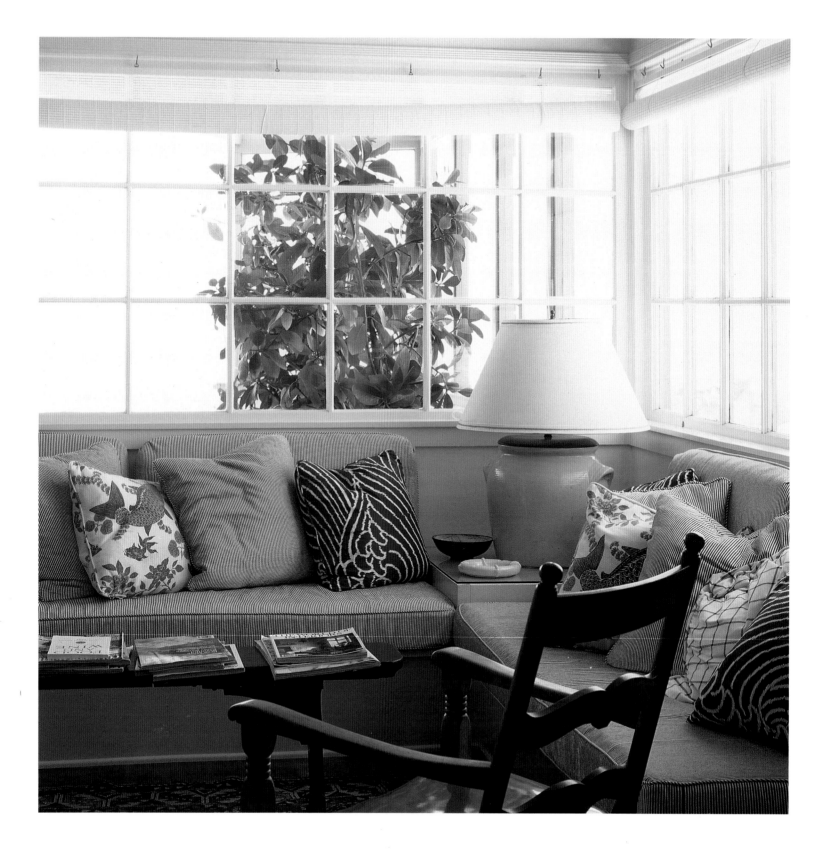

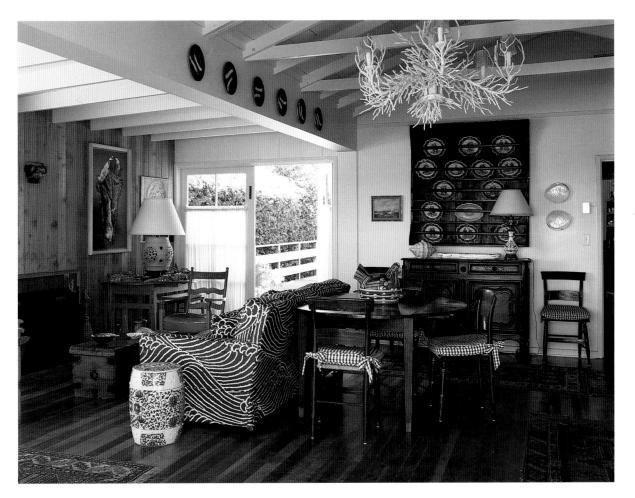

LEFT: The roof trusses of the house, which was originally a barracks, add warmth to the living room. Hitchcock chairs surround a nineteenth-century French drop-leaf dining table. The chandelier, with twig branches that are made to look like coral, was created by legendary Los Angeles designer Tony Duquette.

OPPOSITE: The southwest corner of the living room has built-in seating that looks out to the deck and the ocean beyond it.

RIGHT: Joyce Engs's collection of Victorian shell-covered boxes is grouped around a 1920s shell-covered lamp on a table in the living room, under a painting of a shell by noted Santa Barbara artist John Gorham.

BELOW: In the reading room, a simple Irish pine wash stand, adorned with nothing more than a carved and painted wooden folk art bird and a straw hat, sits under a painting of shells by John Gorham.

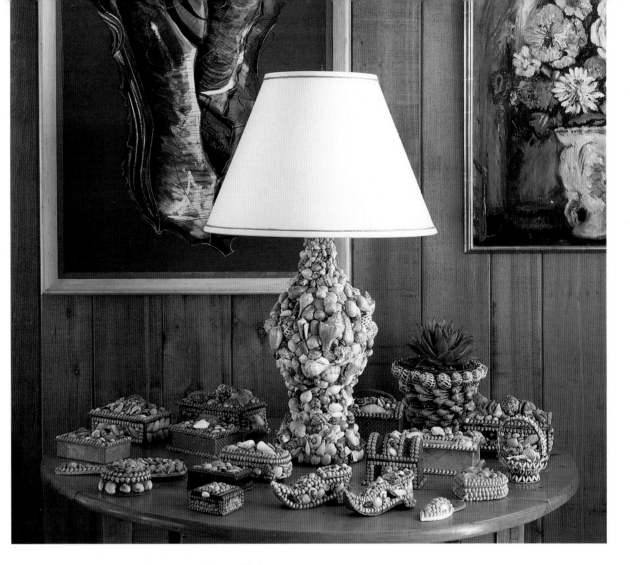

OPPOSITE: The shelves of an English pine cabinet in the reading room display a variety of Quimper ware and a ship model.

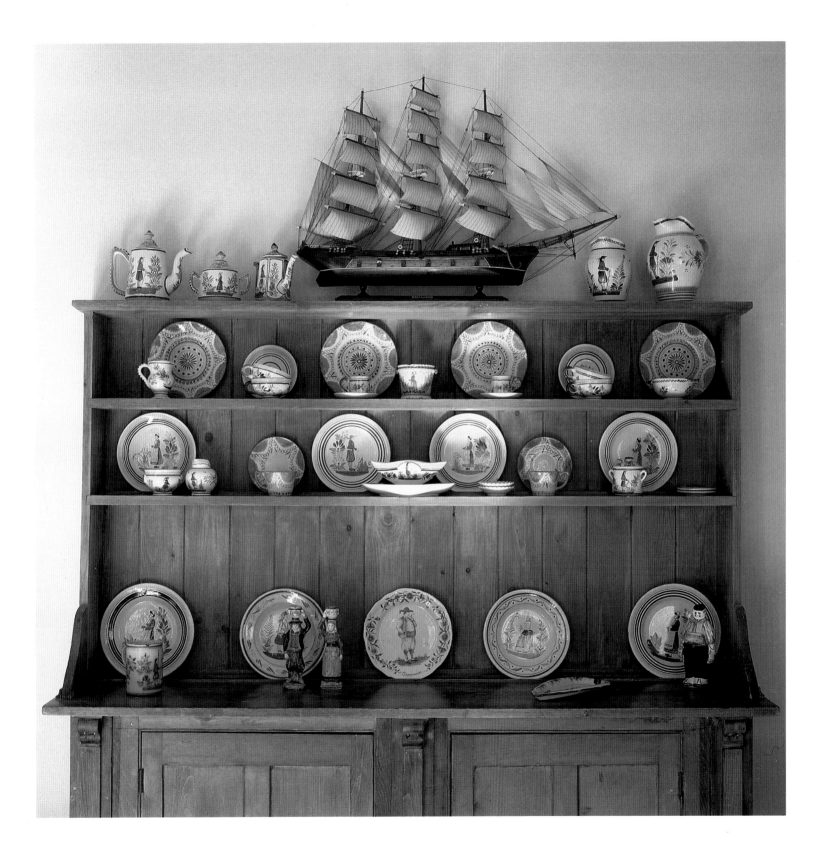

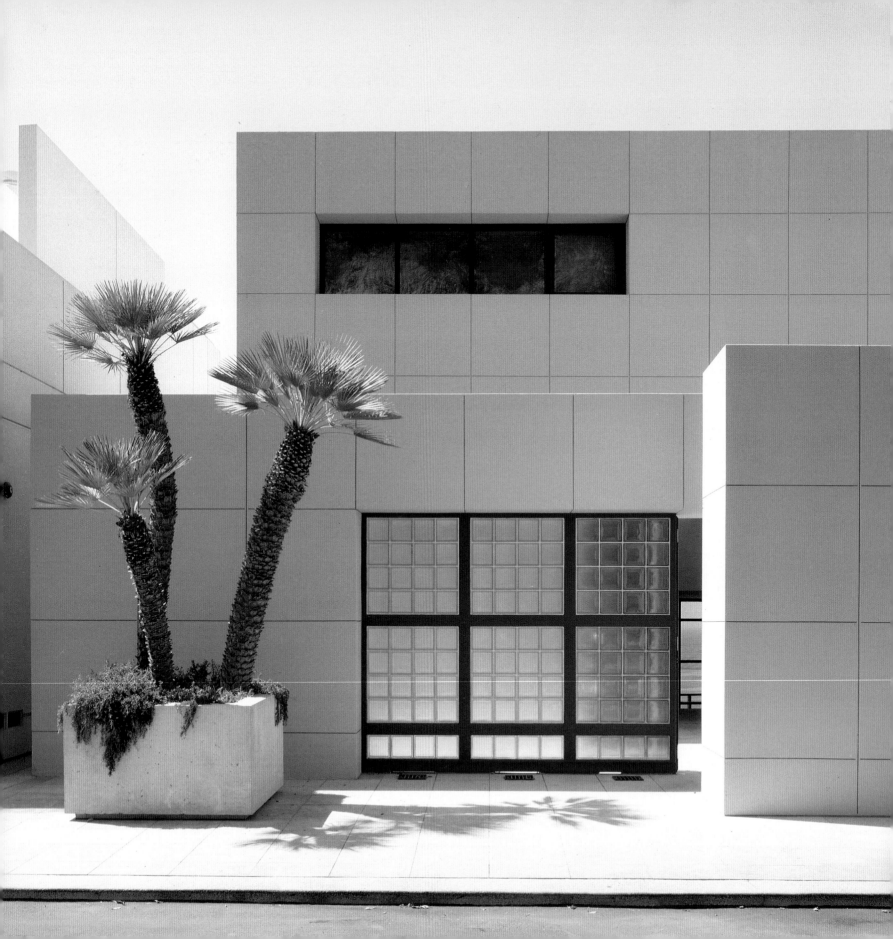

Coastal Contemporary

It's an image right out of the movies: A dramatic, ultramodern house of steel and glass, cantilevered out over towering cliffs, seeming to defy the laws of nature. Cozy, modest beach cottages may be fine for some, but for others, an oceanfront setting demands a more ambitious architectural response. Up and down the California coast, architects have for several decades been designing houses that use a modernist design vocabulary to make the most of the light and fresh air of the beach. In the 1920s, Viennese émigré R.M. Schindler designed a concrete beach house, for the Lovell family on the Balboa Peninsula in Newport Beach, that is considered a milestone in twentieth-century American architecture. In the late 1930s, Richard Neutra, the other modernist master to leave Vienna for the United States during that era, designed a sleek house, with continuous ribbon windows, on the beach on Santa Monica for Albert Lewin, a film writer, producer, and director. Since then, architects have continued to "push the envelope" of beach house design as they create dwellings that seem, for all their formal bravado, to want to become one with the sun and seaspray—to allow their occupants to experience the ocean as fully as possible without actually falling into it. It's as if the limitless possibilities of the ocean stretching beyond them inspire these designers to explore a few of their own.

OPPOSITE: The smooth, sleek volumes of this Malibu house, designed by Jerrold Lomax for Lomax/Rock Associates, are broken only by its slot-like windows and a wall of glass block.

FOLLOWING PAGES: Along this stretch of Capistrano Beach, the "one of everything" architectural aesthetic is enlivened by architect Rob Wellington Quigley's arresting composition of bold forms and materials.

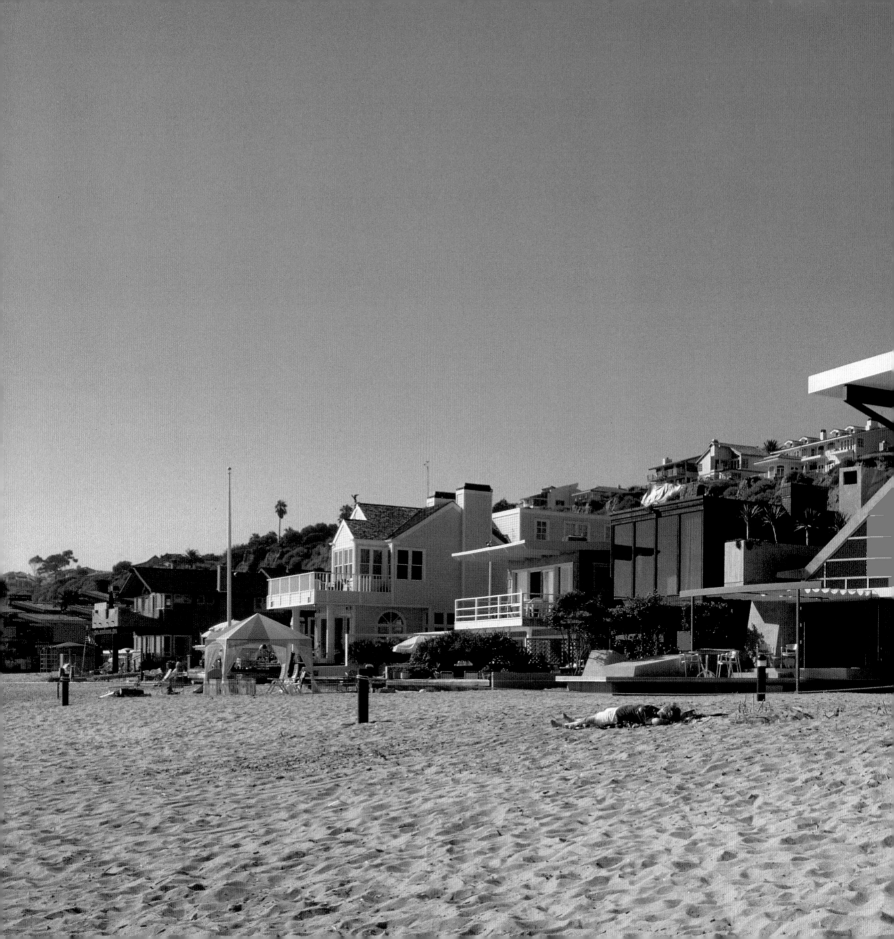

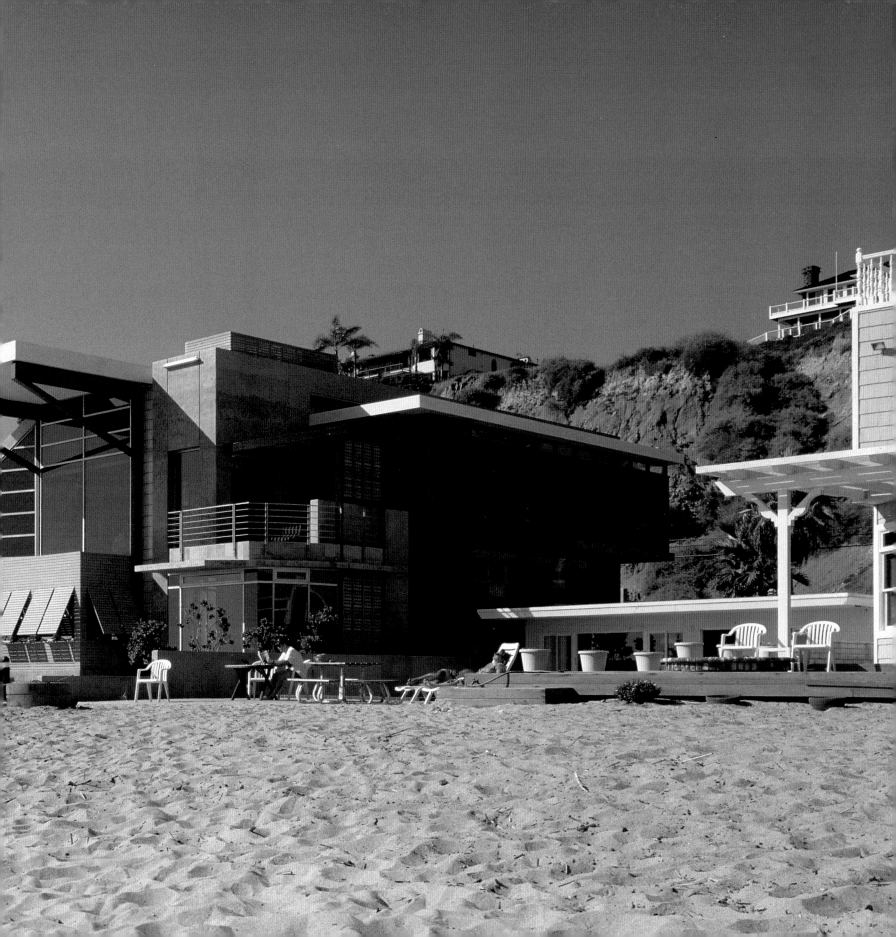

Bold Form in Capistrano Beach

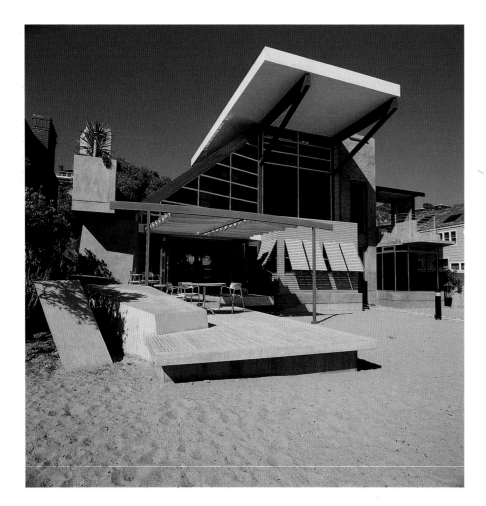

ABOVE: A deep canopy shades the living room, while redwood-slat walls and awnings screen the library on the beach side.

OPPOSITE: A wood deck off the living room, with movable canvas canopies, provides a front-row view of the Pacific Ocean.

The community of Capistrano Beach is a long strip of narrow lots located on the Pacific Ocean south of San Juan Capistrano in Orange County. San Diego architect Rob Wellington Quigley (with project architect Catherine Herbst) was asked to design a house there for a couple who collect art by modern masters and who, he says, "are comfortable with abstraction." The house's ocean-front setting inspired what Quigley calls "a series of architectural juxtapositions." Along its length, the house reflects the rigidity of the parallel lot lines, while at either end, the house's edges are looser and more indeterminate, echoing the naturally eroded forms of the shoreline in front of the house and the bluffs behind it. Quigley designed a two-story concrete structural spine that contrasts with the wood structure of the second-floor master suite, which is wood-framed and covered in black asphalt shingles— a seemingly unusual choice of material, but one that was, like those of concrete, mahogany, stone, and stainless steel, dictated by the area's corrosive climate. On the first floor, a dramatic, sun-filled living room, with a curved glass wall that looks into a garden from one side and out to the beach on the other, contrasts with the shady, redwood-slat-veiled library. Quigley's clients worked with Dan Friedlander and Carmen Doell of Limn, the San Francisco store that specializes in innovative contemporary furniture, to choose furnishings that are as confidently modern as the architecture.

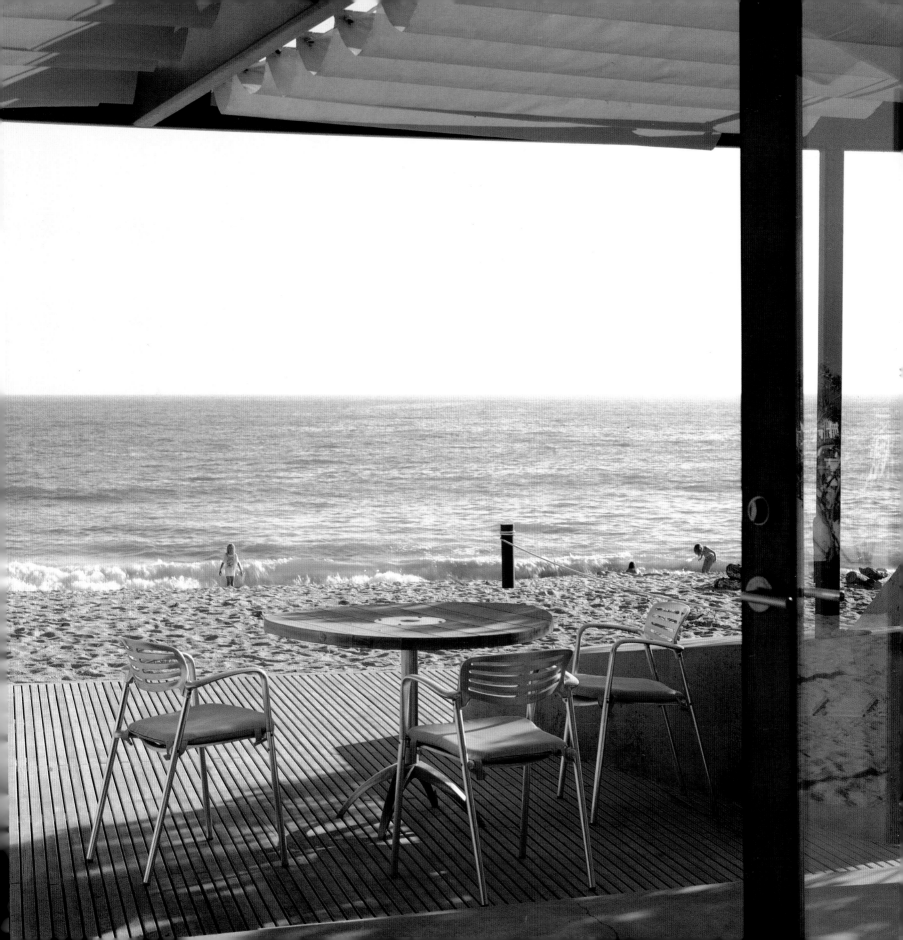

LEFT: A series of concrete steps, whose forms were inspired by the chunks of concrete that are used to make breakwaters, leads to the front door via a short bridge that spans both sand and lawn. The house's two-story concrete spine is visible at left, and the living area's curved glass wall is seen at right.

OPPOSITE: A dramatic curved stair, with a stainless steel structure, mahogany treads, and stainless steel mesh railings, leads from the living room up to the second-floor terrace and master bedroom suite.

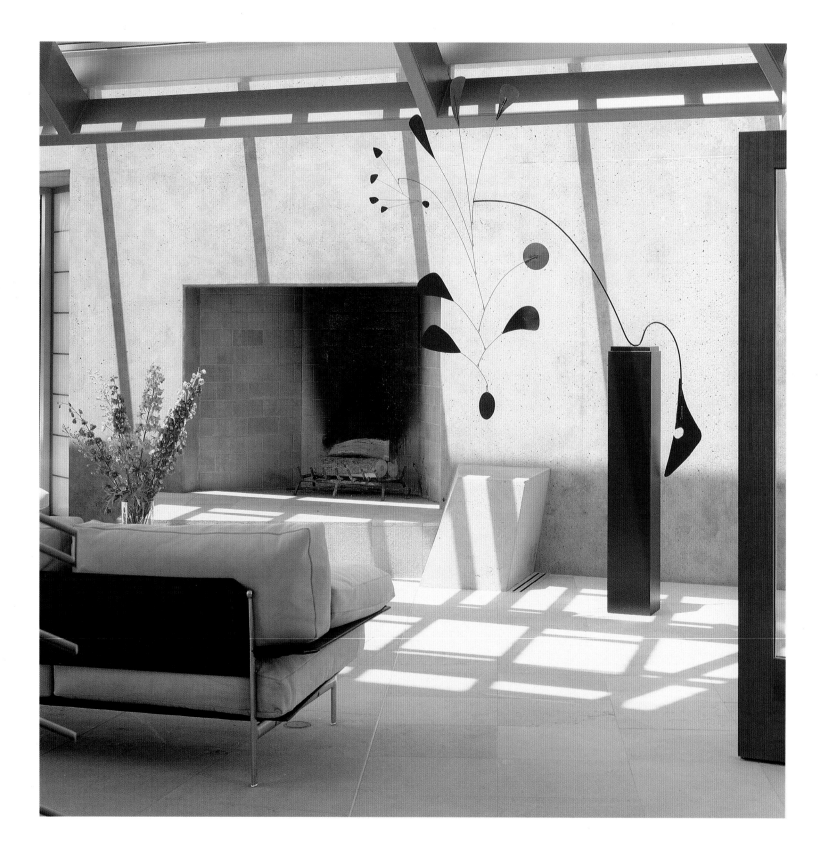

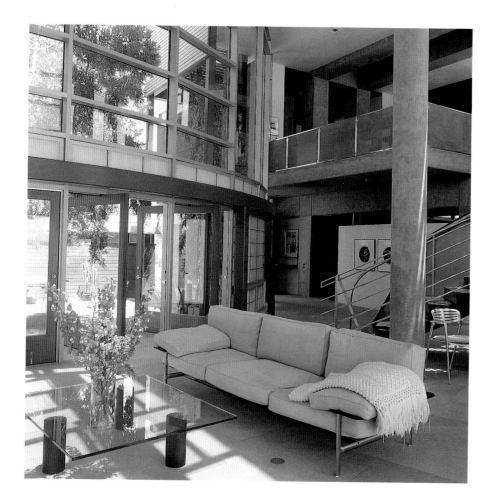

ABOVE: From the living room, the black shingle-clad volume of the master bedroom can be seen through the curved glass wall. The coffee table is a custom design, and the Diesis sofa was designed for B&B Italia by Paolo Nava and Antonio Citterio.

OPPOSITE: The concrete fireplace wall provides a minimalist backdrop for Alexander Calder's painted metal and wire *Red Disc* mobile of 1947. The floor is French limestone.

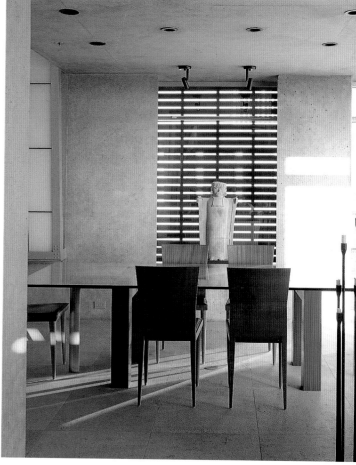

ABOVE: In the dining room, a wood-slat screen filters sunlight. The wood, glass, and aluminum Ercole table is made by Schopenhauer/ Fontana Arte, and the mahogany Diva chairs are made by Sawaya & Moroni.

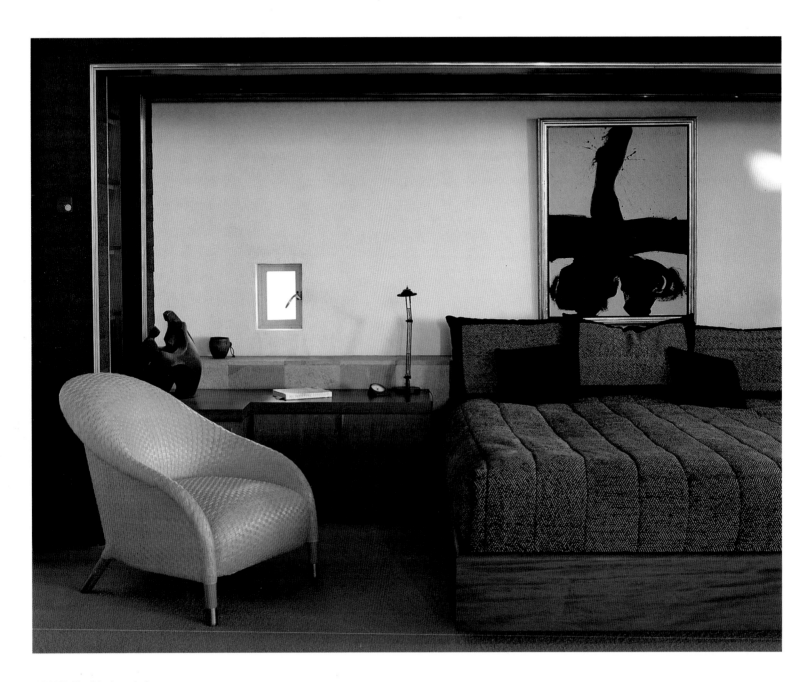

ABOVE: The black asphalt
shingles of the master
bedroom structure wrap
around its interior to
frame the sleeping alcove,
where Robert Motherwell's
1977 painting *Samurai
No. X* hangs above the bed.

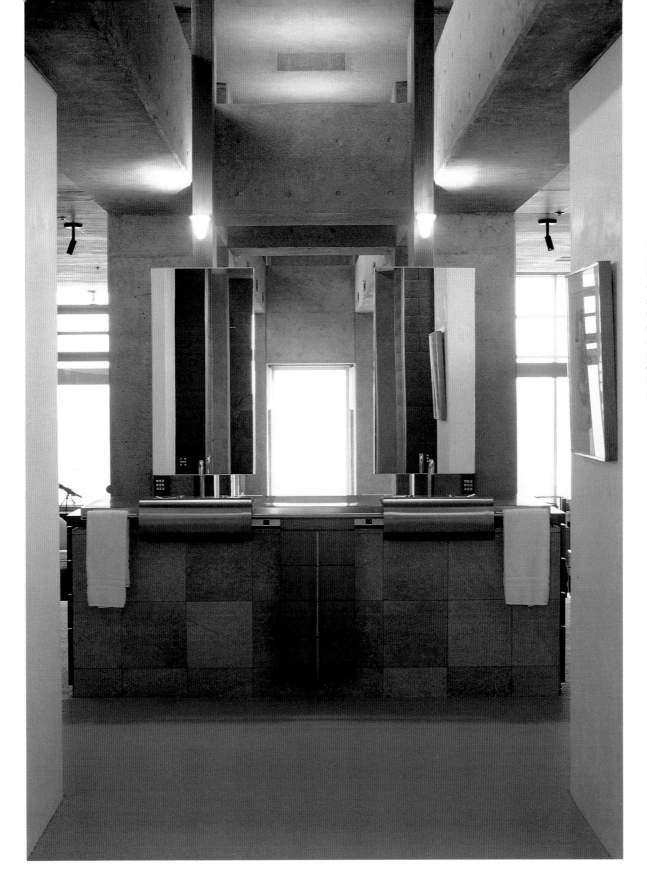

LEFT: The master bathroom is contained within the house's concrete spine. Quigley designed the twin sinks of stainless steel, wood, and limestone. The shower, which is located near the camera's vantage point, is placed at one end of the spine. Quigley calls it "an extremely spiritual place for a shower."

Miller House, Malibu

RIGHT: The wall of the dining area is of translucent glass channels, made in Europe, that allow light into the space while screening out views of the neighboring houses.

BELOW: The entrance to the house illustrates the way in which various materials were used on the different volumes that make up the house; sandblasted glass is used at the front door.

OPPOSITE: The view from the window end of the living room shows the entry in the background at right. Floors throughout the house are made of four-by-eight-foot sheets of plywood, which are sealed with multiple coats of matte-finish polyurethane.

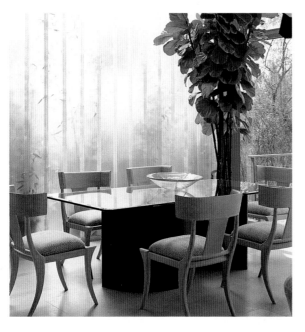

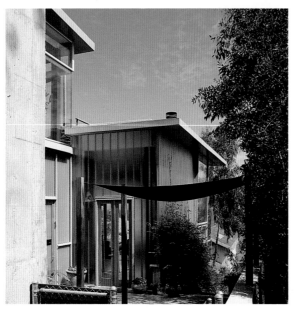

The rugged hills above Malibu offer building sites that are sometimes as challenging as they are spectacular. When Michael Miller and Patricia O'Herlihy Miller bought a long, narrow, and steep lot on which to build a house, they asked Lorcan O'Herlihy and Richard Warner of O'Herlihy + Warner Architects to make the site's sweeping ocean views a priority—but after that, the architects were on their own. According to Lorcan O'Herlihy, who is Patricia Miller's brother (he and Warner have since established separate firms), "We looked at topography as generating the design, and suggested that the house be a series of volumes cascading down the hill, rather than one big box." These volumes, O'Herlihy continues, were to look as light and "dematerialized" as possible.

This was accomplished by cladding each of the volumes in a different material, with the most solid materials covering the volumes closest to the hillside. The part of the house nearest the ocean (which contains the living room on the entry level and the master bedroom one level above) is wrapped in several types of glass—clear (where there is a view), sandblasted, and translucent (to screen views of neighboring houses). The result is a house that doesn't dominate the site, but which nonetheless takes full advantage of its light and views. O'Herlihy and Warner used their characteristically cool, modernist design vocabulary in a way that demonstrates the eloquence of understatement.

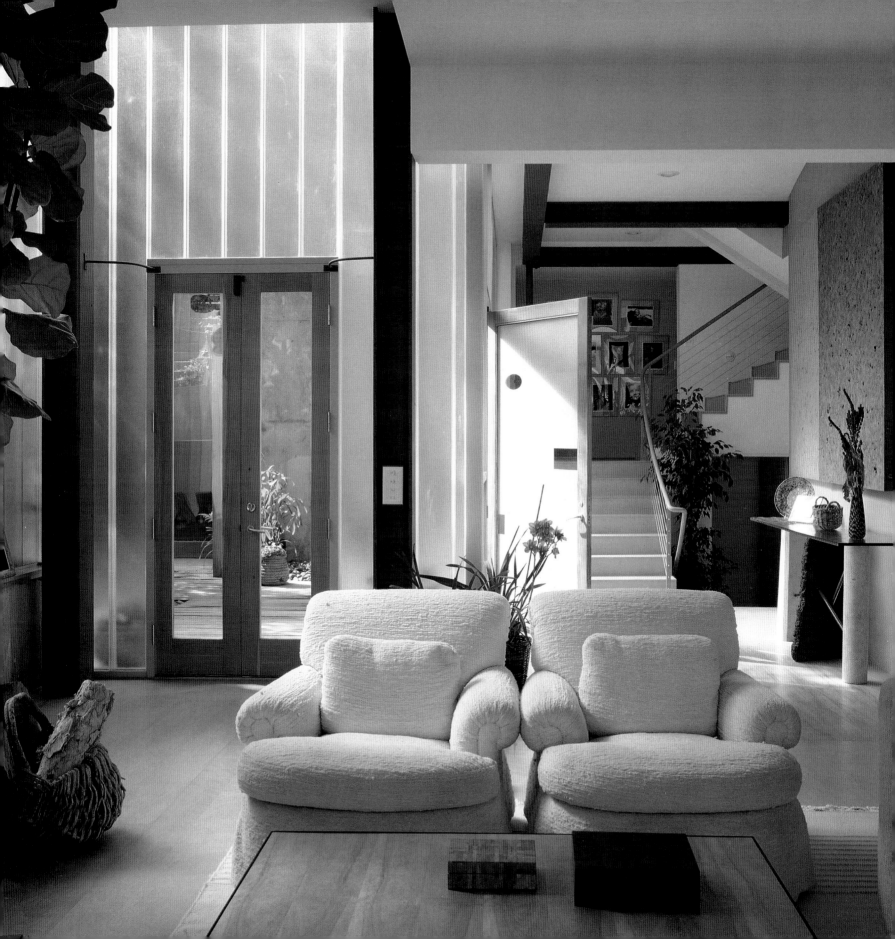

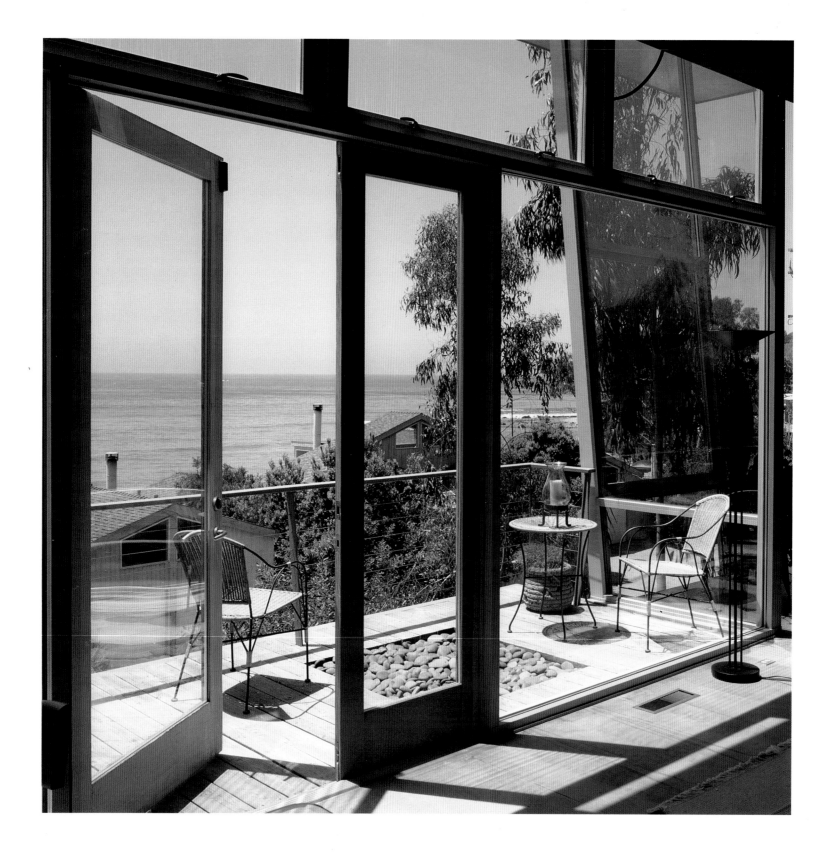

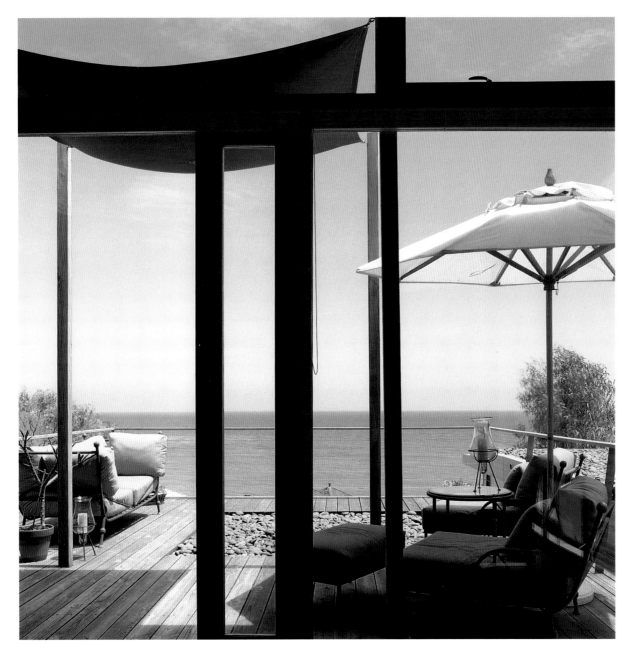

OPPOSITE: The balcony off the living room takes maximum advantage of its Pacific views.

LEFT: The master bedroom is one level above the living area, and is set back so that its terrace—actually the roof of the living room—makes the most of the view while screening views of houses down the hill.

Organic Architecture in Big Sur

ABOVE: Muennig broke the roof of the house (seen here from the back) into several sections to create a variety of indoor spaces.

OPPOSITE: Behind the house, overlooking the ocean, a quiet seating area was created with pieces of stone left over from the construction of the house.

Big Sur architect G.K. Muennig, better known as Mickey, has designed nearly two dozen houses in this place known for its rugged beauty, as well as the town's Post Ranch Inn, the quietly luxurious resort acclaimed for its environmental sensitivity. Muennig was a student of Bruce Goff, the onetime apprentice to Frank Lloyd Wright, who took the idea of organic architecture to a level that made Wright look like a raging formalist. "One thing that Goff taught us," recalls Muennig, "was that there are as many types of houses as there are people." Muennig's house designs—which are similarly tailored to their owners—are known for their careful siting, exuberant forms, and complex geometries. This small, dramatic house in Big Sur is a case in point. The owners love Japanese architecture and the image of "just a couple of simple roofs sticking up over the horizon," as Muennig puts it. They also like triangles. They presented their architect with the challenge of building on a small, steep site on a mountain overlooking the Pacific. "I mixed all those ingredients up, and came out with this," says the architect, gesturing toward the two-level main space of the house. Being in the house is, as Muennig describes it, "like living under a tree"—at once complex and serene, and wonderfully connected to the outdoors while still providing a sheltering solidity.

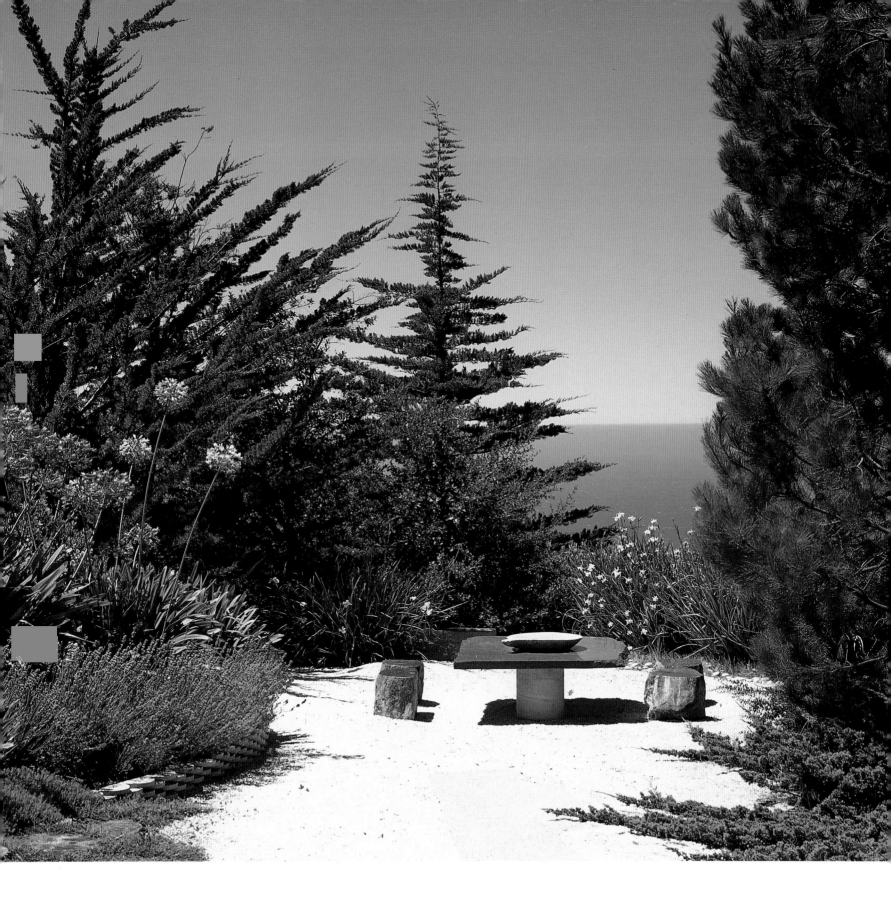

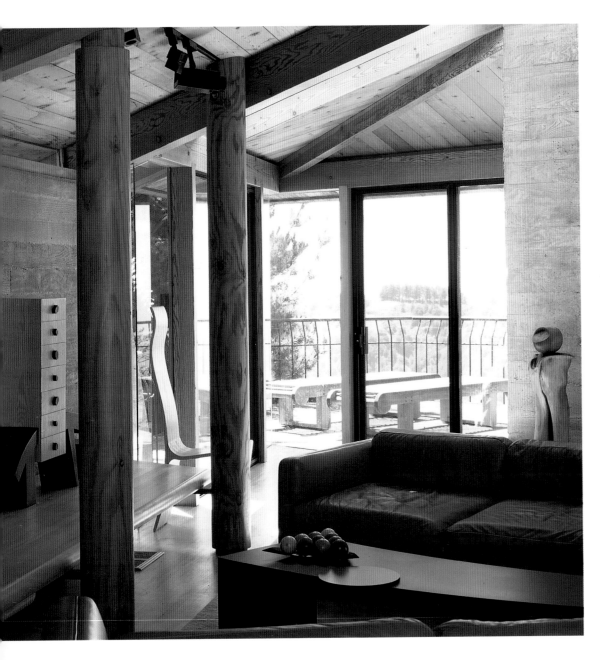

ABOVE: Columns and a beamed ceiling of fir contrast with the board-formed concrete walls in the living room.

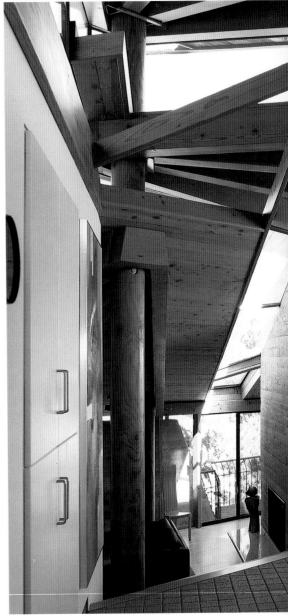

ABOVE: The complex geometry of the house is best seen in this view from the upper-level kitchen and dining room down to the living room. A single ten-inch-diameter fir column supports two roofs; when they come together, it is "like living under a tree," as Muennig describes it.

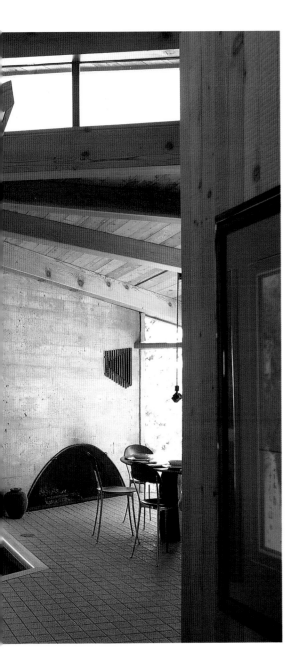

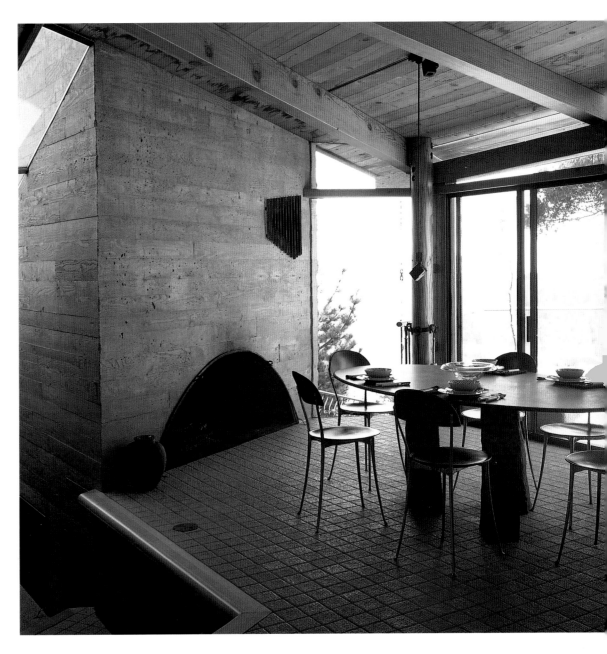

ABOVE: The dining room
and kitchen are paved with
granite floor tiles from
Japan. Most of the rooms
in the house open directly
to the outdoors.

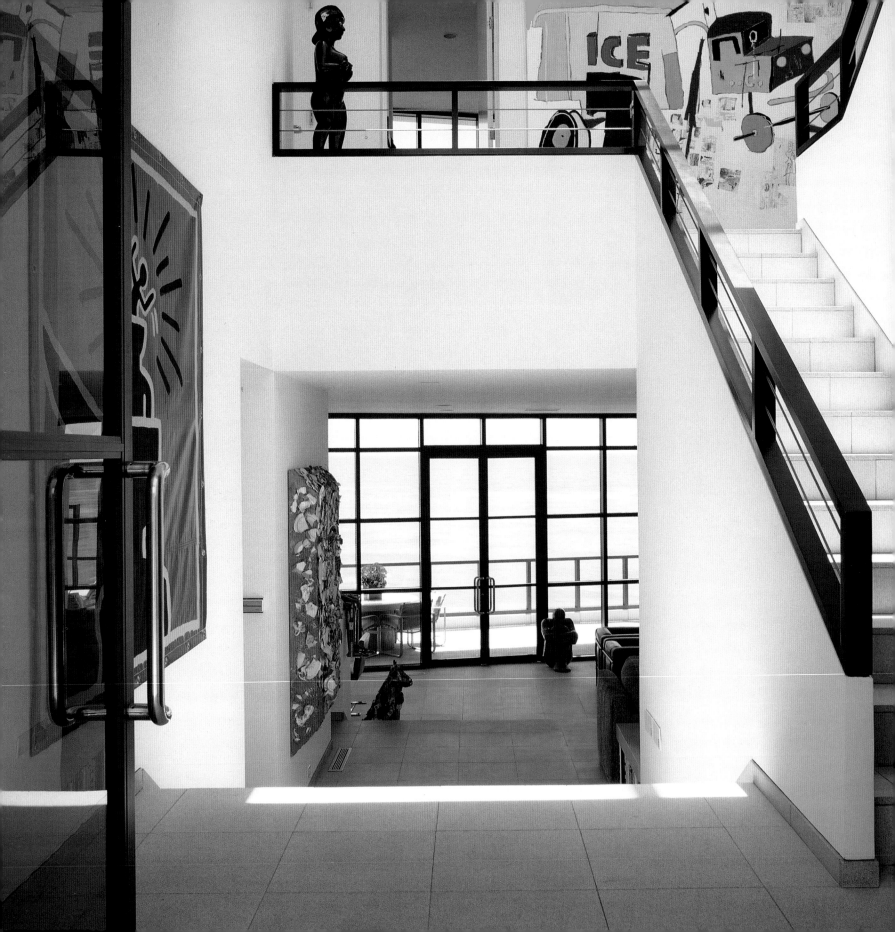

This taut, cool house, set on a Malibu beach, is about as far from a cozy beach cottage as you can get. Its owner prefers a more contemporary aesthetic, with smooth, monolithic materials and crisp, meticulous detailing. For Carmel-based architect Jerrold E. Lomax (who designed the house when he was a partner in the firm Lomax/Rock Associates), the challenge in this project was to create a house that balanced natural light while it took maximum advantage of the ocean views, and which would accommodate more than four thousand square feet in three levels on a relatively narrow lot. The owner of the house didn't like the look of vast areas of plate glass, so Lomax designed a three-foot-square grid for the steel-framed windows and doors. Inside the house, a ten-foot-tall entry leads to a double-height atrium, with a flight of stairs leading up to the bedrooms, and steps that lead down to the two-level living room, dining area, and kitchen. Walls throughout the house had to be tall enough to accommodate the owner's collection of contemporary art, and materials had to be easy to maintain. "My client likes meticulous surfaces," explains Lomax. Los Angeles decorator Linda Marder used neutral fabrics and simple, classic modern furniture for the interiors: "Basically, it was about being comfortable," she says. And that's exactly what it is.

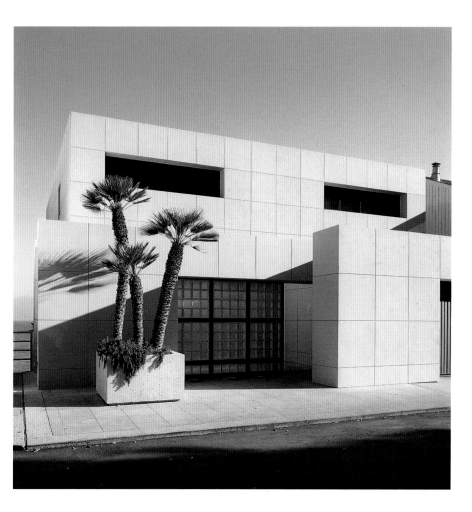

OPPOSITE: From the entry, you can see straight through the two-level living room to the ocean-view terrace.

ABOVE: The smooth-troweled cement plaster surface of the house's exterior is inscribed with the same grid as that of the windows and doors.

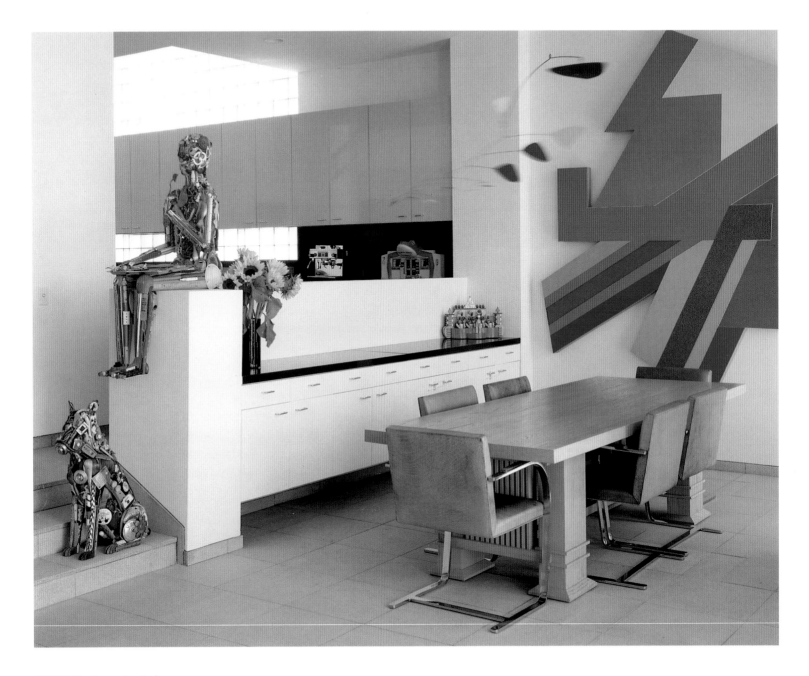

ABOVE: The lower level of the living room also contains the dining area, where Mies van der Rohe's classic Brno chairs are grouped around a table copied from a Frank Lloyd Wright design.

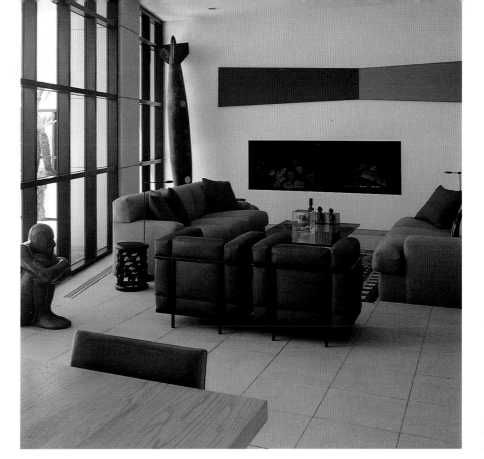

LEFT: The living room's cool palette of white walls and gray honed granite floors is reinforced by neutral-toned fabrics. The painting above the fireplace is *Series—Blue/Green Horizon* by Leon Polk Smith. The room's upper level contains more seating, and film projection equipment that is concealed in the walls.

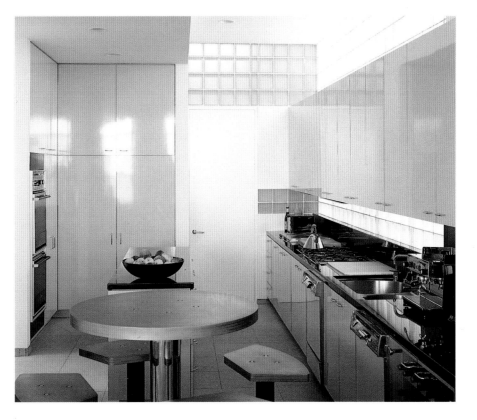

BELOW: With its black absolute granite counter-tops, gray plastic-laminate cabinets, and gray granite floors, the kitchen is as cleanly and crisply detailed as the rest of the house. The built-in breakfast table and stools are stainless steel with a sandblasted textured finish. Glass block windows above the sink allow light in while screening out views of the neighboring houses.

RIGHT: The master bedroom's white walls and light wood cabinets make it feel even sunnier than it is. The freestanding wall at left houses both a fireplace and a television. The painting that hangs above the bed is *Lady Killer* by Jerry Kearns.

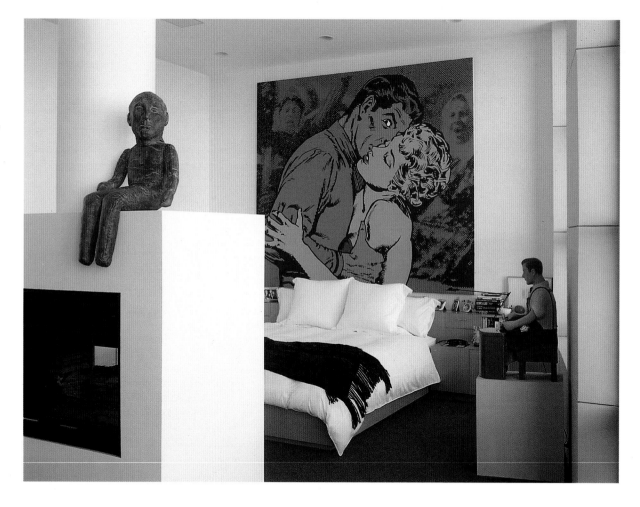

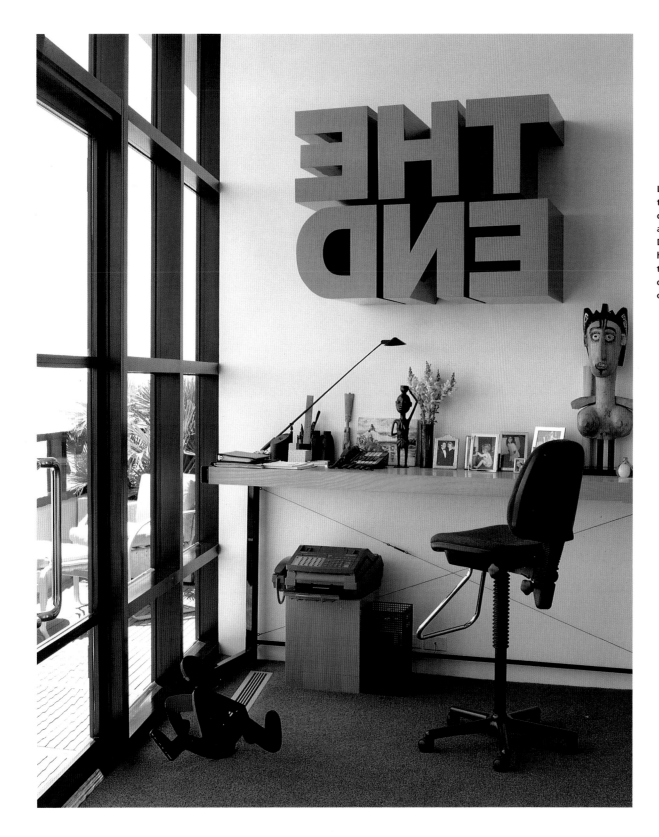

LEFT: The opposite end of the master bedroom contains a sitting area and a small work area. Nancy Dwyer's sculpture *The End* hangs above the desk. To the left, the gridded doors open onto a terrace that overlooks the ocean.

Rosequist House, Montara

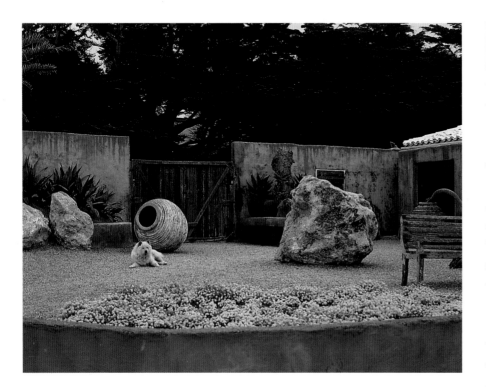

ABOVE: Simple, massive objects, such as a Portugese oil jar and a seven-ton boulder, make Ivy Rosequist's courtyard seem like a sculpture garden. Bear, the designer's chow chow, enjoys the view.

OPPOSITE: The compound's gray stucco walls are easy to maintain and nicely offset plants, such as the agave that grows near this doorway.

For designer Ivy Rosequist, design is about editing. "When I do a house," she explains, "the first thing I do—even if all the new furniture hasn't arrived—is to take things out and move things around. Every house has potential." Including her own house, which overlooks the Pacific Ocean in Montara, a half-hour south of San Francisco, and which Rosequist shares with William Giffen, an architecturally trained designer who is also her business associate. (In addition to her design firm, Rosequist also owns the furniture company Wicker Wicker Wicker.) The house was not always the serene compound of gray stucco walls and flowing, daylit spaces that it is today. When Rosequist found it, it was an unprepossessing amalgam of red tile roofs, tiny windows, surrounded by high brick walls, and seemed oblivious to its spectacular site. Rosequist stuccoed the house and perimeter walls, graded and terraced the property, made a new gravel courtyard, and brought in a hundred and forty tons of rock for the dramatic landscaping. And she opened the house to the light and views by adding big windows and removing the doors between rooms. Inside, the house—just like its owner—is always impeccably turned out in white. "It's a matter of distilling," explains Rosequist matter-of-factly. But when you look out of her calm, comfortable living room, down the rolling green lawn that is punctuated by large bolders, and out to sea, you know that it takes a keen eye— like Rosequist's—to turn subtraction into an art.

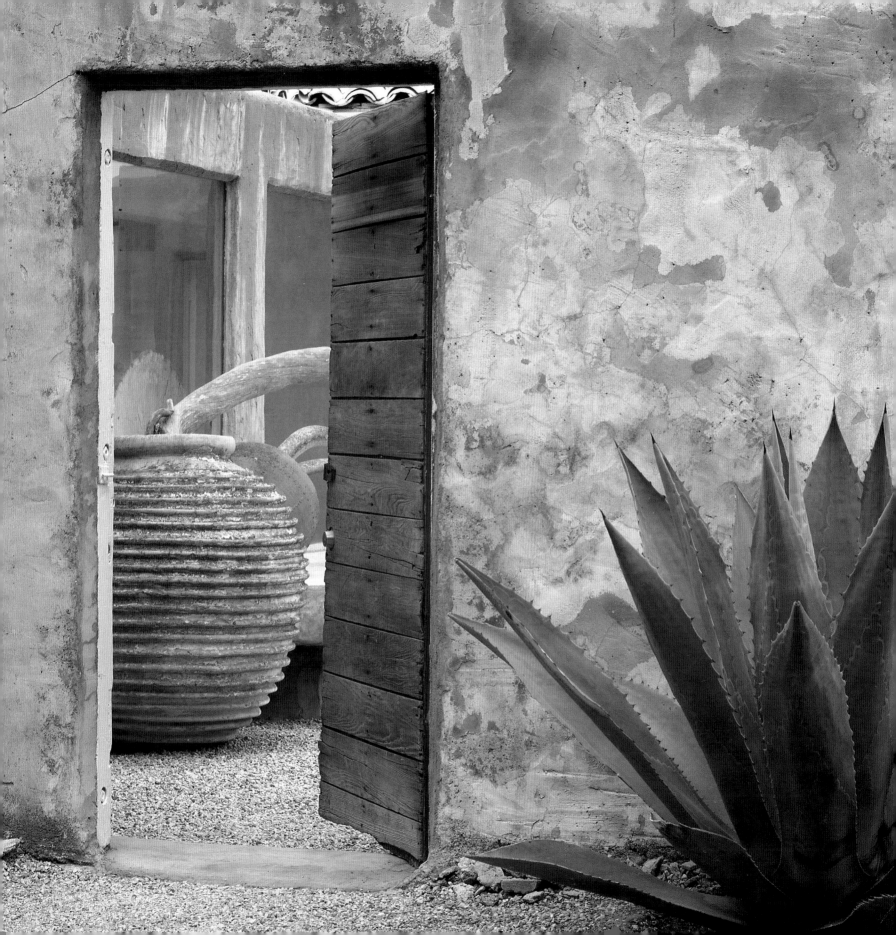

ABOVE: A window in the
living room frames a view
of the ocean beyond a
still life, on the greenhouse
roof, of Chinese bamboo
poles and a terra cotta
container from Mexico.

LEFT: A stack of firewood looks like a giant sculpture behind a sitting area that contains two chairs designed by Rosequist for Wicker Wicker Wicker. On the concrete platform are a pair of cast brass chargers, a large coral fossil from Mexico, fragments of Mallorcan grain rollers, and two rock crystals.

BELOW: Rosequist's eye for combining diverse objects is evident in this still life, in which an antique Mallorcan waterwheel frames two ceramic burial houses from the Ming and Sung dynasties, two crystal balls, and a small Buddha.

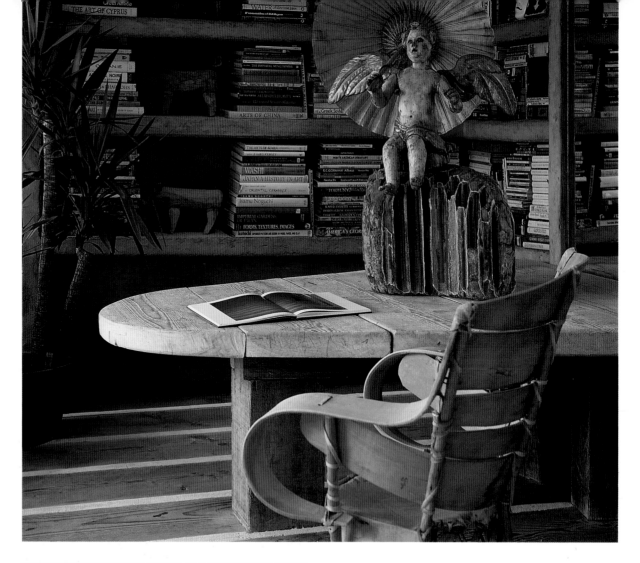

RIGHT: The library is presided over by a sixteenth-century Italian painted wood angel, which holds a parasol and sits on a chunk of broken dock support that washed up on the beach below the house.

BELOW: An arrangement of sand dollars adorns a narrow concrete table in the gravel courtyard.

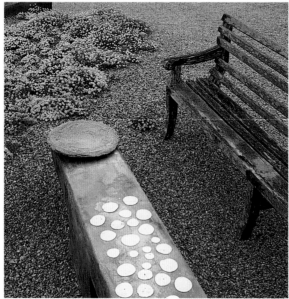

OPPOSITE: A Mexican table in the entry houses a wonderful array of found objects: a round piece of wood that mirrors the shape of the window next to it; two mudballs from San Gregorio Beach; and beach glass accumulated during eight years of Rosequist's walking her dog.

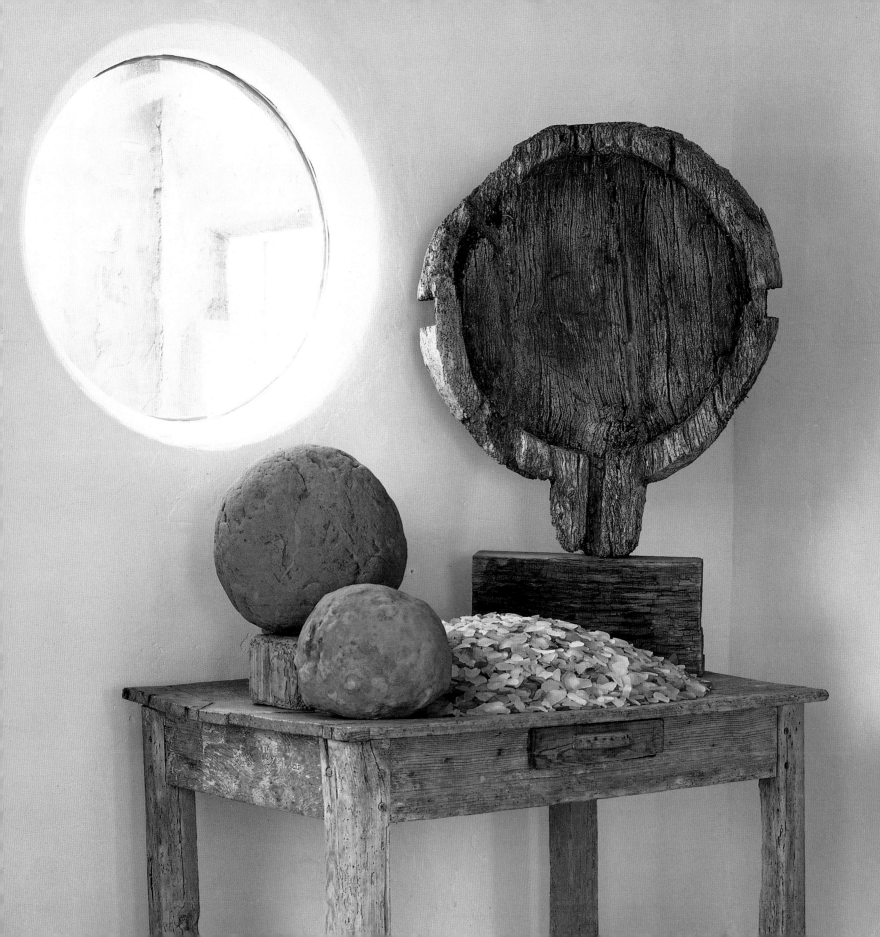

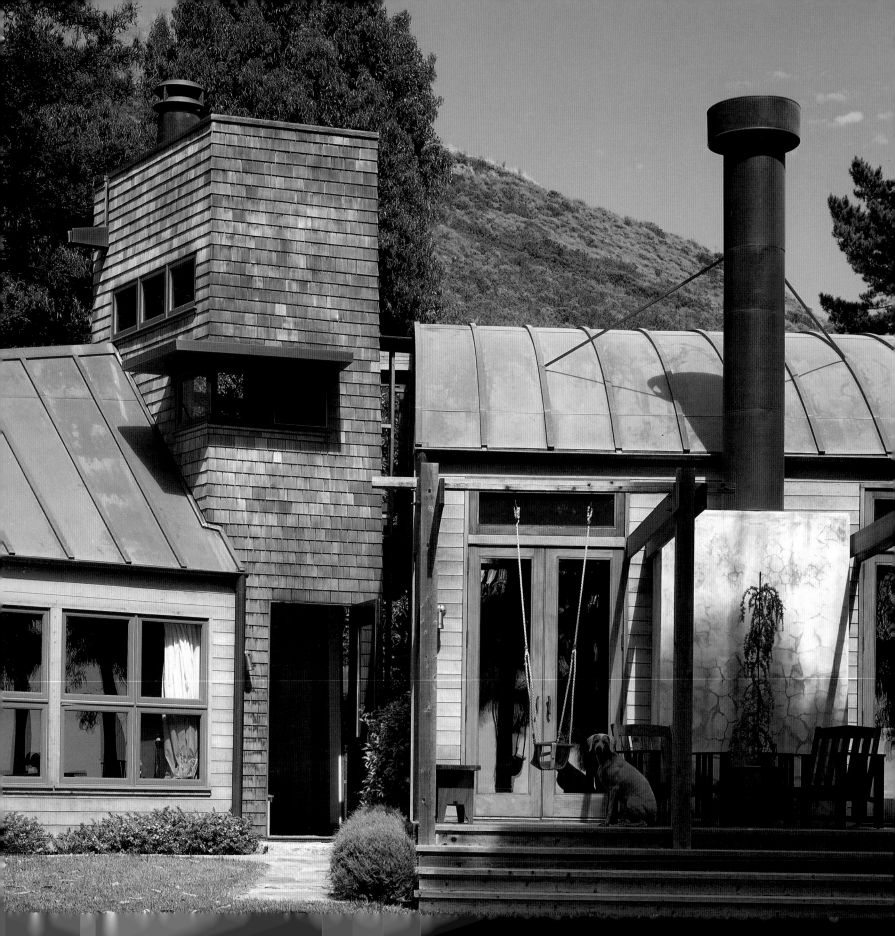

Carmel-based investor John Krasznekewicz and New York architect Peter Wormser have been friends for twenty years, and have, as a result, collaborated on a number of architectural projects. So when John and his wife, Sarah Miles Krasznekewicz, bought land in Big Sur—on the edge of a canyon and with breathtaking views of the ocean—Wormser was asked to remodel a house that existed on the site into a weekend house for the couple and their children.

The house, christened K Ranch after its owners, was conceived as a cluster of cedar-clad, copper-roofed volumes—one for the living room and children's rooms, one for the kitchen, and one for the master bedroom—based on traditional building forms, but with a modern twist. Indeed, Wormser and his client (who is extremely well versed in contemporary architecture) call its style "twisted vernacular." Each volume has a different roof shape, both to distinguish it on the exterior and to create a different feeling on the interior. The rooms themselves were decorated with the help of both Menlo Park designer Jo Ann James (the master bedroom and an adjacent guest house) and magazine editor and stylist Jody Thompson-Kennedy (the living room). But every part of the house is open, physically as well as visually, to the outside. As John Krasznekewicz recalls, "We wanted the house to be part of the land, not vice versa."

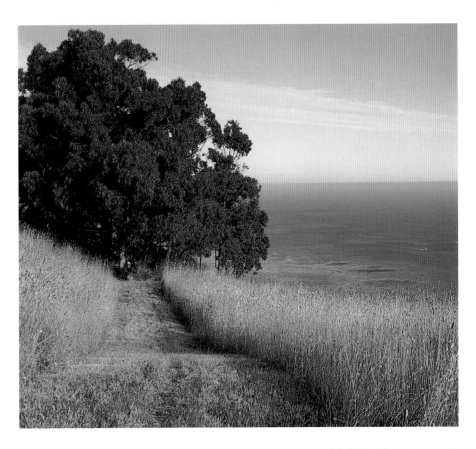

OPPOSITE: The various parts of the house are broken into distinct volumes. A two-story tower, containing the entrance and a "crow's nest" office upstairs, also joins the master bedroom wing at left and the living room to the right.

ABOVE: The meadow at the front of the house rolls down to the edge of a cliff, providing a panoramic view of the Pacific Ocean.

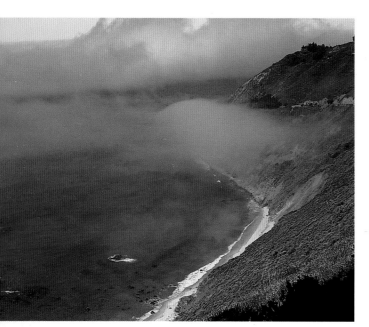

ABOVE: A narrow path (not visible here) winds down to a secluded beach.

RIGHT: Doors in the living and dining room open onto a deck, which doubles as an outdoor dining area. In the distance, two eucalyptus trees provide the perfect spot for a hammock.

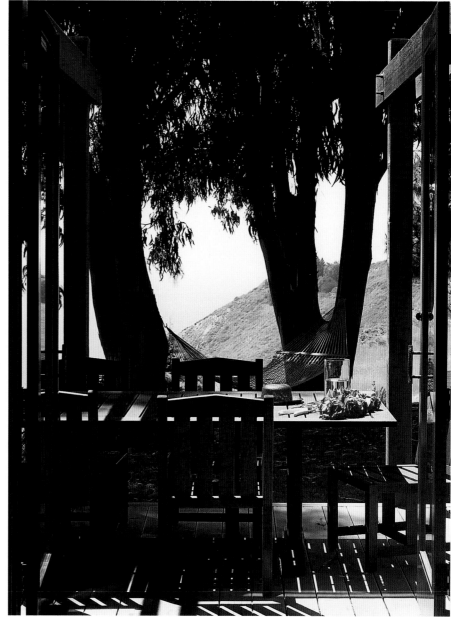

OPPOSITE: In the half-barrel-vaulted living area, the hanging steel light fixtures were made by New York sculptor Bill Hall, and the dining table is a single slab of redwood.

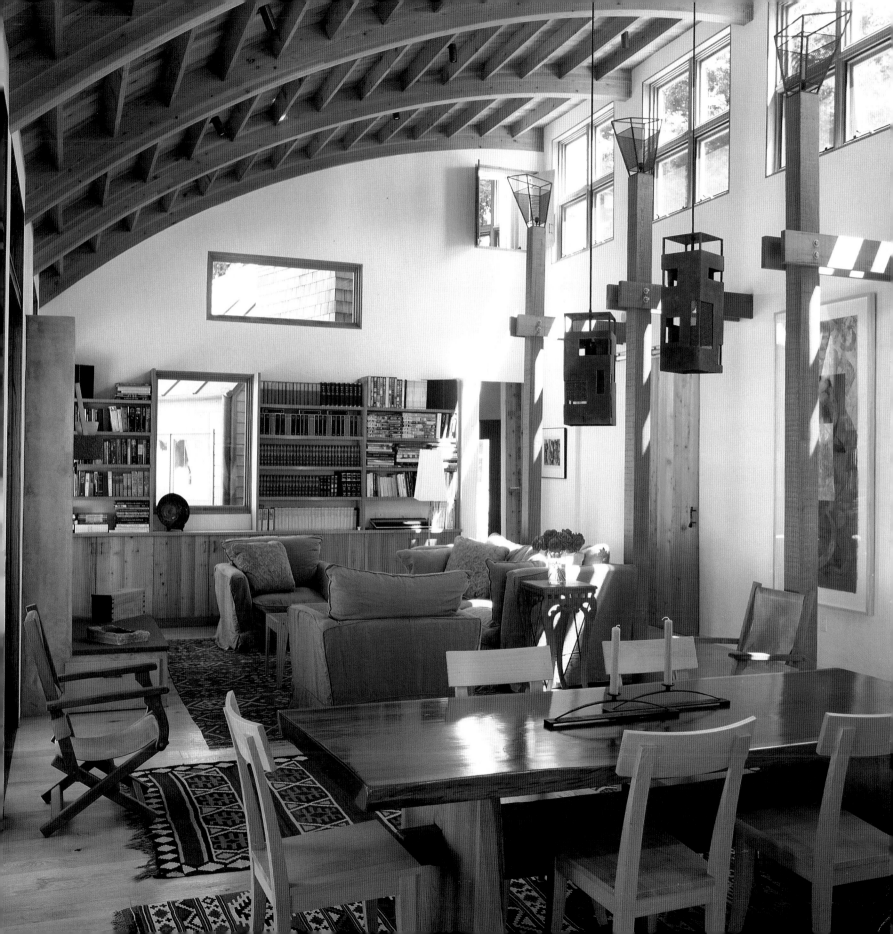

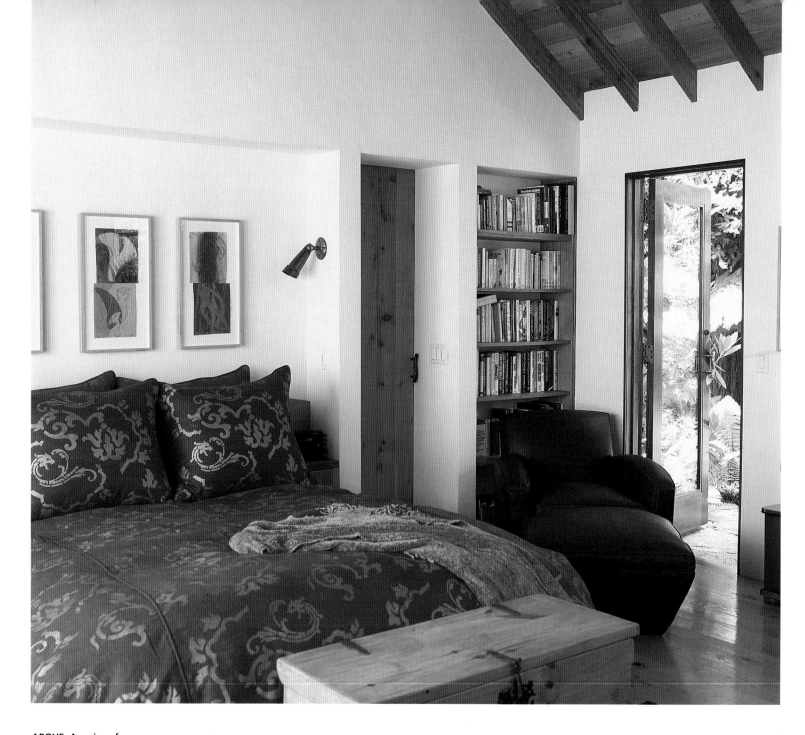

ABOVE: A series of
monotype collages by Steven
Sorman, one of Sarah
Krasznekewicz's favorite
artists, hangs in the master
bedroom. The hand-painted
linen by Nomi is available
through Randolph & Hein,
as is the leather-covered
Quatrain armchair.

LEFT: The desk in the master bedroom was designed by Peter Wormser and John Krasznekewicz and made by Martin Dehmler in Carmel.

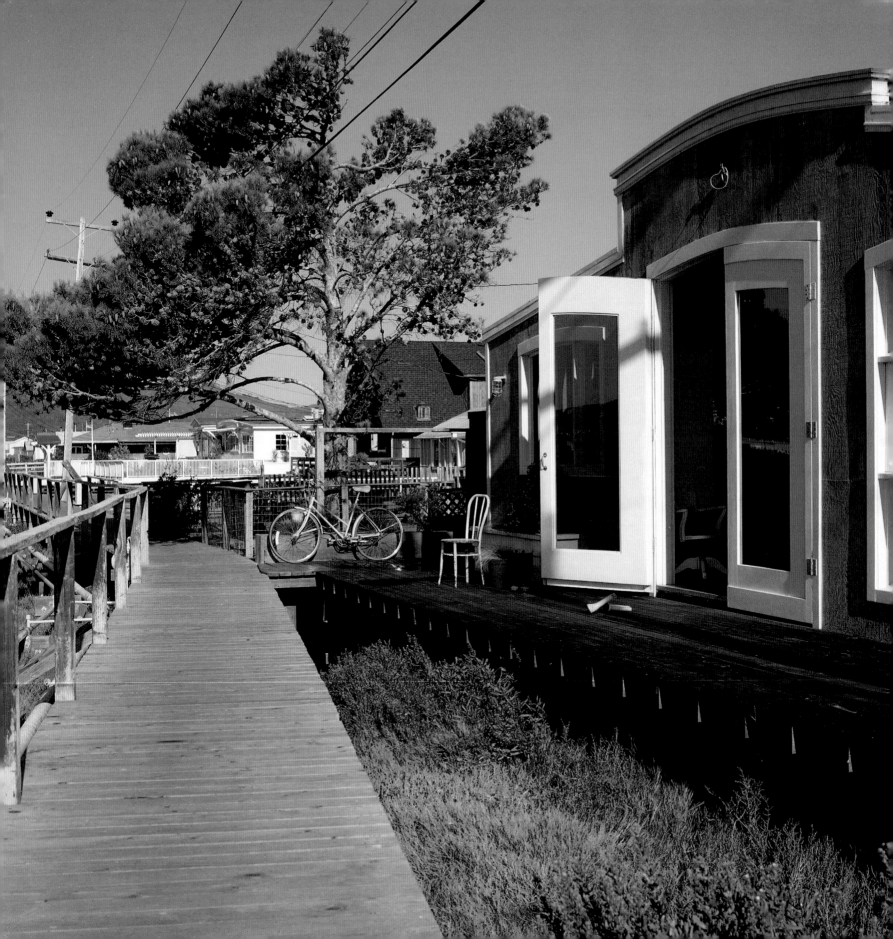

ShipShape

One of the most appealing aspects of living by the sea is its sense of simplicity. Not only do we feel as if we are casting off the cares of the workaday world when we go to the beach—the sunshine, brisk salt air, and ocean breezes seem to make them evaporate somehow—but we also tend to leave behind many of the material goods that encumber us on a daily basis. For a seaside week of walking, reading, evening conversations around the fire, and good nights' sleep, you don't need much: a floppy hat, a bathing suit, sandals, a favorite old sweater, a stack of books. It's a profoundly liberating sensation to travel that light.

Some of the most appealing houses along the California coast seem to embody just that philosophy. No matter what style, these houses share an almost nautical economy of means: There's not the slightest bit of excess. That doesn't mean, however, that these houses aren't luxurious; on the contrary, their simplicity seems to underscore the sensual pleasures afforded by their proximity to the ocean. Whether their nautical references are direct, as in the case of a porthole window or a ship's mast column, or abstract, as illustrated by lots of built-in storage and dual-purpose furniture, that same less-is-more sense prevails.

OPPOSITE: A beached houseboat was transformed into a spacious house for a family of four on this Marin County salt marsh.

FOLLOWING PAGES: A distinctive feature of the California coast are the houseboat communities for which the Marin County town of Sausalito is famous.

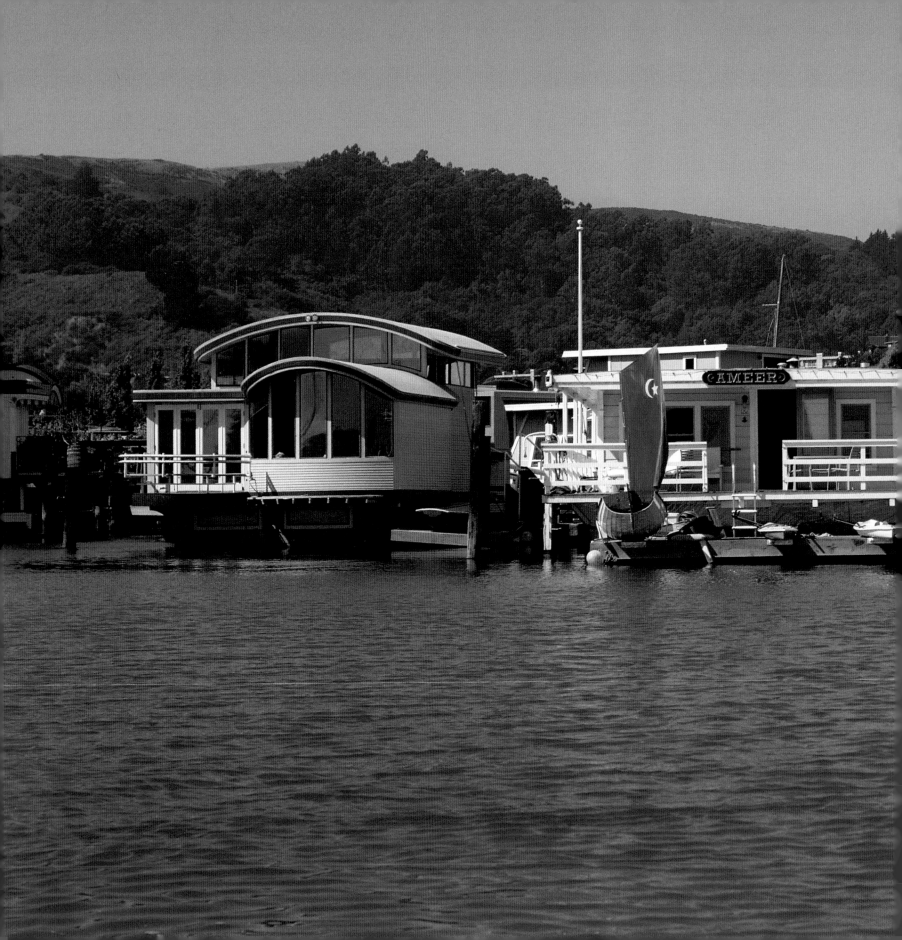

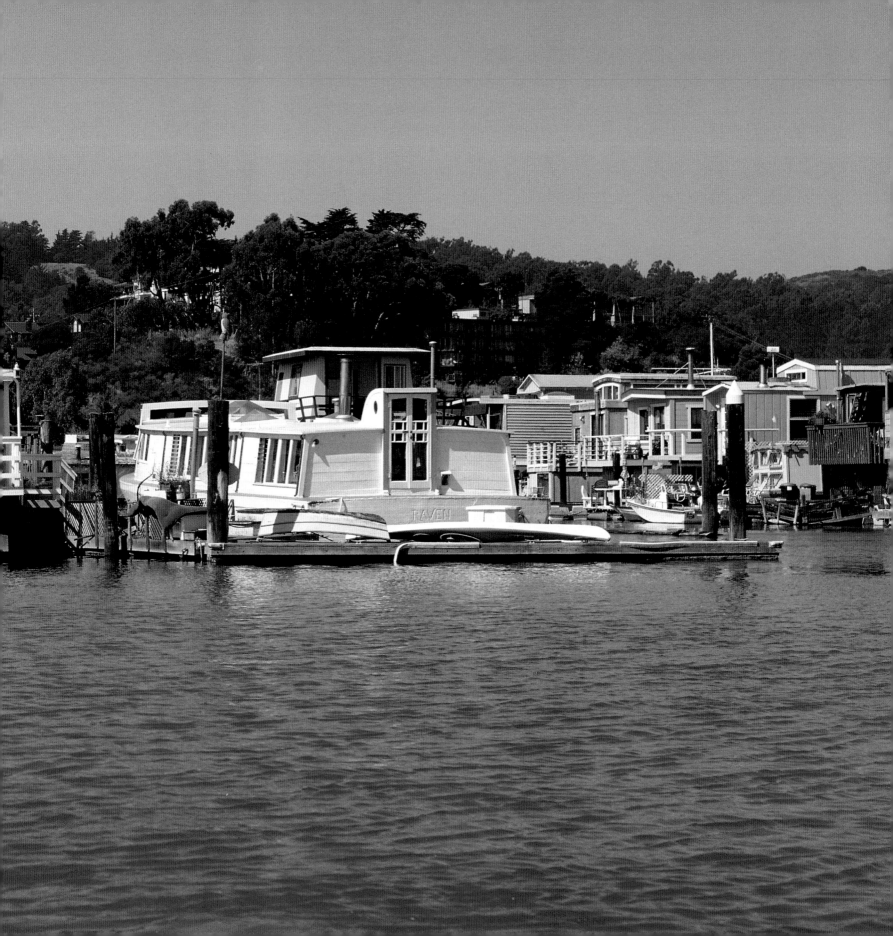

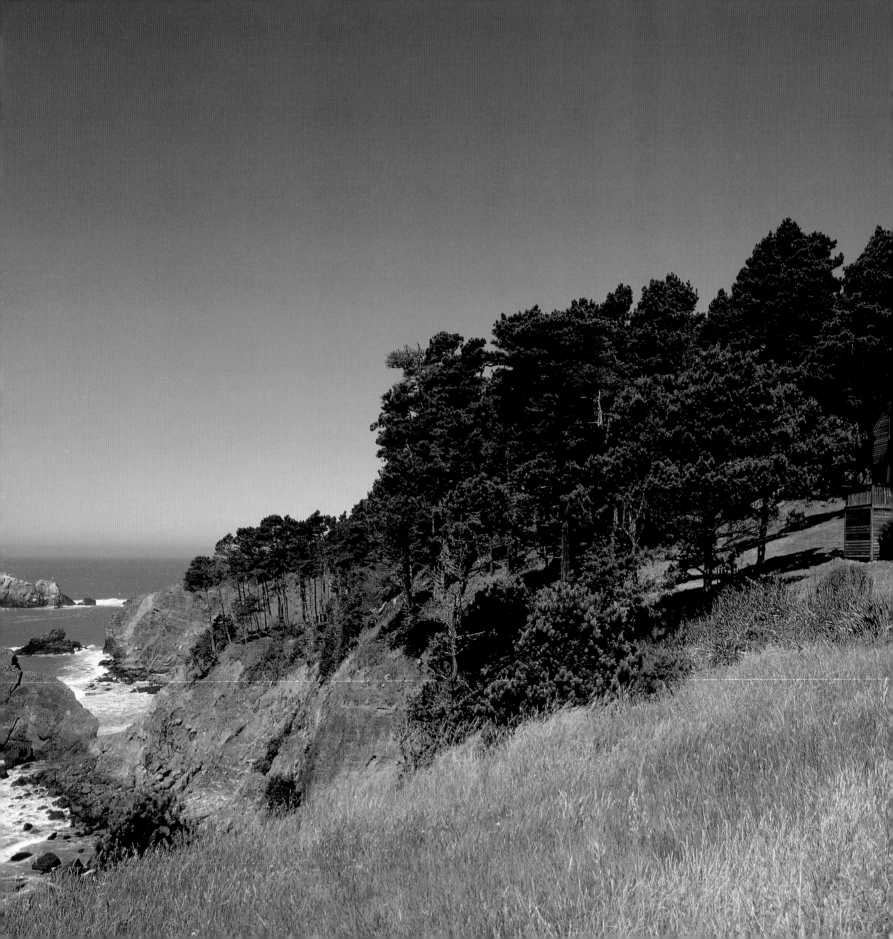

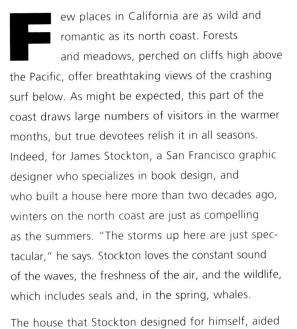

F ew places in California are as wild and romantic as its north coast. Forests and meadows, perched on cliffs high above the Pacific, offer breathtaking views of the crashing surf below. As might be expected, this part of the coast draws large numbers of visitors in the warmer months, but true devotees relish it in all seasons. Indeed, for James Stockton, a San Francisco graphic designer who specializes in book design, and who built a house here more than two decades ago, winters on the north coast are just as compelling as the summers. "The storms up here are just spectacular," he says. Stockton loves the constant sound of the waves, the freshness of the air, and the wildlife, which includes seals and, in the spring, whales.

The house that Stockton designed for himself, aided by an architect friend who did the working drawings, is an appropriately low-key foil for the natural wonders that surround it. "The house is a simple, austere, bare-bones kind of place," he explains. "I didn't want to make an architectural statement." The house may well be simple and austere, but it's hardly bare-bones. Its elegant proportions and abundant light give this small house, as well as the building Stockton recently added to contain a garage and library, a sense of luxury that has nothing to do with square footage or costly materials. And Stockton has filled these spaces with a carefully edited collection of objects, both plain and fancy, that only add to the house's charm.

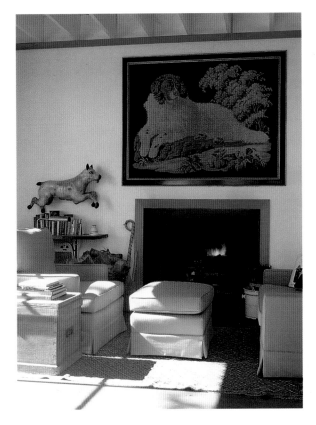

OPPOSITE: The Stockton house overlooks woods and meadows high above the ocean. In addition to the crashing surf, the sound of seals can be heard from the rocks at the far left.

ABOVE: In the living area, a canine theme prevails: A framed nineteenth-century Swedish needlepoint hangs above the fireplace. To its left, a dog from a carousel, probably French, hangs above the bookshelves.

RIGHT: One end of the large, open living area is given over to the kitchen. A big wooden table sits on the bare polished wood floor, and a pair of old steel rolling carts with enameled metal shelves serve as open storage for plates, serving bowls, and pots and pans. They also help to screen the cooking area from the table. The windows, seen at right, and doors open onto the ocean views, and can be covered by rolling barn-style doors on tracks.

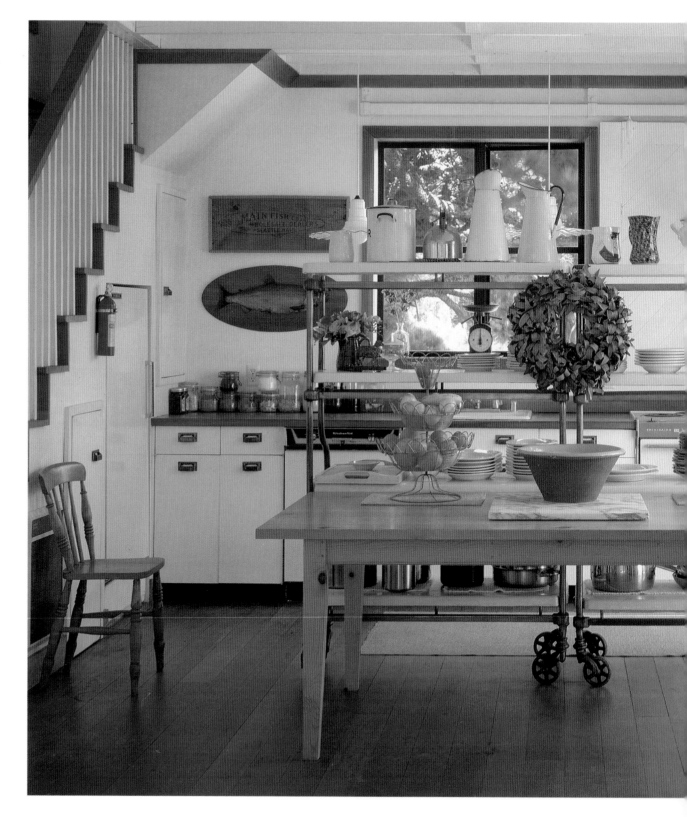

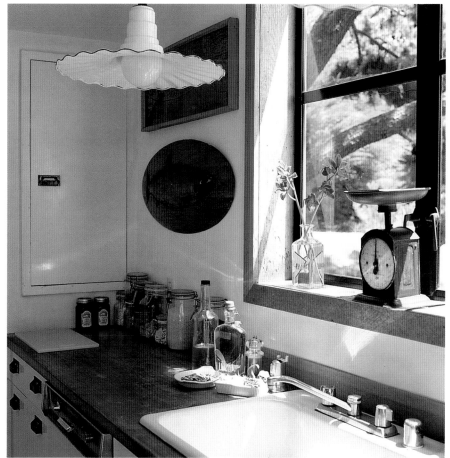

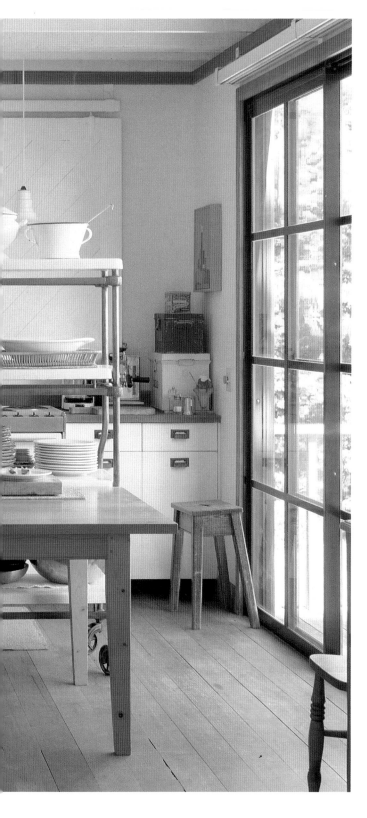

ABOVE: In the interest of economy, Stockton used simple, utilitarian, and inexpensive industrial hanging lights in his kitchen well before they became fashionable. Objects such as the stuffed and mounted fish reinforce the house's seaside motif, while the old scale, stoppered bottles, and mason jars add warmth to the kitchen.

RIGHT: The bathroom's walls, ceiling, and floor are painted a crisp white, reflecting the sunlight that pours into the room in the morning. The pitched roof, with its dormer window, adds to the room's charm, and the illuminated "S" sign to the left of the sink is one of numerous items in the house that are adorned with Stockton's initial; many of them were given to him by friends as gifts.

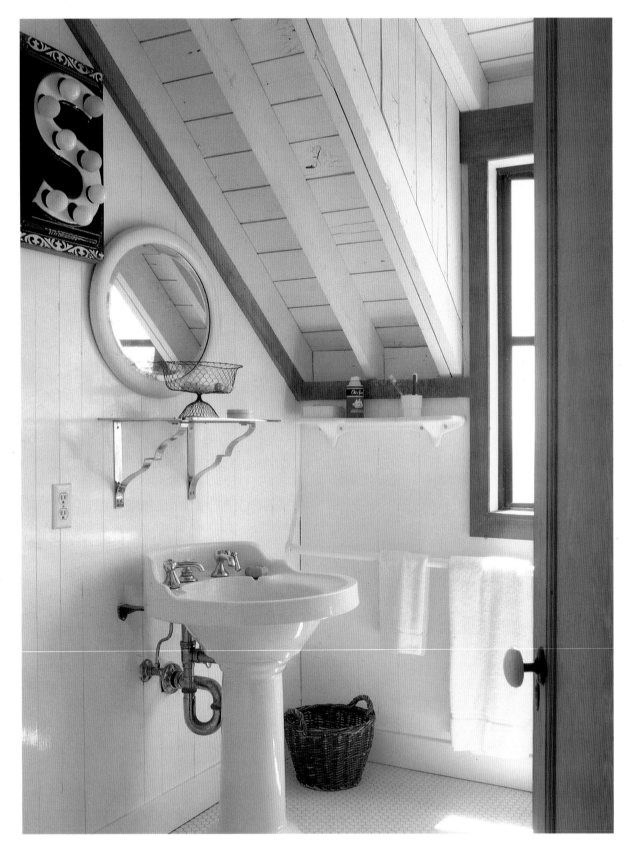

The front door opens into a single first-floor space that houses the living and dining areas as well as the kitchen. Barn-style interior doors, devised by Stockton, can be rolled across the doors and windows that face the ocean, both to protect the house and to function as "curtains" at night. Upstairs, the bedroom and white-painted bath are tucked under the house's peaked roof. The color palette is light, warm, and monochromatic, with no-fuss finishes and economical but stylish fixtures, such as the industrial lights that hang over the kitchen counter. In contrast to the house's rustic simplicity, the library in the new building next door possesses the sophisticated chic of a San Francisco drawing room. This tall volume is painted a glossy ship's gray—a surprising choice, but one that helps give the room its urbane quality. Lined with bookcases and filled with ship models—a particular passion of Stockton's—the room feels cool by day, and, with a fire blazing in the fireplace, warm and inviting by night. "I've been driven by wanting to surround myself with a place that is comfortable and beautiful," says Stockton. With his keen designer's eye and a disciplined economy of means, Stockton has attained his goal, and then some.

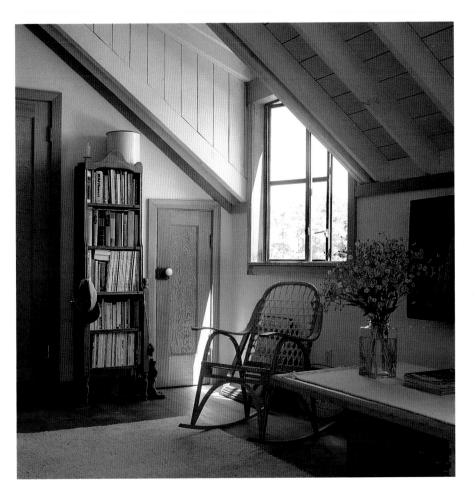

ABOVE: In the bedroom, a sunny corner houses a bookcase and a snowshoe rocking chair. The ceiling's exposed rafters give this room the cozy feeling of a converted barn.

LEFT: In a bathroom window, a tiny toy boat, a playful relative of the ship models that Stockton collects, hauls a barge laden with an apt cargo of miniature bars of soap.

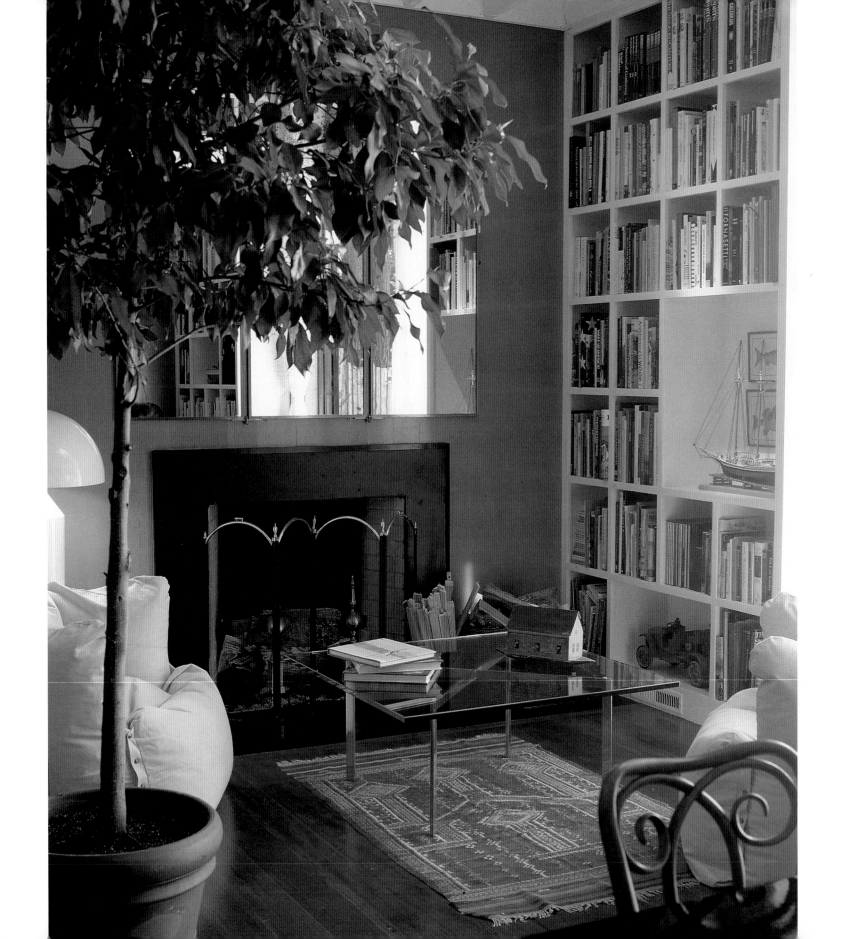

OPPOSITE: Stockton recently added a second building that contains a library. In contrast to the almost rural feeling of the main house, this room is an urbane, sophisticated volume, with gray walls and floor-to-ceiling book-cases. Grouped around the Mies van der Rohe coffee table in front of the fire-place are two Air Chairs, designed by Stockton's friend, graphic designer Lawrence Green.

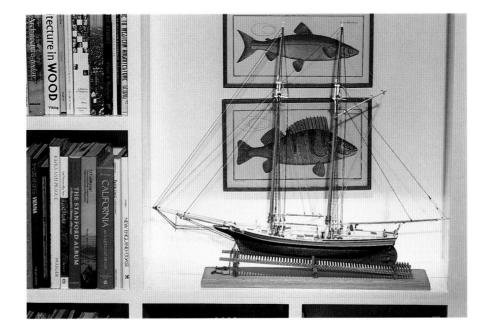

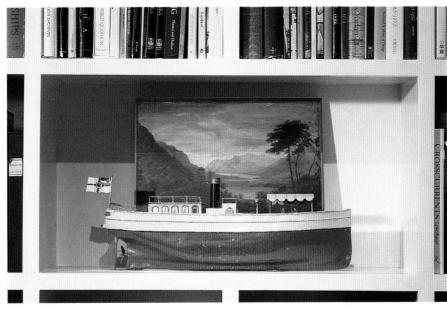

ABOVE: Stockton, a lifelong sailor, loves to collect ship models, such as this one of a schooner, that stands in front of a pair of framed fish prints.

LEFT: "There's no real method to my collecting," says Stockton; his holdings range from a large naval architect's model of a steamship to this whimsical painted tin toy boat.

Murphy Trailer, Pacific Palisades

ABOVE: The dining table is two-by-fours, sealed with yellow liquid plastic, and a sheet of wire glass.

OPPOSITE: A bright red wall of bougainvillea separates Murphy from his neighbors, and he added pots of cactus and grasses for an even greater sense of privacy.

Brian Murphy has an eye for the unexpected. He has designed light fixtures out of orange plastic drafting triangles, and made a bathtub of glass. His taste for the offbeat governs his choice of residence, too. The Santa Monica–based Murphy, whose company, BAM Construction and Design, has designed houses for Hollywood luminaries such as Dennis Hopper and Belinda Carlisle, has lived everywhere from funky Venice lofts to whimsical beach shacks. So it isn't surprising to find Murphy installed in one of the trailer parks that dot the Pacific Coast Highway between Santa Monica and Malibu. As one might imagine, these are no ordinary trailer parks; their once-mobile homes are carefully land-scaped, and often command the kind of ocean views that usually come with a much higher price tag.

That proximity to the Pacific is what lured Murphy— an avid surfer and swimmer—to this Streamline Moderne–influenced "room with a view," as he calls it, although the trailer actually consists of two rooms. Murphy's strategy in organizing these tight spaces was to "think in a small scale, and not try to break up the space." He kept to a mostly white palette, playing up the trailer's metallic finishes. Murphy stored large items, like his surfboards and bicycle, by turning them into decorative sculpture, and once again turned the prosaic into the poetic, as when he joined a bunch of hardware-store metal clamp lights to make an amusing chandelier. "I tried to make it come alive," explains Murphy, adding that, even for a designer, "Living in one of these things is a real education."

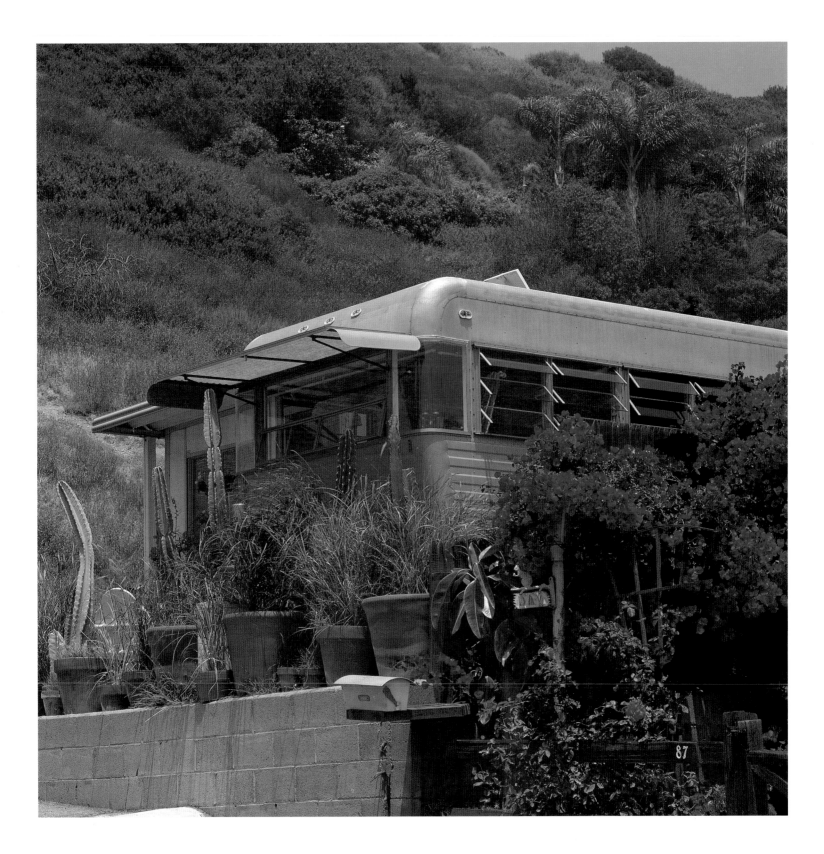

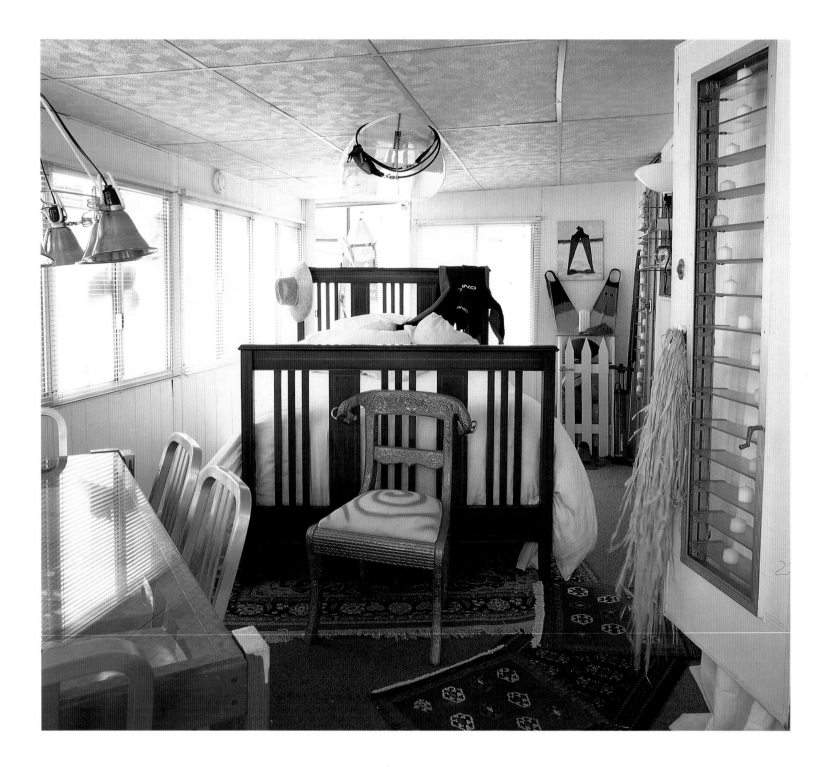

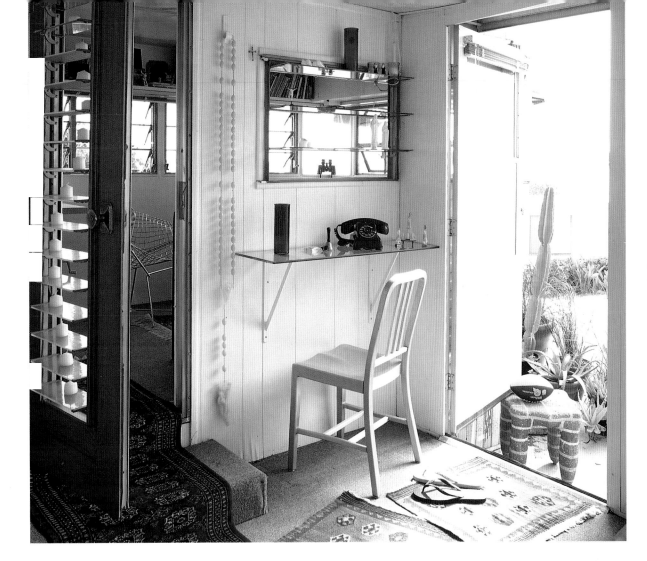

LEFT: One of Harry Bertoia's classic wire chairs is visible through the door from the addition to the original trailer. A variety of small, colorful rugs accents an otherwise white color scheme, which Murphy felt would make the tiny spaces seem more expansive.

BELOW: When stowed against the wall, a bicycle becomes sculpture. The chandelier above the table was made by Murphy out of an armload of plain metal clamp lights, which he strung together, tying their cords into one big knot before hanging it up.

OPPOSITE: The room that was added to the original trailer (to the right of the jalousie doors) now contains a bed and dining table. Murphy's surfboard hangs from the ceiling, and a storage cupboard made from picket fencing now houses sports equipment.

Sultan House, Marin County

ABOVE: The bedrooms at the back of the house open onto a deck with views of the bay and mountains.

OPPOSITE: Tomb and Randolph designed the cork-topped table in the dining area; aluminum masts separate it from the kitchen and living room.

Visiting Larry and Kelly Sultan's house is a slightly disconcerting experience. By the time you've walked the long, narrow wooden pier, past a handful of dwellings—many of which are landbound houseboats—that look out over a peaceful tidal marsh, you begin to wonder what decade you're in, much less whether you are indeed just a few minutes' drive from the Golden Gate Bridge. That is precisely why the Sultans chose to live here with their two sons, in an old houseboat that had been enlarged through a series of—to say the least— ad hoc additions. The Sultans needed to make it livable, but they didn't want to destroy the house's sense of history, the disparate nature of its old and new sections, or its relationship to the marsh. Which is why Larry, a photographer whose work has been the subject of books and museum exhibitions, and Kelly, an interior designer who admits she's "not comfortable with the idea of everything matching," chose to work with Bruce Tomb and John Randolph, partners in the Interim Office of Architecture in San Francisco. The Sultans admired Tomb and Randolph's sculptural approach to design, and their imaginative, thoughtful explorations of materials.

RIGHT: At the opposite end of the master bedroom, the antique Scandinavian bed has a view out to the bay and mountains.

BELOW: The bathroom demonstrates Tomb and Randolph's knack for using materials in new ways. The basin is set in a gimbal, similar to the one used to keep a ship's compass horizontal, and the drain-pipe is flexible hose.

OPPOSITE: The original wood paneling of the old houseboat gives what is now the master bedroom and its work area a genuinely nautical feeling.

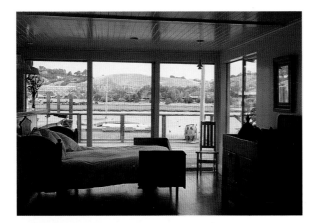

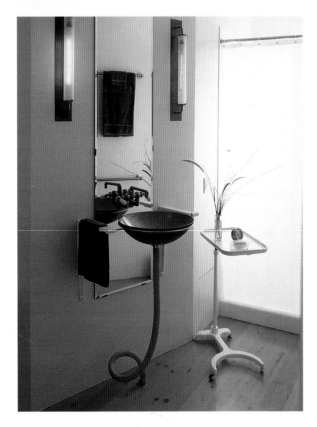

Tomb and Randolph's approach was one of "restructuring from the inside," as they put it. The bedrooms are now in the back part of the house (the original houseboat). At the front of the house, a new kitchen and living room flank a tall, skylit central dining area that is defined by two rows of aluminum ship masts, used here as columns. With its gently curved ceiling, this space evokes, as Larry notes, "an upside-down boat, or the feeling of a ship's deck." Tomb explains, "We tried to resurrect some of the original volumes, to make that central space sing," And, as Randolph recalls, "We soon learned, in the course of meetings over wonderful meals, that the heart of the house was going to be the dining room, not the living room. Kelly loves to cook." Moreover, much time and effort was spent refining the relationship between the dining room and kitchen. As Larry says, "Our first question was, 'What do you want to see when you do the dishes?' It seems all we do is wash dishes, and we wanted whoever is the dishwasher to be able to talk to the guests." Despite the fact that they are tougher customers than most, the Sultans are nonetheless satisfied ones. "As an artist, it's not easy for me to accept other people's ideas," says Larry of the design process. "But in the end, every decision Bruce and John had was good." Kelly reports, "You can still be surprised and enchanted by the volumes they've created. There's something very flexible about this interior."

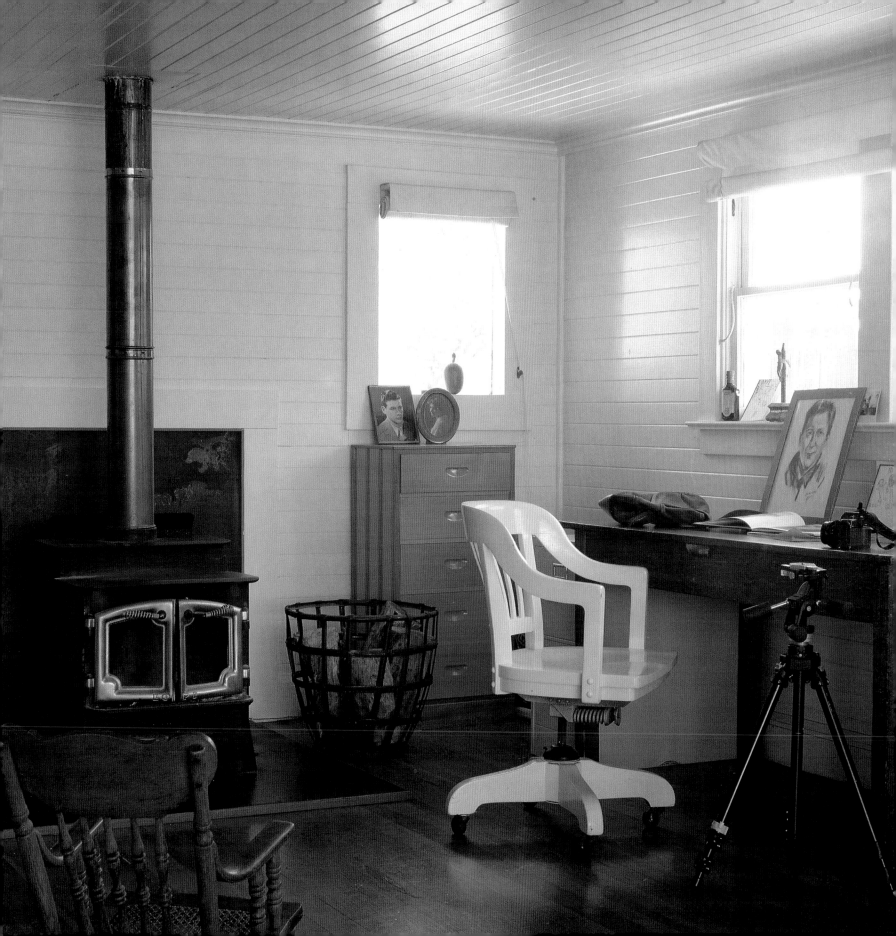

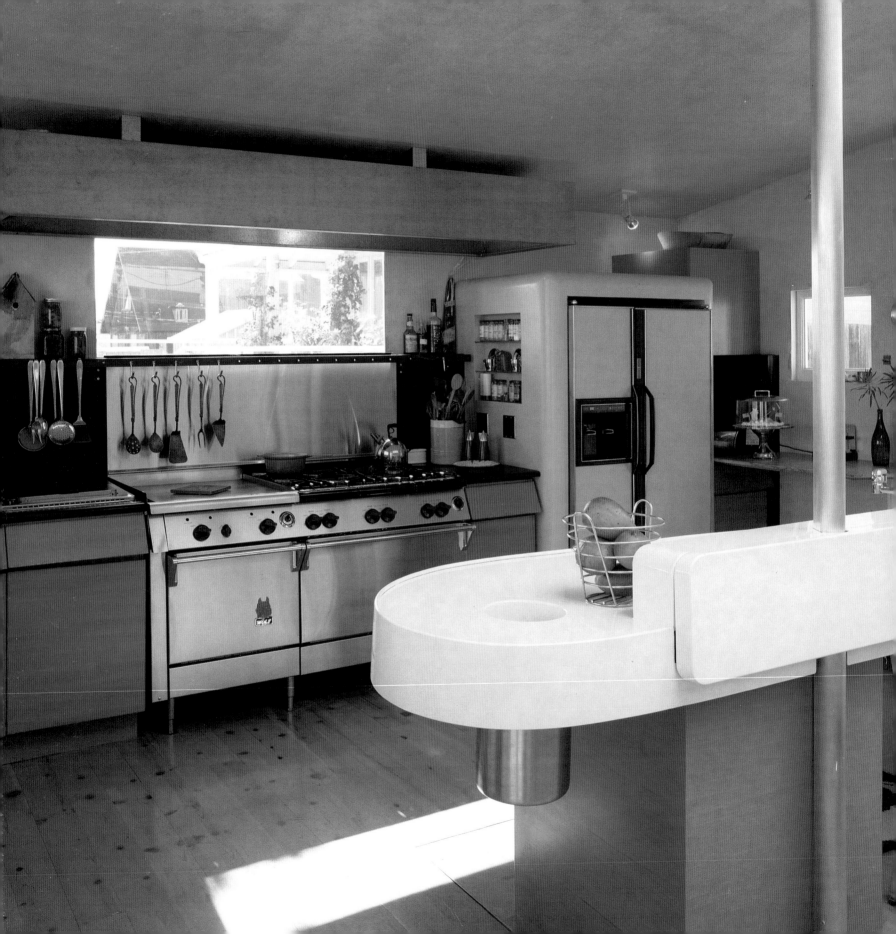

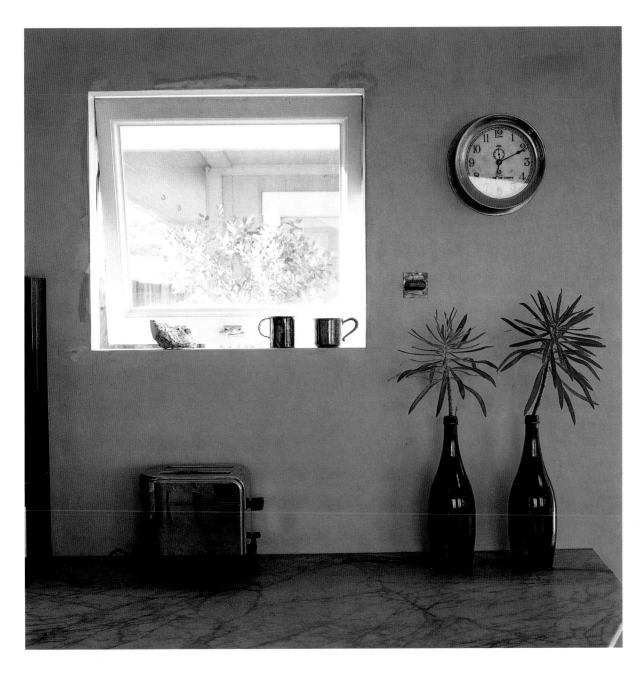

OPPOSITE: The kitchen was designed so that the Sultans could talk to their guests while doing dishes, and so that Kelly could cook undisturbed. The rounded end of the steel sink is another nautical reference—but it also eases circulation through the space. The knife-edged window, which frames a view of Mt. Tamalpais, was inspired by the work of artist James Turrell.

LEFT: Drywall mudding compound, impregnated with an iron-oxide pigment that oxidized to a reddish tint, was applied to the walls. In the kitchen, Kelly Sultan wanted materials, like the marble used for this counter, that would only look better with use.

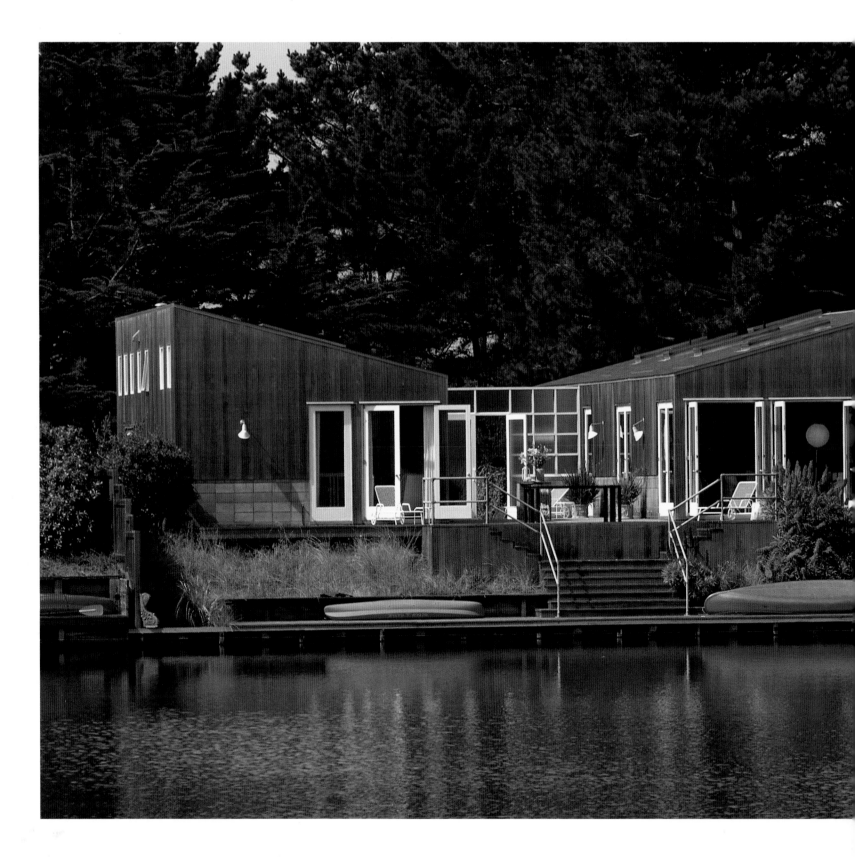

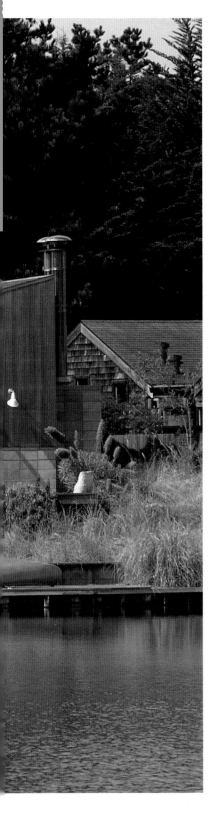

For some people, living near the water is a take-it-or-leave-it proposition. For others, it's almost an addiction. That's what San Francisco graphic designer Lawrence Green and his wife, interior designer G.G. Green, discovered when they moved to Mill Valley after having lived at Stinson Beach for ten years. They loved Mill Valley's verdant lushness, but they just plain missed the beach. So the Greens bought a lot in the Stinson Beach community of Seadrift, and hired San Francisco architect Geoffrey E. Butler—who frequently collaborates with G.G.—to design a weekend house for them.

"I always thought it would be nice to have a house that was two separate buildings," explains Larry Green. "It seemed like a natural idea for outdoor living, especially in a second home." He envisioned a house that was oriented inward, but which had views to the lagoon and hills beyond. Butler concurred, and presented the Greens with a design that consists of two shed-roofed buildings set on either side of a courtyard. On the street side, the courtyard is screened by a textured glass wall; on the lagoon side, it opens onto a spacious deck. "Courtyards are common at Stinson Beach," notes Butler, "because of the winds. The glass wall in front gives the Greens privacy from the street, but the house itself has seventeen doors opening onto the courtyard and deck, so the courtyard doesn't feel closed-in." Moreover, it provides a sort of decompression space when the Greens arrive on weekends. "The courtyard is a nice transition," says Larry. "You get a real vacation-y feeling the minute you walk in."

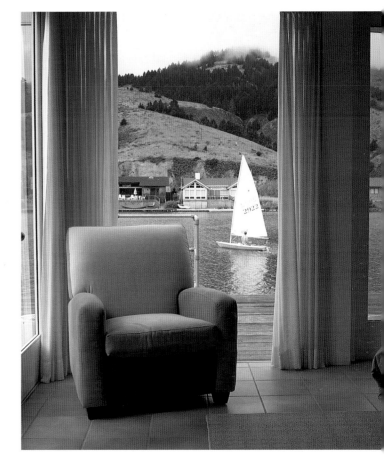

OPPOSITE: The building to the left of the courtyard contains two bedrooms; the one to the right houses the living areas and garage.

ABOVE: In the master bedroom, sheer curtains adorn the open doors, which frame views across the lagoon to the foothills of Mt. Tamalpais— and a passing sailboat.

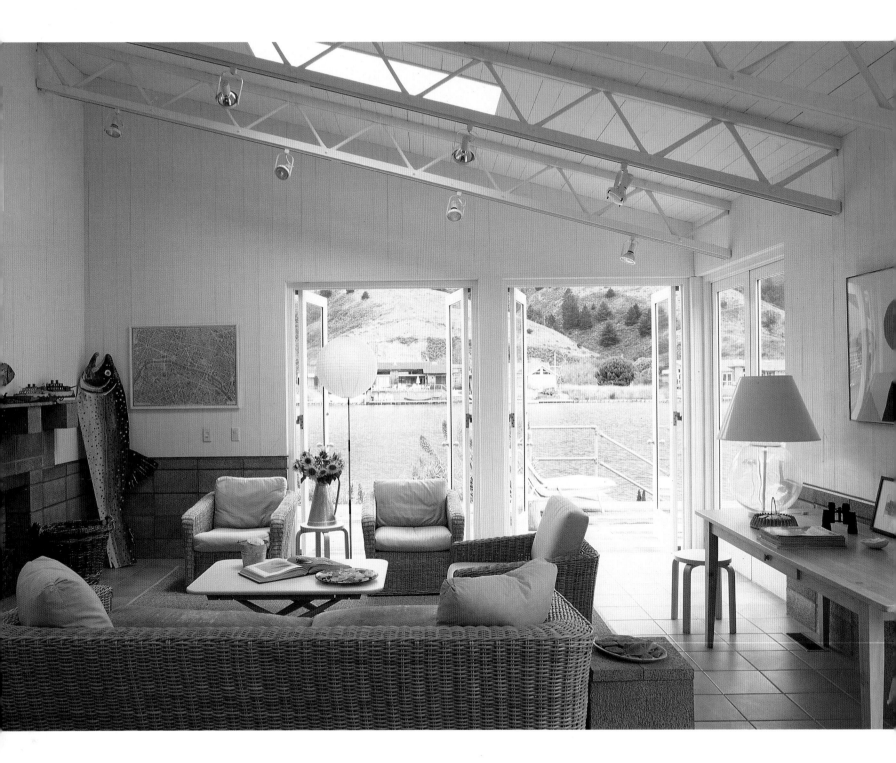

The house is made of simple, easy-to-maintain materials. The base is made of concrete block, which also helps turn the courtyard into a passive solar heat sink. The salt air at Stinson Beach can be extremely corrosive, so the cedar siding has stainless steel nails that don't rust, and the steel doors have a baked enamel finish that doesn't need repainting. Inside, exposed trusses, high windows, and skylights give the two buildings—one houses the living-dining-kitchen area, a children's room, and garage, the other a master bedroom and guest room—an open, sun-washed quality. And the profusion of doors enhances the house's indoor-outdoor feeling. "The spaces are pleasant even when the weather's bad," notes G.G. The rooms are painted a warm, creamy color that provides a perfect canvas for the Greens' arrangements of simple, no-fuss furniture and offbeat objects, which include everything from a collection of ship models to artworks by the Greens' children. "You can't cover anything up here," explains G.G., "so it has to function." Or, as Butler notes with obvious pride, "There weren't too many tricks in this house. Simplicity was the key to its success."

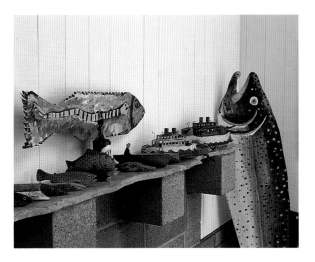

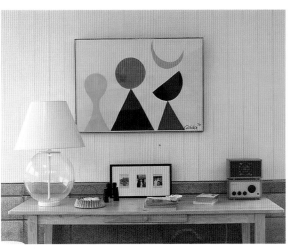

OPPOSITE: The living room's open trusses, ample daylight, and uncluttered furnishings give it the simplicity that makes for relaxing weekends.

LEFT: The mantelpiece, which is made from a piece of scrap marble, is home to a collection of fishing lures, toy boats, and a folk-art fish. The giant fish in the corner is an old sign found on a trip to Lake Tahoe.

BELOW: On the opposite wall of the living room, a tempera painting by Alexander Calder hangs above a simple wooden table that holds books, magazines, and family memorabilia.

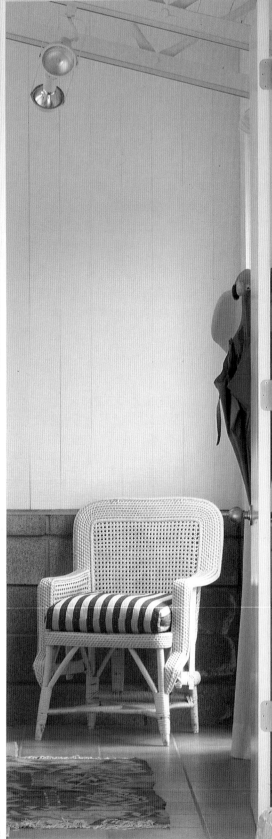

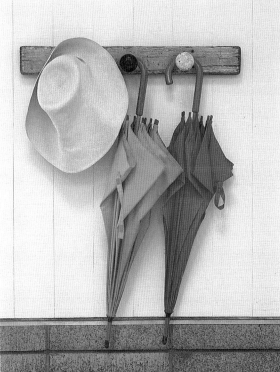

OPPOSITE: In the master bedroom, the bed and table, which are reminiscent of the Arts and Crafts movement, harmonize with masks, Mexican religious art, and modern Italian design in the form of Richard Sapper's Tizio lamp from Artemide.

LEFT: In the guest room, framed collections of vintage buttons found by G.G. Green are grouped around a Mexican tin mirror, which reflects a painting done by one of the Greens' children, and a Sarasar lamp, with a glass-bead shade, designed by Roberto Pamio and Renato Toso for Leucos, from Limn in San Francisco.

BELOW: A hatrack, from the Summerhouse Gallery in Mill Valley, holds a pair of colorful umbrellas— just in case—in addition to the ubiquitous straw beach hat.

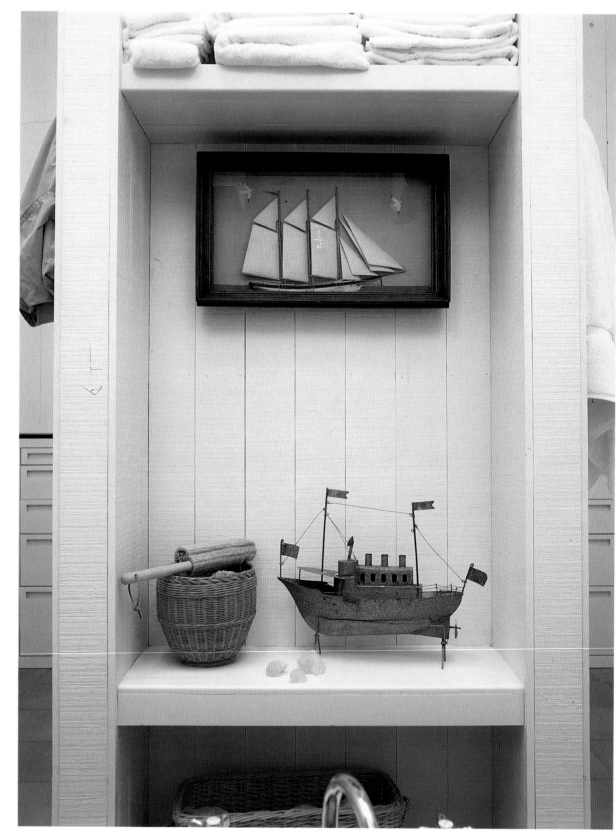

RIGHT: In the bathroom, a tower-like arrangement of shelves houses a framed ship model and a galvanized metal toy boat—part of a collection—as well as baskets of soaps and sponges, in addition to extra towels. The storage units in the background are actually artists' flat files.

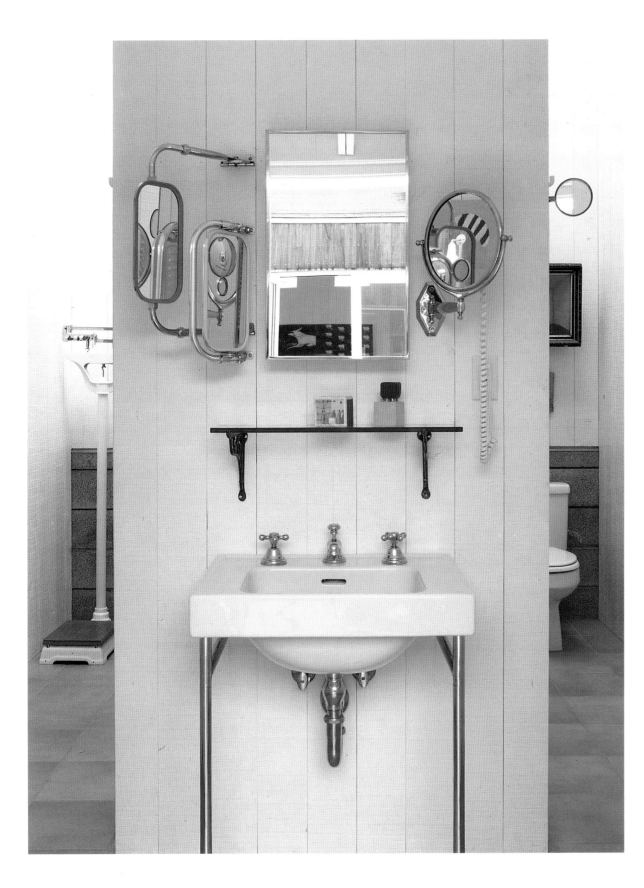

LEFT: On the other side of the storage tower, the mirror above the vintage sink is flanked by a collection of adjustable mirrors, including truck and motorcycle mirrors, and one that G.G. purchased at a Paris flea market.

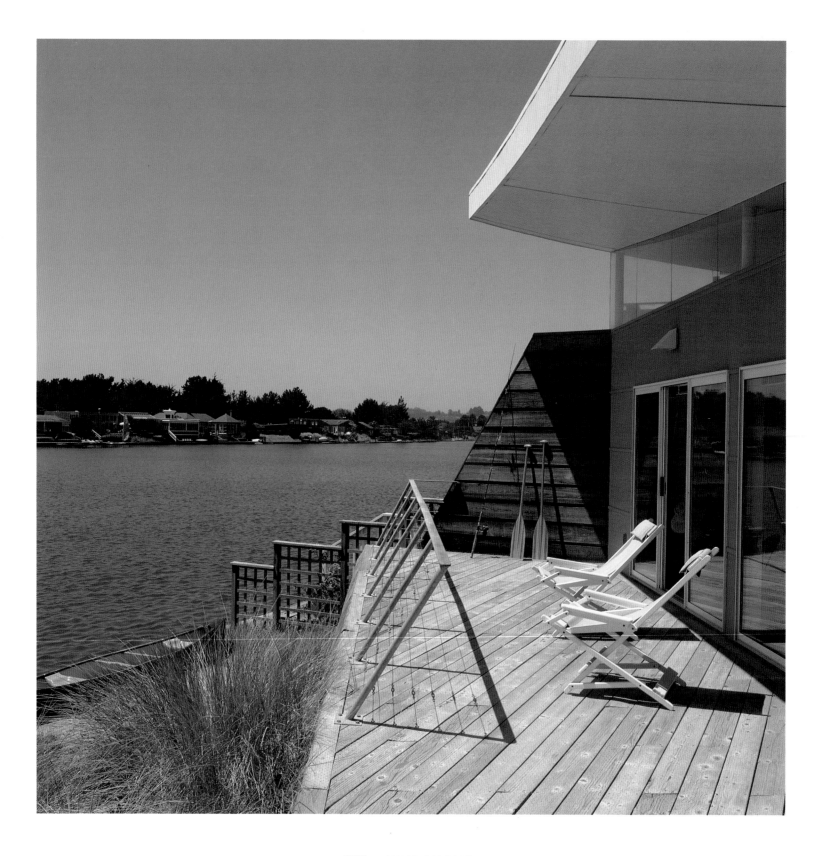

San Francisco architect Stanley Saitowitz is very much a modernist, but he is one who has always been interested in the geography of a building site. Rather than looking as if they had come from somewhere else and could, in fact, be anywhere at all, Saitowitz's houses have a real relationship to the land on which they stand. This house in Stinson Beach, designed as a weekend house for Jim and Mary-Lou McDonald, is no exception. Using an exceptionally economical formal and material vocabulary, Saitowitz created a building that seems to be half-house, half-boat, but which is always moored firmly to its surroundings.

The McDonalds wanted something completely different from their house in San Francisco, which is Victorian and filled with their various collections. "We wanted a house that puts you in a different frame of mind, that says you're at the beach," explains Jim, a contractor, who built the house himself. "We wanted something bright, and sensitive to the site." That site was a lot on the Seadrift Lagoon, with views across the lagoon at one end, and views of the mountains of West Marin at the other. Marine metaphors informed Saitowitz's design process. First, he pictured a "crusty, driftwood exterior protecting a fragile, iridescent interior," as he puts it. (The driftwood became redwood ship-lap siding.) Second, since the house is not actually on the beach—and even if it were, that beach is not always a balmy one—Saitowitz decided to treat the interior of

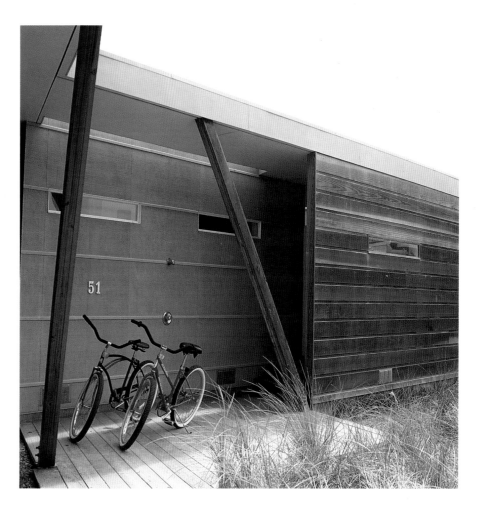

OPPOSITE: The roof of the house sweeps up over one corner of the deck, looking like an enormous sail.

ABOVE: The street side of the house, with its narrow windows and weathered siding, belies its light and airy interior spaces.

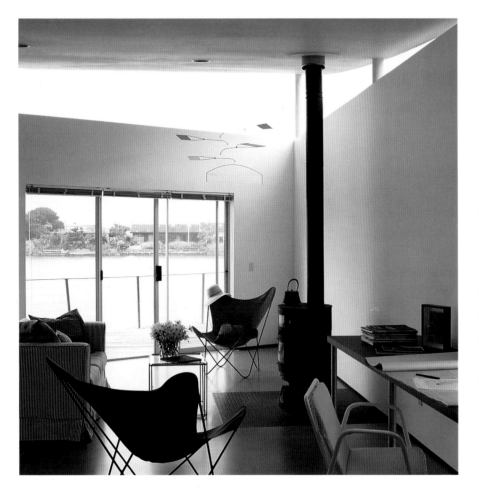

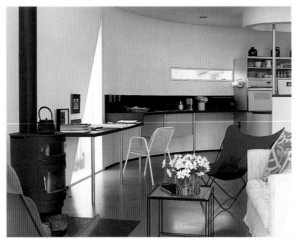

the house itself as a beach, with the roof as an umbrella, and golden-stained particle-board floors recalling the color of sand. And finally, he saw the house almost as a boat; indeed, its sloping profile and deep overhangs give it the look of a ferryboat—one that symbolizes the transition, from hectic city life to the peaceful water-side existence, that the McDonalds wanted. "You arrive by car," says Saitowitz, "but you escape by boat."

In order to maximize the deck's exposure to sun and its view of the lagoon, Saitowitz rotated the house twenty-six-and-a-half degrees on the site so it faced due south. At the corner of the house closest to the water, the roof sweeps up like a sail, creating a clerestory, above the sliding glass doors that open onto the deck, which lets light pour into the single, uncluttered space that serves as the house's living-dining room and kitchen. A sail-shaped window along the west wall of the room offers a different glimpse of the view from the built-in desk. And a narrow ribbon of a window runs horizontally below the ceiling above the kitchen sink, offering a view of the mountains that could even make washing dishes a magical experience.

The two-bedroom, eleven-hundred-square-foot house may be modest in size, but its judicious layout and no-fuss materials make it seem spacious. Still, its greatest luxury is not meant to be that of space; instead, it offers an abundance of those increasingly rare commodities—quiet, light, and fresh air.

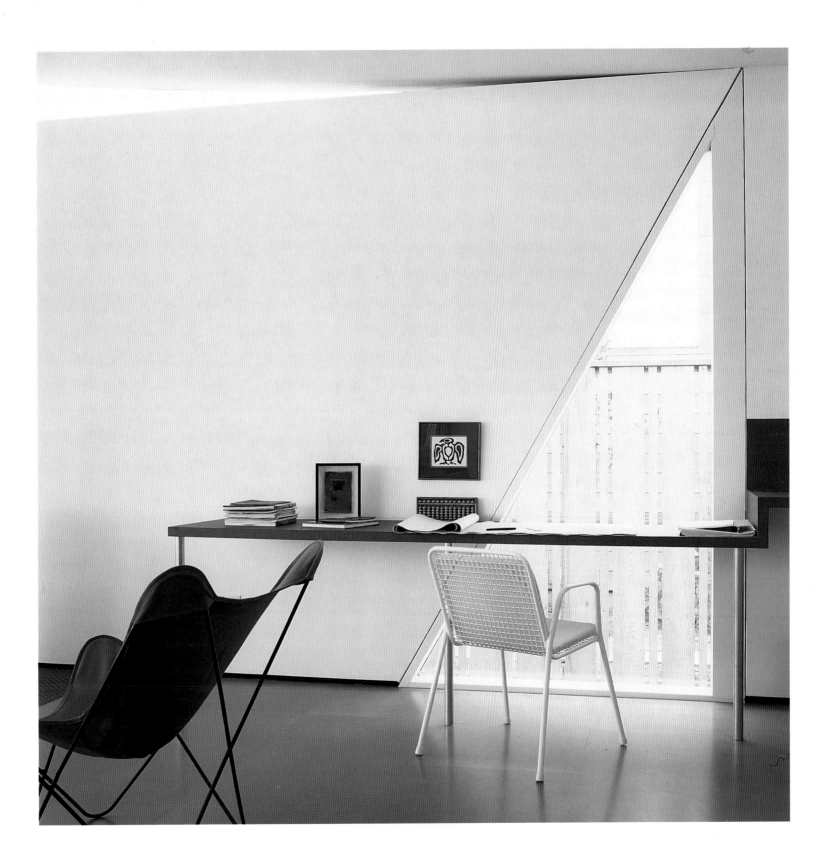

About ten years ago, actor-director Peter Horton was looking for a house to rent in a charming Central Coast town, when he came upon this house. It was covered in wavy cedar shingles, and it had a porthole in its front gate. "I just wandered in," Horton recalls. "It was fate." Horton bought the house from the woman who had spent the last three years renovating it herself. E. Tarkington Steele, known as Tark, has made a career out of buying houses, redoing them from the ground up, and then selling them. And although she works in whatever architectural vocabulary is appropriate to a particular house or place, Steele knows from nautical: She once worked on a high-seas tuna-fishing boat. To transform what had been a banal 1950s box with Swiss-chalet trim and fake paneling, she used lots of salvaged materials, as is her wont, cutting the wavy shingles by hand, finding the cast-bronze dolphin faucet handles in antique stores, and doing the rock-work in the bathrooms herself, with rocks from the cove just below the house. "Regardless of where I am," she says, "I'm interested in producing an organic, natural feeling in a house—a rustic elegance. These houses are really labors of love," a fact that is not lost on the owner of this one. "There are a million little touches that make this place unique," says Horton. "I come up here, and I feel like all's right with the world."

OPPOSITE: A birdhouse, a gift from Peter Horton's mother, stands next to a driftwood railing.

ABOVE AND LEFT: The front gate is adorned with a driftwood handle and a porthole window.

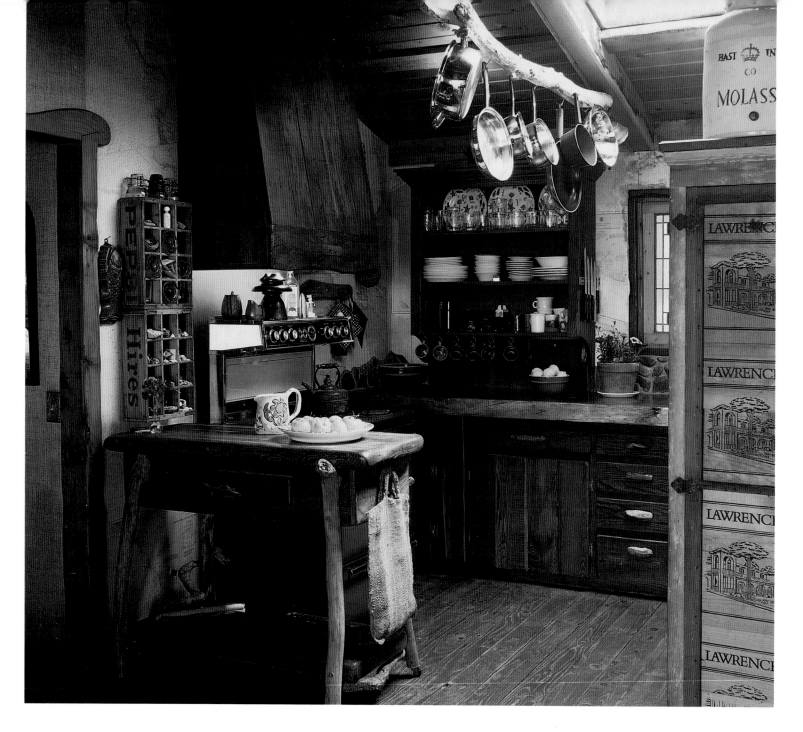

ABOVE: Salvaged fence
boards became kitchen
cabinets, and redwood
slabs were used for the
countertops. Pots and
pans hang from a drift-
wood rack.

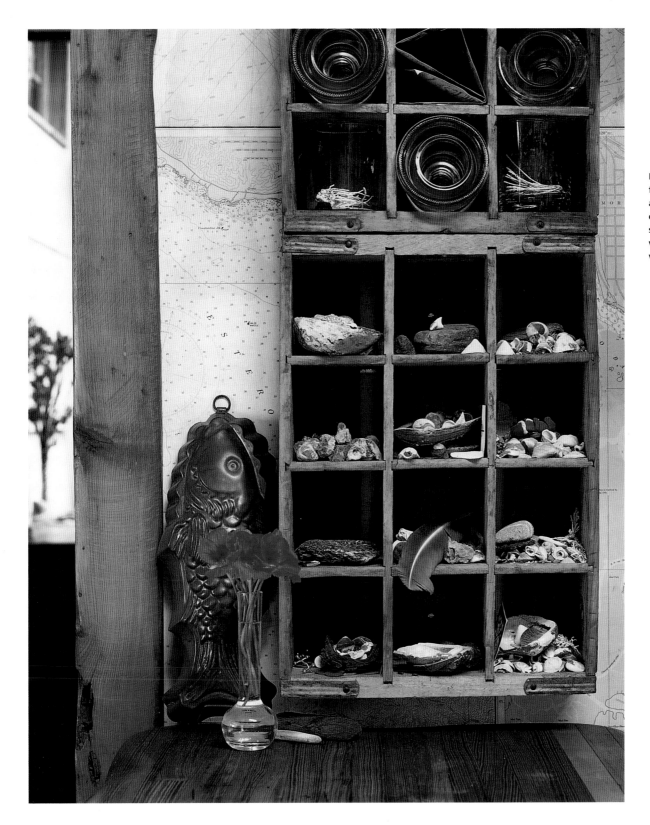

LEFT: A collection of shells, feathers, glass insulators, and other odds and ends fills these pigeonhole shelves in the kitchen, where maps are used as wallpaper.

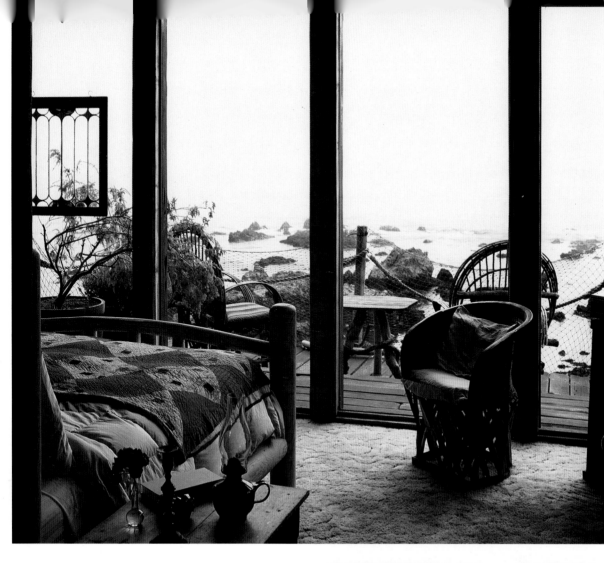

OPPOSITE: The deck off the master bedroom, with its rope railings and fishnet, sets the mood for sitting and watching the waves and the marine life—such as whales, sea otters, and pelicans—that abounds on this stretch of the coast.

ABOVE: The master bedroom is a double-height space that offers a dramatic view of the ocean. Behind the bed, a staircase leads to a loft library.

RIGHT: In the guest bathroom, a walnut slab was used for the sink counter. A seashell doubles as a soap dish, and dolphin handles adorn the faucets.

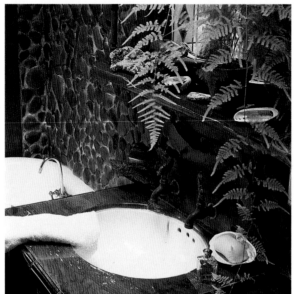

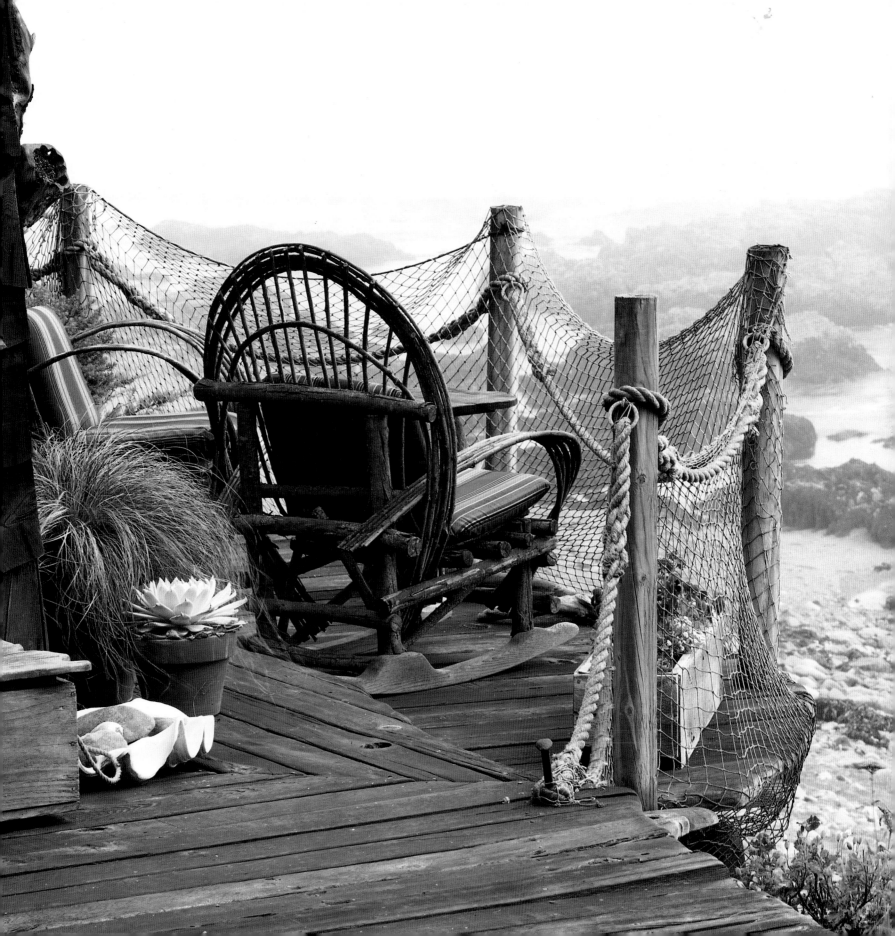

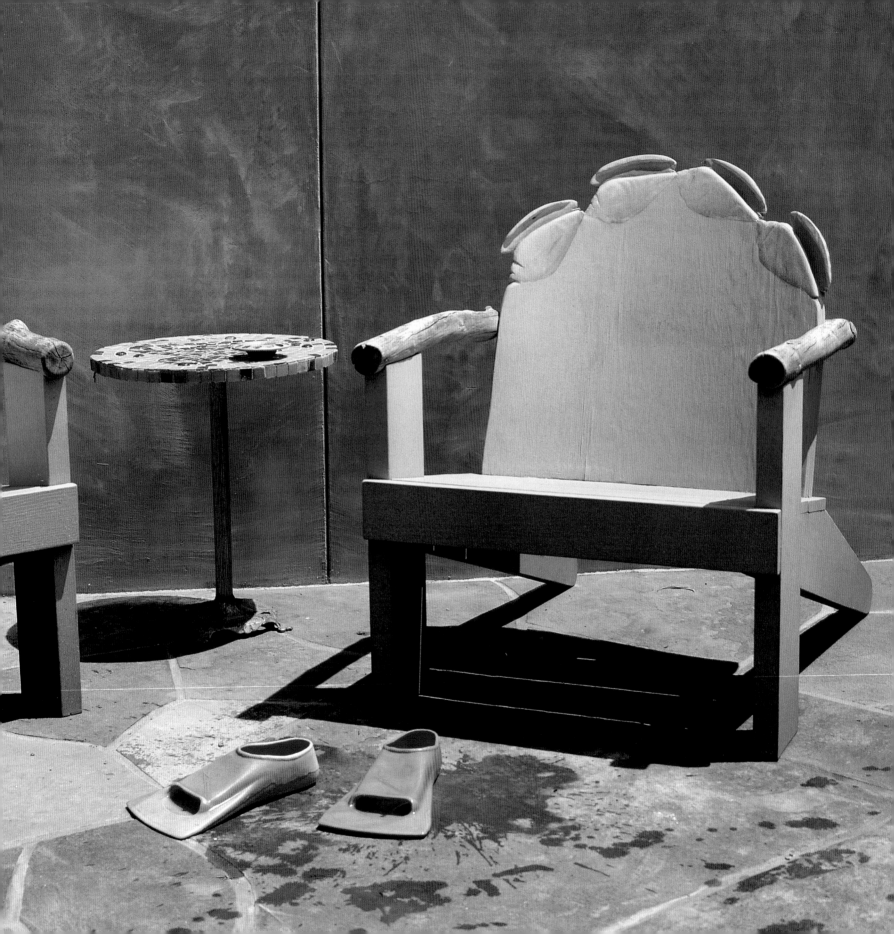

City Beaches

Before I moved to California, I spent five years traveling there regularly—usually to Los Angeles—in my capacity as an editor at *Progressive Architecture* magazine.

And although I could have stayed anywhere in the city, I was drawn to Santa Monica—which is, in fact, a city in its own right. I loved the fact that this was a bustling, thriving, sophisticated urban center—and it was right on the beach. With the exception of Miami and Miami Beach, it's hard to think of another place in the U.S. that offers this alluring combination of big-city life and fun in the sun. Moreover, Santa Monica and Venice, the community just to the south, have downtown areas with a low-rise, pedestrian-oriented scale that make them particularly beloved of Britons and Europeans, both tourists and transplants. Finally, these areas have provided an especially fertile ground for architectural innovation in the last fifteen years; they attract creative people who want to live in something out of the ordinary. It's no coincidence that the houses featured in this chapter are inhabited by an artist, a decorator, a producer-director, and an actress, respectively. After all, who ever said that the beach was just for sunbathing?

OPPOSITE: Whimsical chairs with driftwood arms and seashell-motif backs enliven the patio of Hannah Hempstead's Venice house.

FOLLOWING PAGES: The Venice canals are among the last vestiges of the dream city built by Abbot Kinney in the early 1900s.

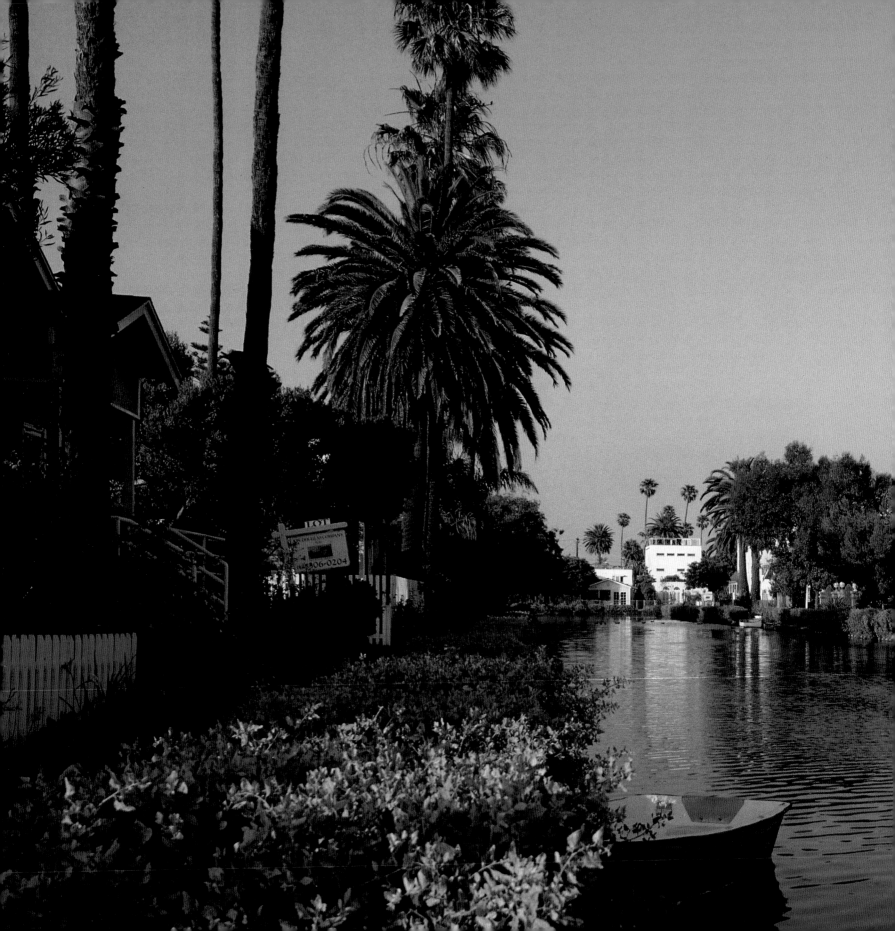

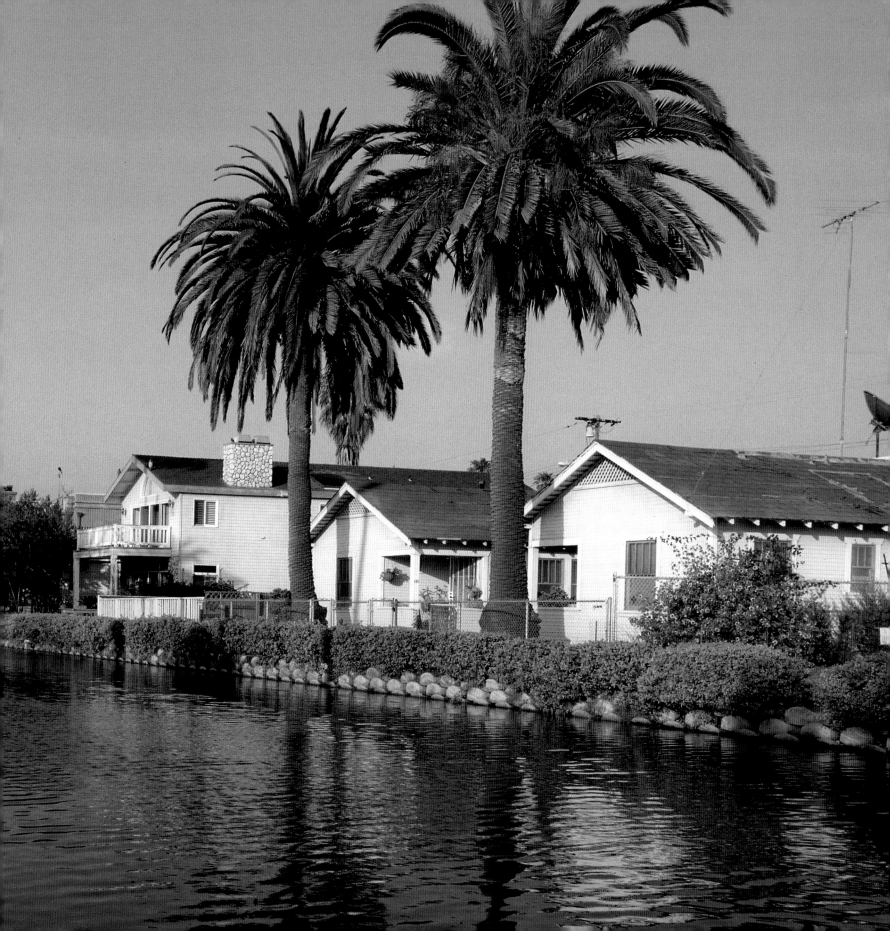

Bleifer House, Venice

Venice Beach is one of the most colorful neighborhoods in Los Angeles, with an ethnic and economic diversity that is growing increasingly rare as the city's beach communities become more gentrified. It is a community of contrasts, with quiet, pedestrian-only "walk streets" running perpendicular to what is still called the board-walk—despite the fact that it is essentially a concrete sidewalk—with its hordes of tourists, rollerskaters, street people, and, of course, the bodybuilders on Muscle Beach. It was exactly this atmosphere that drew Ken and Sandy Bleifer to Venice. Ken, a doctor, and Sandy, an artist who works in paper, had lived in the suburbs for many years. But when their children grew up, Sandy decided that it was time for a change. "Venice offered a lot of diversity and creative people," she recalls. And she loved the idea of living on a walk street, undisturbed by cars. "When you go out in the morning to pick up the newspaper, you see your neighbors," she says. "And people watch out for one another."

The Bleifers asked Los Angeles architect Frederick Fisher to design them a house that was completely unlike the one they were leaving. "They wanted a loft life," reports Fisher, "with the living room, dining room, and kitchen all in one space." In addition, Ken wanted a cellar and tasting area for his large wine collection, and Sandy wanted a studio and office.

ABOVE: Stairs lead from the entry of the main house up to the glass bridge at right, or to the pantry balcony, above the kitchen, which is on the left.

OPPOSITE: Looking from the living room toward the dining area, Sandy Bleifer's paper construction, *Uze*, is seen on the long curved wall. A collection of vintage chairs, by designers such as Norman Cherner and Charles and Ray Eames, surrounds the dining table, which is by Roy McMakin.

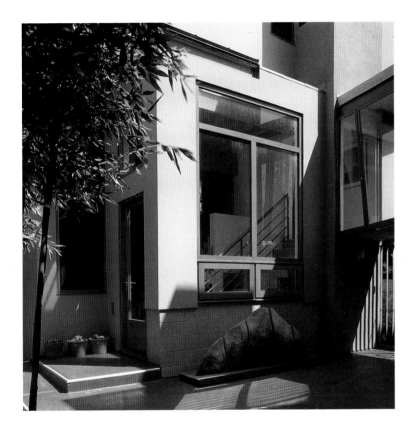

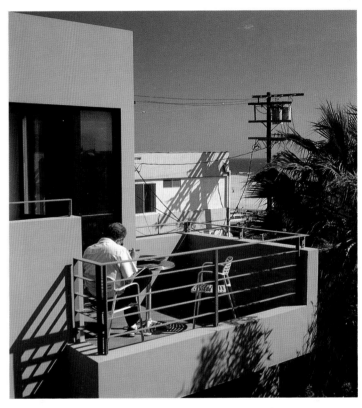

ABOVE: A bamboo tree frames the entry in the light well between the main building and the studio and garage building; the two are joined by a bridge, which is visible to the right.

LEFT: The roof terrace offers sweeping views of Venice Beach and the surrounding cityscape.

ABOVE: A small balcony, located on the front of the studio/guest house/ garage building, was designed to allow Ken Bleifer a place in which to indulge his passion for good cigars undisturbed.

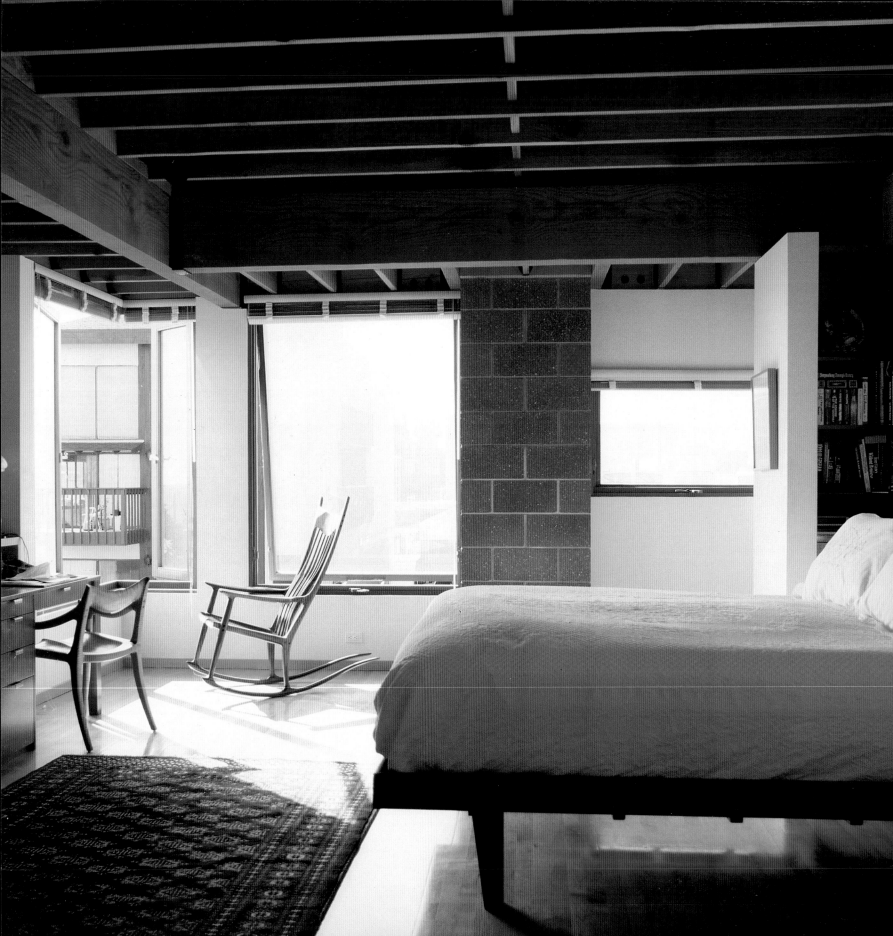

Fisher's response to his clients' program was to design what he calls a "diptych house," divided into two parts—one, with a curved side, for the living areas and wine cellar, and the other, smaller building, for the studio, office, guest room, and garage. A short, glass-walled bridge connects the two parts, and helps define a light well in the open space between them.

One reason that the Bleifers hired Fisher was that they admired his use of humble building materials. "He uses them for their own qualities, and doesn't try to disguise them," notes Sandy. In this house, Fisher created a concrete-block structure, which includes the chimney tower, that is intended as a "ruin" from which the stucco walls rise—a reference to the discontinuous way in which urban buildings are built, demolished, and rebuilt on the same site. Inside, the exposed framing on the ceilings strikes a slightly gritty contrast to the polished maple floors and mahogany and maple kitchen cabinets. Fisher placed the windows for what he calls "a variety of picturesque effects." One frames a view of the bamboo garden in the light well; corner windows in the bedroom open onto a view of the beach. And the roof terrace offers panoramic views of the city as well as of the ocean.

Once their programmatic requirements had been met, the Bleifers gave Fisher a great deal of freedom in making design decisions. He recalls that Sandy told him, "We just want you to paint your own picture." As Sandy herself explains it, "I'm a wall artist. Spatial concerns are entirely out of the realm of my experience." Fisher appreciated their confidence. "When people give you that gift of trust, you just try that much harder," he says.

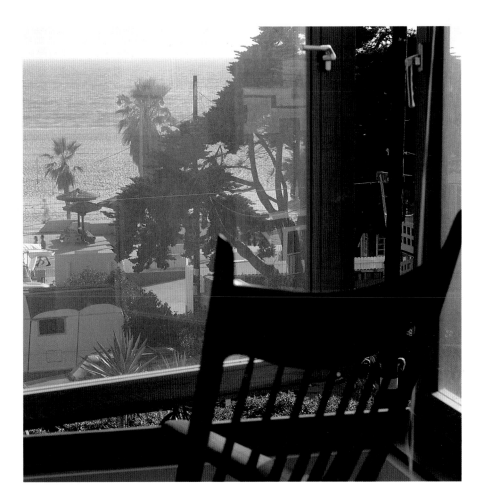

ABOVE: In the bedroom, a pair of windows are placed so that the corner seems to "disappear." This corner offers a quiet spot from which to admire the views of beach and ocean.

OPPOSITE: Fred Fisher designed the bed and the built-in desk at left. The desk chair, and the rocking chair in the corner, are both by the noted furniture maker Sam Maloof.

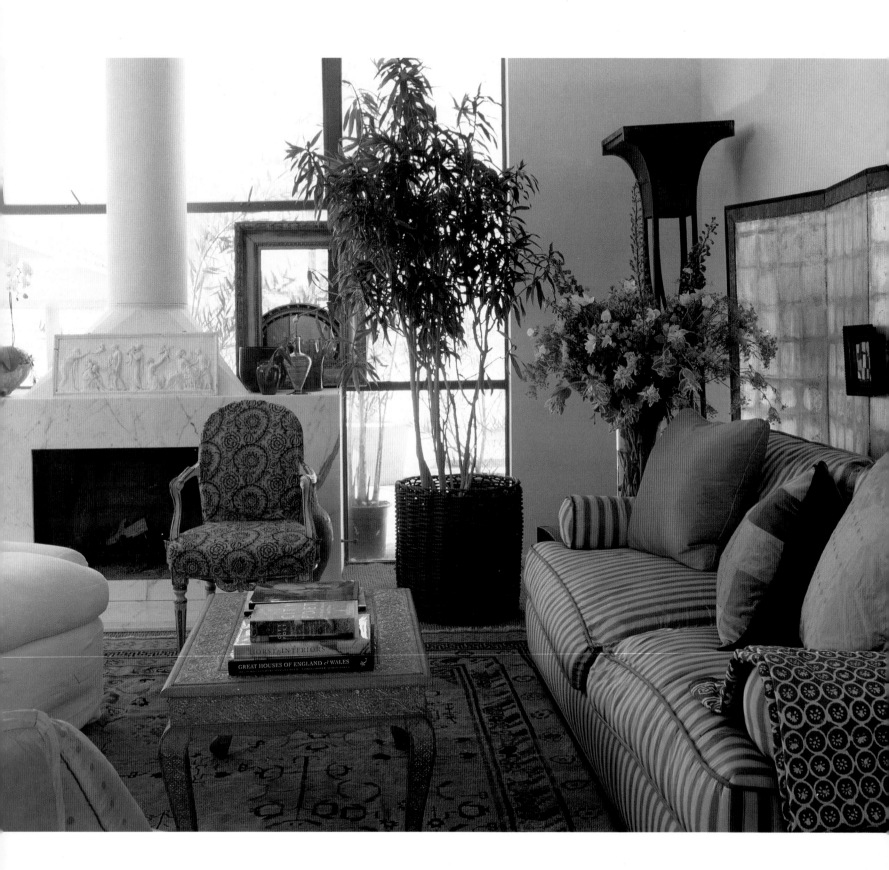

Smith Penthouse, Santa Monica

In just a few brief years, Michael Smith has sped to the top ranks of Los Angeles decorators. At an age where he could still be classified as a boy wonder, and with an *enfant terrible* manner to match, Smith has the kind of Hollywood clientele—names so big you're not allowed to name them—that decorators twice his age would envy. How did he do it? Smith charmed the entertainment community by doing their houses in a traditional-with-a-twist style that they found irresistible. He continues to sharpen the edge that he puts on history, as his own home—a penthouse in a low-rise building just a few blocks from the beach in Santa Monica—makes very clear.

A modern building without architectural detail wouldn't seem quite Smith's cup of tea. "The space was pretty raw," he recalls, "and sort of Seventies high-tech. But it has light on three sides and a view of the ocean, and I couldn't get those things anywhere else." So Smith's solution to these less-than-distinctive spaces was, as he explains, "to make them more sensitive to the kinds of things that I wanted to put into them, using color to make it work." And work it does. Filled with furnishings old and new, and colors both subtle and outspoken, these rooms are young, modern, and chic.

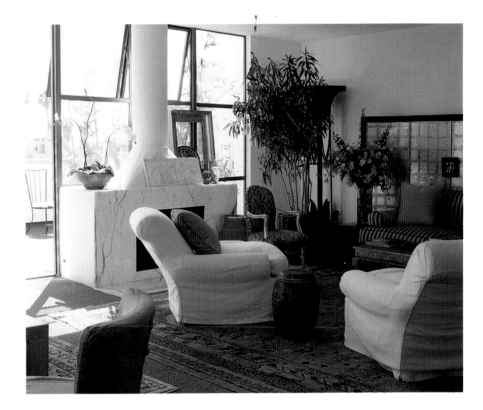

ABOVE: Generous armchairs, slipcovered in white cotton, sit opposite the sofa. Smith painted the walls white; under the rug, the entire floor is carpeted with sisal.

OPPOSITE: Michael Smith's sunny living room is a study in sophisticated contrasts. A banquette covered in striped silk sits on a Samarkand rug, as does a hammered tin coffee table from India.

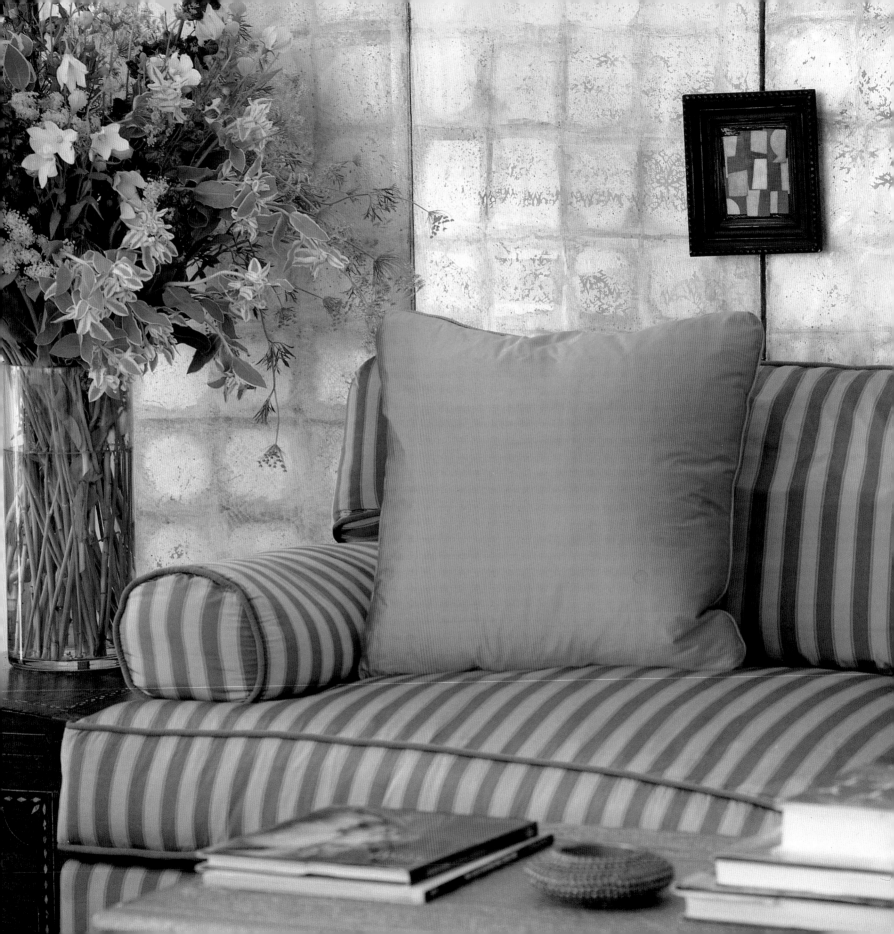

Smith is nothing if not a voracious student of decorating, design, and style in general. And he tends to describe his work in terms of the images that inspire him. His vision of these spaces was based in part on Charles de Beistegui's Paris penthouse, which was designed by the great modernist architect Le Corbusier in the early 1930s, and then decorated—also at de Beistegui's request—by Spanish architect Emilio Terry in a wildly neo-historicist style. Smith describes the Thai silk-covered banquette in his living room as "a weird Fifties penthouse thing." Ask him about the silk fabric on his bed, and Smith will tell you that it's "petroleum green—very Charles James," referring to the revered American fashion designer. And when you ask him just what color the walls of his library actually are, Smith replies, "a Fauve orange," summoning visions of the early twentieth-century French painters, led by Henri Matisse, whose bold use of intense color earned them the nickname *fauves*, or "wild beasts." For Smith, the color is the subject of a mini-crusade: "Orange has always been the stepchild of colors," he explains, "but there is a California tradition of orange—in the Latin culture, in the California poppy. I thought it would be interesting to make orange look sophisticated."

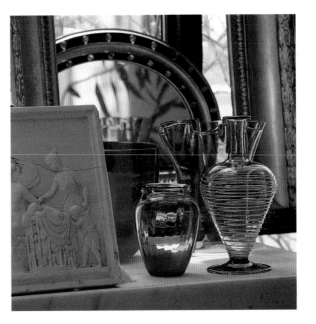

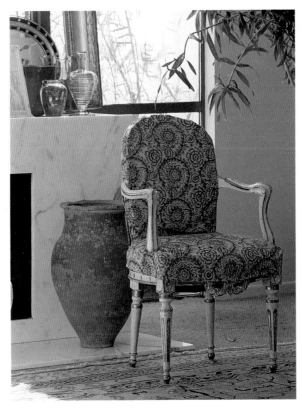

LEFT: Atop the fireplace, Smith arranged a classical plaster frieze, an Irish Regency mirror, and glass from the nineteenth and twentieth centuries.

BELOW: Smith's flair for the unexpected shines in this juxtaposition of an eighteenth-century Swedish armchair, covered in Indian fabric, and a large French terra cotta jar.

OPPOSITE: Behind the banquette, which is covered in a "taupey gray and blue" Thai silk, stands an antique Japanese screen covered with silver leaf. A small painting by Mark Innerst hangs on the screen.

RIGHT: Smith placed the twelve-and-a-half-foot-tall steel bed, which he describes as designed after one that belongs to the painter Balthus, on the diagonal. A Barbizon School landscape hangs on the bed curtains; a steel desk lamp from the 1920s stands on the Indian table. Smith covered the Italian chair with woven raffia.

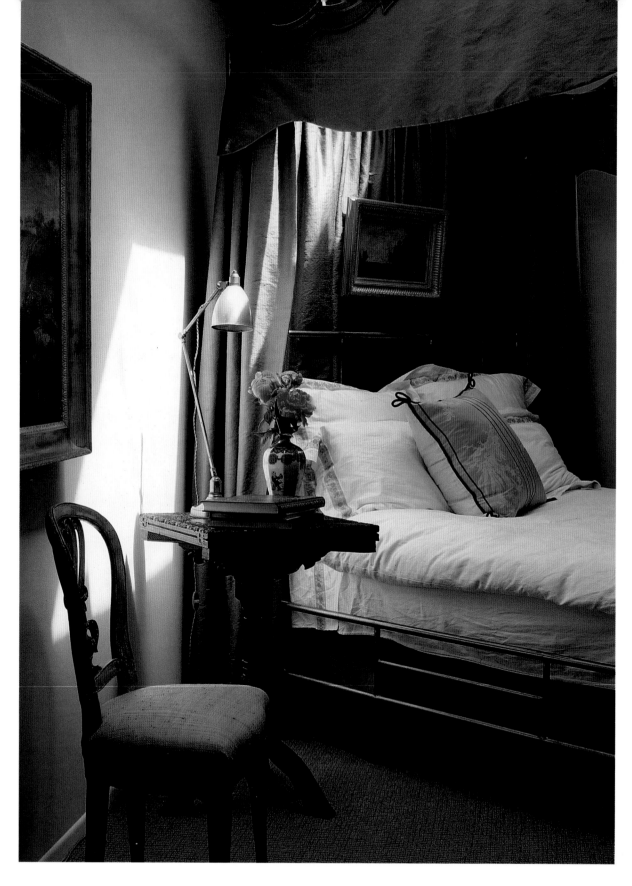

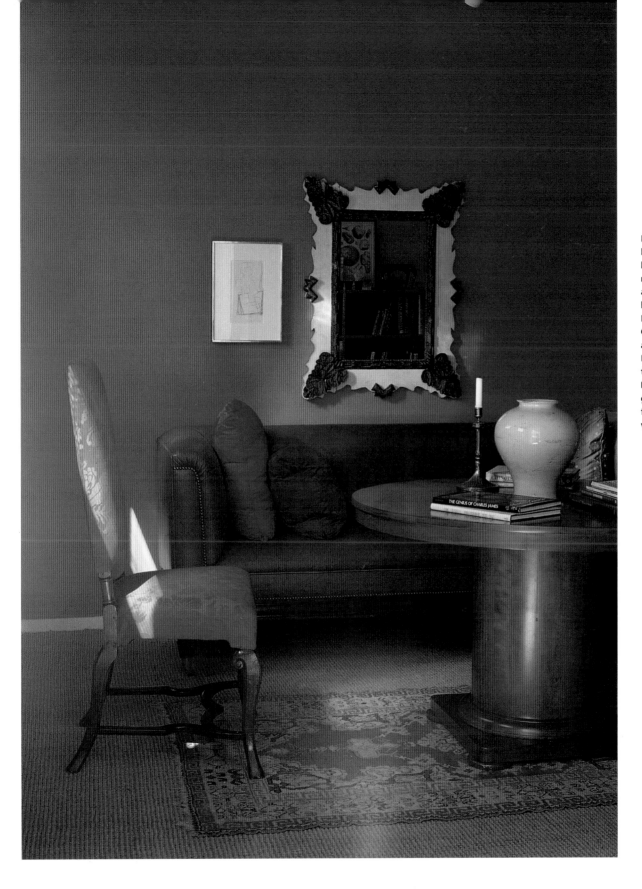

LEFT: In his "Fauve orange" library, a small sketch by Arshile Gorky hangs next to a white-painted and gilt mirror that belonged to the legendary Los Angeles decorator Gladys Belzer, who was also the mother of actress Loretta Young. Next to the leather-covered William IV sofa stands an "exaggerated and baronial" chair from the 1920s; the table was designed by Smith.

Several years ago, film producer and television director Hannah Hempstead was casting the part of an architect for a commercial—but she wanted a real architect. Enter Steven Ehrlich, the Santa Monica architect who is known for his distinctive brand of design, which enriches modernist forms with vernacular traditions from all over the world. Not only did Ehrlich get the part; he also got the commission to renovate the unremarkable tract house that Hempstead had purchased in Venice. Ehrlich, working closely with his client, created a walled oasis that is both serene and lively—or, as one might say these days, both very hot and ultra-cool.

"The house is very much about an interest in Cubism," explains Ehrlich of the play of rectilinear solids that make up the three-level house. Ehrlich also cites the influence of the great Mexican architect Luis Barragan, whose buildings used austere but intensely colored forms, and the thick, solid walls of vernacular Mediterranean buildings, which also have deep openings for walls and doors. "They give protection from the sun," says Ehrlich, "and they create a great variety of shade and shadow." The burnished, hand-troweled plaster that covers the exterior walls was pigmented with yellow ochre and burnt sienna—colors that came from a coffee cup Hempstead bought in Italy.

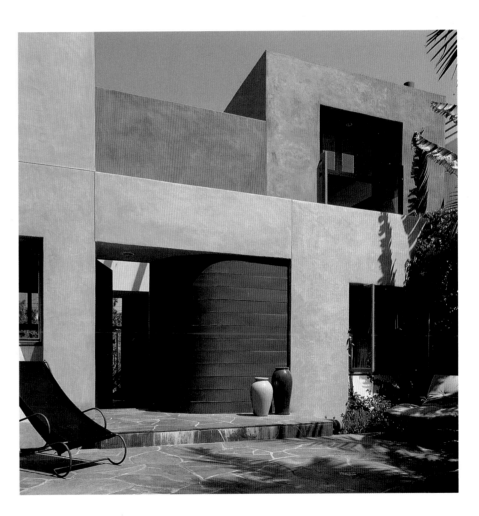

OPPOSITE: A crisply detailed flight of stairs and pigmented plaster wall create a bold composition.

ABOVE: The front of the house illustrates its Cubist origins; the window of the study can be seen at upper right. The curved entry wall is wrapped in copper.

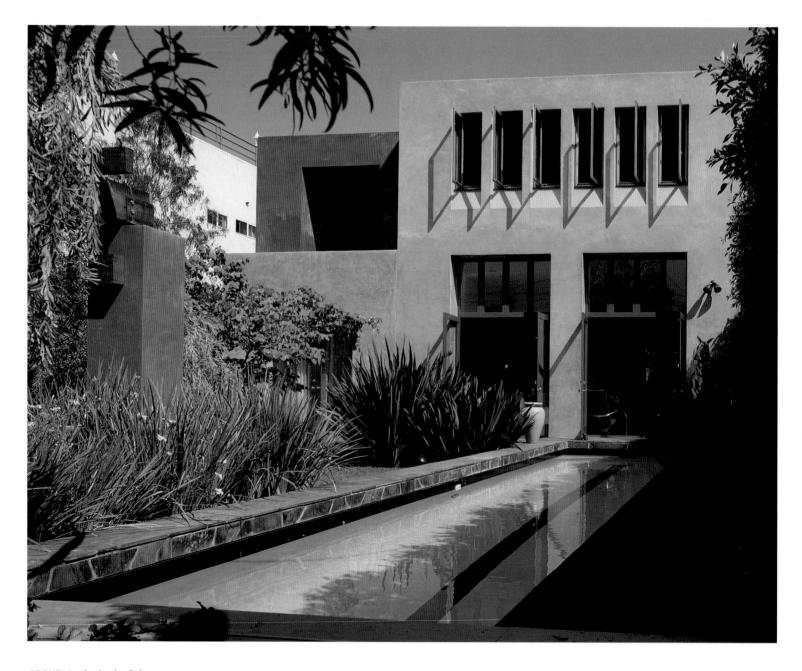

ABOVE: At the back of the
house, the living room
doors open directly onto the
swimming pool. The plaster
column at left is a corner
of the pergola that is used
as an outdoor dining area.

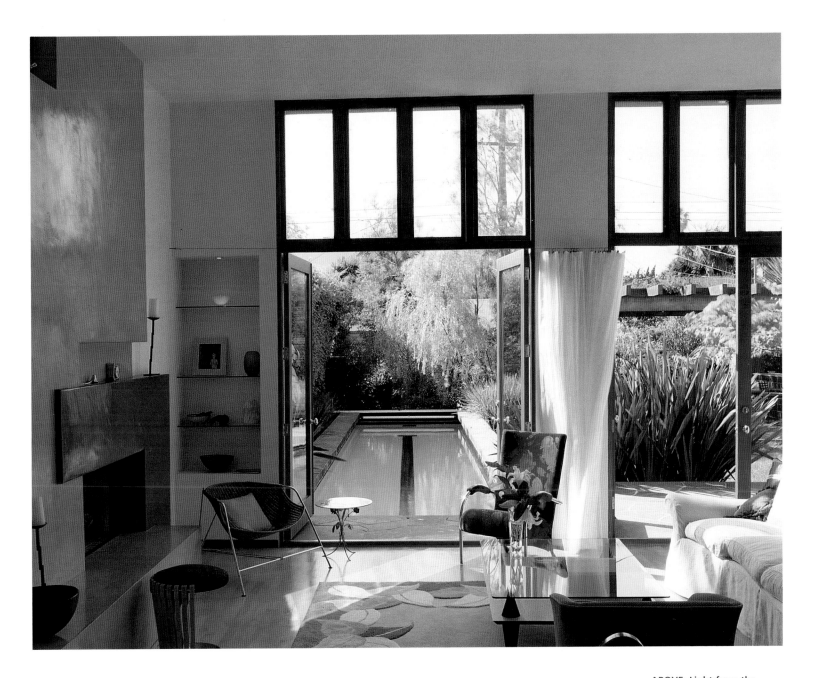

ABOVE: Light from the doors and windows floods the living room. Among the eclectic furnishings is an upholstered maple and stainless steel stool, next to the fireplace, designed by Stephen Courtney.

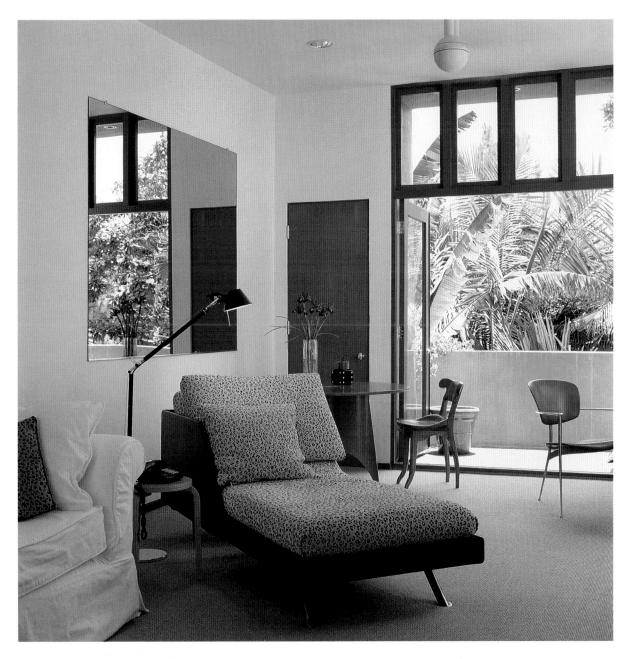

LEFT: The entertainment room is located on the second level of the house and overlooks the garden. The leopard print of the chaise is echoed in the pillow on the white-slip-covered sofa; the chair in the corner is a reproduction of an original design by the early twentieth-century Spanish architect Antonio Gaudí.

OPPOSITE: Ehrlich brought the colors of the house's exterior to the inside; but here, in the living room fireplace, the plaster has a glazed finish.

BELOW: The master
bedroom is decorated with
simple but dramatic pieces.
The overscaled mirror was
used as a prop in the film
Three of Hearts, which
Hempstead produced, and
the bench was designed
by Stephen Courtney.

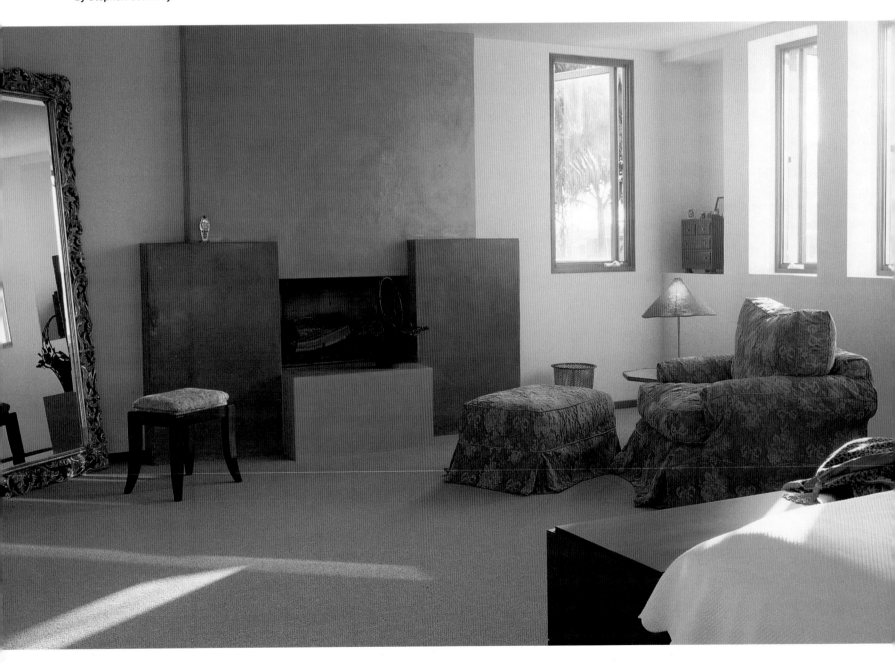

The elegantly proportioned doors and windows fill the rooms with daylight. They also emphasize the house's indoor-outdoor feeling, which Ehrlich says is especially crucial because the house sits on a rather small, narrow lot—which was landscaped in a spirit of lush informality for which its designer, Jay Griffith, is known. Ehrlich reinforced this indoor-outdoor connection by bringing the front and back patios' Idaho flagstone into the entry and kitchen, and by repeating the exterior plaster colors on the living room and bedroom fireplaces.

Inside the house, Ehrlich's cleverly proportioned rooms are filled with a varied assortment of furnishings chosen by Hempstead on her extensive travels. "Hannah has a great eye," notes Ehrlich. "She has been a garage-sale junkie, but she's also not afraid to fly to Barcelona to track down a particular chair." The resulting mixture of comfortable upholstered and slipcovered sofas and armchairs, snappy contemporary chairs, and high-impact accessories—like the overscaled bedroom mirror—creates an atmosphere that feels fresh and current, but not trendy. In keeping with its eclectic but pulled-together interiors, the house is, as Ehrlich describes it, "modern, but very warm. It pulls together architecture from several different cultures." With its emphatic forms and colors, which are offset by the softer textures of the plantings in the patio and garden, the house seems both urbane and casual—the perfect house for a city beach.

ABOVE: A very modern take on the traditional headboard enlivens the bed, above which hangs a work by Ellsworth Kelly. Hempstead kept the palette neutral; accents of color come from the art, fabrics, and the plaster fireplace.

or some Californians, the best part of living near the ocean is not the beach but the view. For Emmy Award-winning actress Dana Delany, this contemporary Santa Monica house, in a neighborhood that still retains a lot of its old funkiness in spite of its ever-increasing hipness, offers wonderful vistas of rooftops, swaying palms, and the blue Pacific. In addition to the views, Delany liked the house, which was designed for a previous owner by architect Michael W. Folonis, for its spare, open feeling—each of the three floors is basically one big room.

For the interiors of the house, Delany called on an old friend for help—designer Kevin Walz, whom the actress had known from her New York days. Walz is known for his unorthodox use of materials and his sensual eye for color and texture, and his approach to Delany's house was no exception. "I wanted to celebrate the views, the light, and the extremely vertical feeling of the house," he explains. Walz, who worked with Brian K. Rogers of BKR Construction, accomplished this by treating each floor differently. The lower floor, which opens onto the pool, doubles as Delany's office and guest room, and Walz didn't fight the fact that it gets little natural light; indeed, he made it as nest-like as possible, with belting leather baseboards, warm-colored sisal carpeting, and walls covered with a German outdoor paint that has a lime-stone texture.

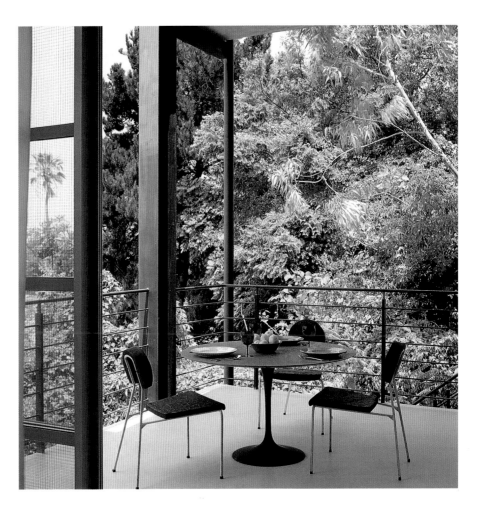

OPPOSITE: Surrounded by cascading bougainvillea, the pool offers a quiet spot for reading and sunbathing.

ABOVE: The living room leads to an open porch, where an Eero Saarinen table with a matte black base and a stone top is set for an al fresco lunch.

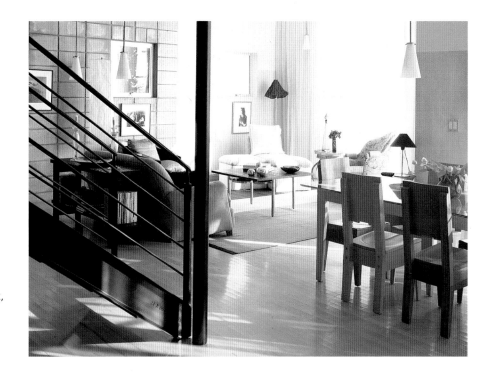

On the second floor, which houses the main entrance, living-dining area, and kitchen, Walz made the most of its breezy, open quality. To unify the room's several different ceiling heights, Walz drew what he calls a "datum line" around the walls at four-and-a-half feet, and from that point down rubbed the walls with a mixture of bowling alley paste wax and aluminum powder. The result is a soft but seductive shimmer— a theme that is repeated in Mary Bright's iridescent-fabric curtains. Walz dealt with the house's existing recessed lighting—which he dislikes on principle— by replacing the downlights with brass and milk glass fixtures of his own design that can simply be plugged into the existing ceiling fixtures. On the top floor, Delany's bedroom reflects what Walz calls his client's "modern, strong, feminine" nature. "The colors— rose, pink, coral, orange—are stereotypically feminine colors, but we put them together in a different way, so that they look vibrant and edgy," he says.

Delany calls the house "clean and serene. It's almost temple-like; I decompress whenever I come back here." The house is, she says, perfect for someone with her busy work schedule; it almost runs itself. It is, she says, "self-sufficient, simple, playful, and unique." If a good house can be said to be a portrait of its owner, then Walz got the picture.

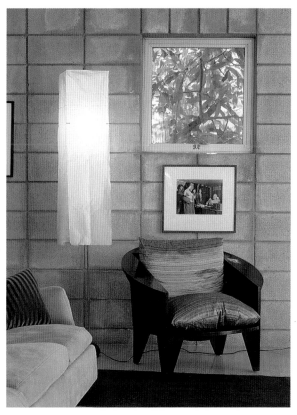

ABOVE: The living-dining area is one large room; the kitchen, not visible in this photograph, is behind the open steel stair at left. The living room looks out over Santa Monica to the ocean.

LEFT: In a corner of the living room, color and texture play off one another in Walz-designed furniture: the suede sofa with mohair pillow, and the wood chair with Thai silk cushions.

OPPOSITE: The dining table and chairs were designed by Roy McMakin, but Walz modified the table by adding a top that is a sandwich of laminated glass and copper mesh. Walz likes to say that he "put the tablecloth in the table, rather than on it."

RIGHT: Reflected in the dressing-table mirror is the cherry and bronze bed that Walz designed for Delany, with a headboard covered in a cork-faced fabric. A leopard-print stool strikes the perfect note of glamour at the dressing table, where the cedar storage compartment is rubbed with gold to clash with its copper lid. The walls are covered with pink mineral paint, and the baseboards are terra cotta tiles.

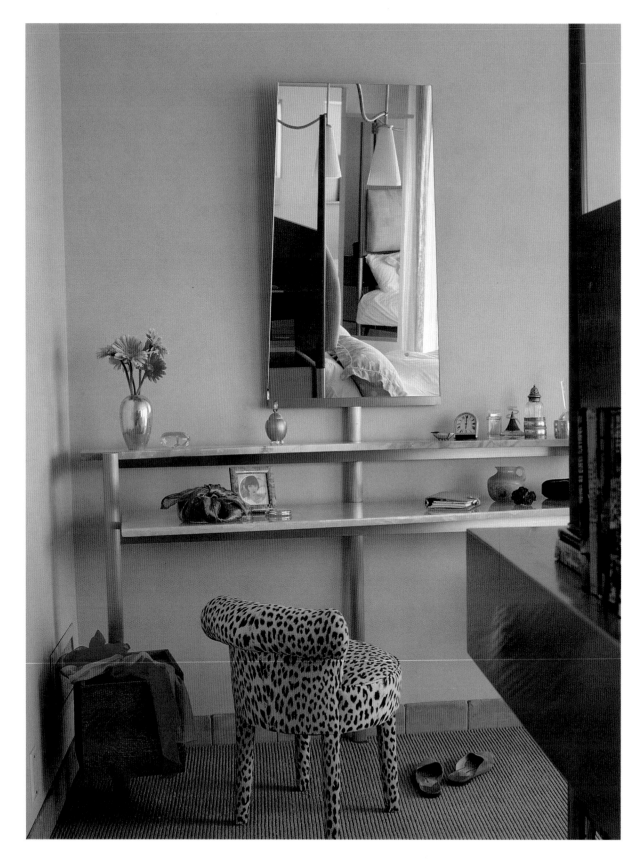

LEFT: The dressing table is made of copper tubing, white onyx, and yellow sienna marble. The framed photograph is one of several that Delany owns of the legendary silent-film star Louise Brooks— a woman who was, in her own day, modern, independent, and famously alluring.

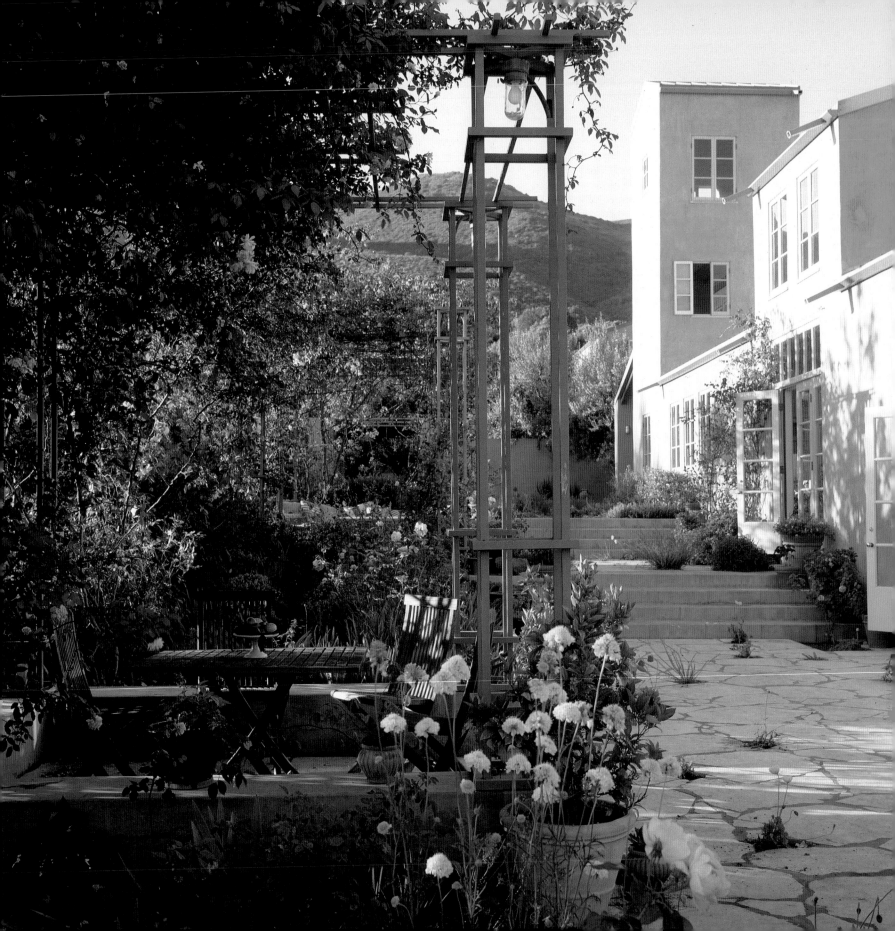

Ocean Villas

Not everyone subscribes to the less-is-more school of seaside living. For some people, a house—even a beach house—is not a home unless it possesses all the comforts thereof. And the more comforts, the better. These houses aren't necessarily large or expensive; some are weekend houses, while others are full-time residences. What they do have in common is a sense of elegance, of life lived as graciously as possible. Literature and film are full of fantasy houses on the water: Think of Tom and Daisy Buchanan's East Egg mansion in *The Great Gatsby;* of the Côte d'Azur terrace where Cary Grant romanced Grace Kelly in *To Catch a Thief;* or Manderley, the imposing, enigmatic house on the cliffs in Daphne du Maurier's *Rebecca.* Strangely enough, though, one of the most fantastic of all fictional ocean-view villas was drawn from the real thing. Xanadu, the vast, ornate palace in Orson Welles's film classic *Citizen Kane*, was based on La Cuesta Encantada (The Enchanted Hill), the one-hundred-fifteen-room extravaganza that newspaper magnate William Randolph Hearst had architect Julia Morgan build for him on his "ranch" at San Simeon, on California's Central Coast. But even if a sixty-five thousand-square-foot beach house—never mind the forty-six guest rooms contained in three cottages—is not your cup of tea, it's still possible to live by the sea in style.

OPPOSITE: The west side of Buzz Yudell and Tina Beebe's Malibu house opens onto a series of gardens.

FOLLOWING PAGES: At Donald and Alice Willfong's Montecito house, gardens flank a parterre that ends in a pavilion that frames the view of the ocean.

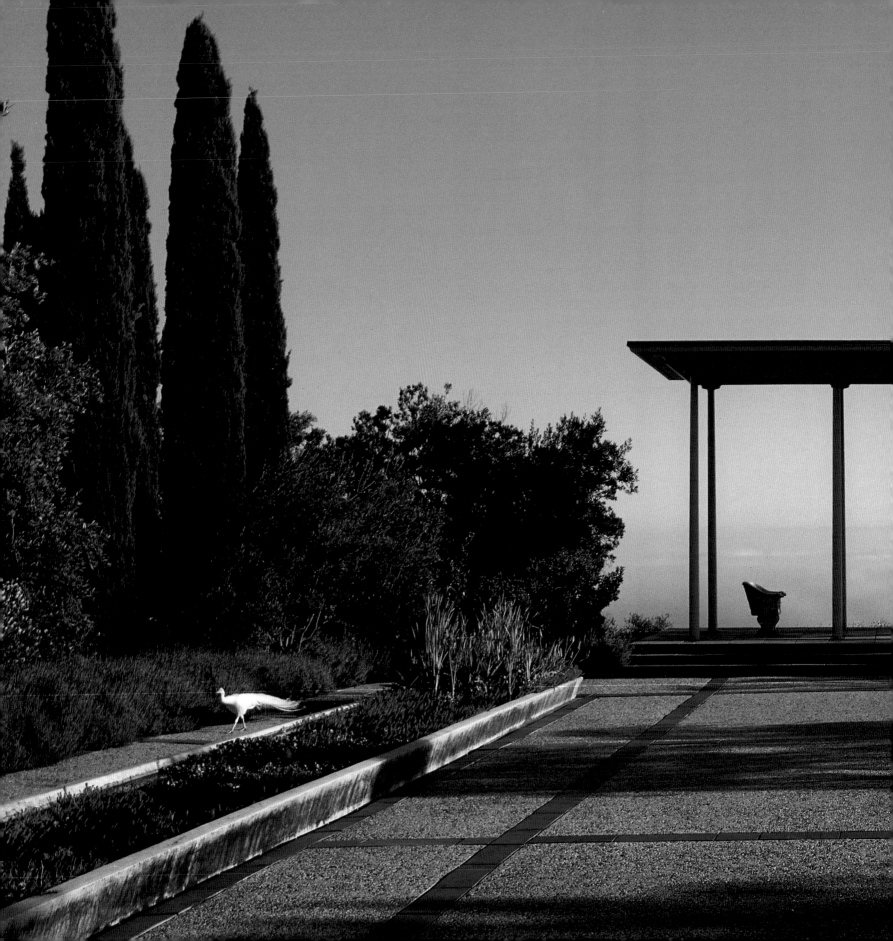

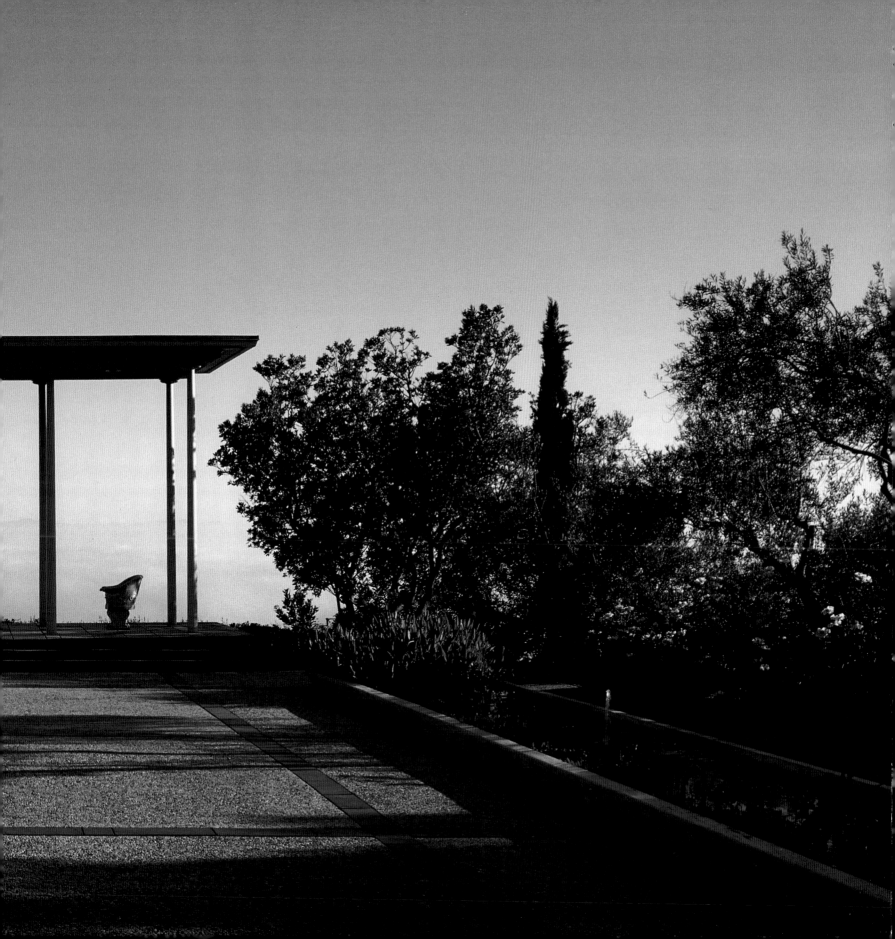

Willfong House, Montecito

ABOVE: The living room opens onto a classically inspired porch, which leads to a spacious parterre that culminates in a pavilion with an ocean view.

OPPOSITE: A marble torso of Hercules, which was purchased by Wright Ludington, stands atop a column in the middle of the square swimming pool.

In the mid-1950s, the noted art collector Wright S. Ludington commissioned Lutah Maria Riggs, a well-known Santa Barbara architect, to design a house for him in Montecito—specifically, up in the Santa Ynez Mountains, where the house could look out toward the Pacific Ocean and the Channel Islands. The house, which Ludington called the Villa Hesperides after the famed garden of Greek myths, was essentially a villa for one: its main house consisted of a fifty by twenty-five foot Palladian double-cube living room, dining room, gallery, bedroom, and dressing room lined with eighteenth-century French boiserie. The stuccoed adobe house, its guest house, and pool were set in gardens—of olive trees and lavender—designed by landscape architect Elizabeth Kellam de Forest. As dream houses go, this one was hard to beat.

But, as so often happens with dream houses, one dream is replaced by another. The villa did not fare well under subsequent owners, who subdivided its elegant gallery, added doors and skylights where they didn't belong, and otherwise took liberties with the house's austere elegance. Then, one day several years ago, Donald and Alice Willfong showed up. They had been out looking for a weekend cottage to buy, but no matter. "We love architectural houses," says Don, a stockbroker. "This one felt Pompeiian, with that austere front."

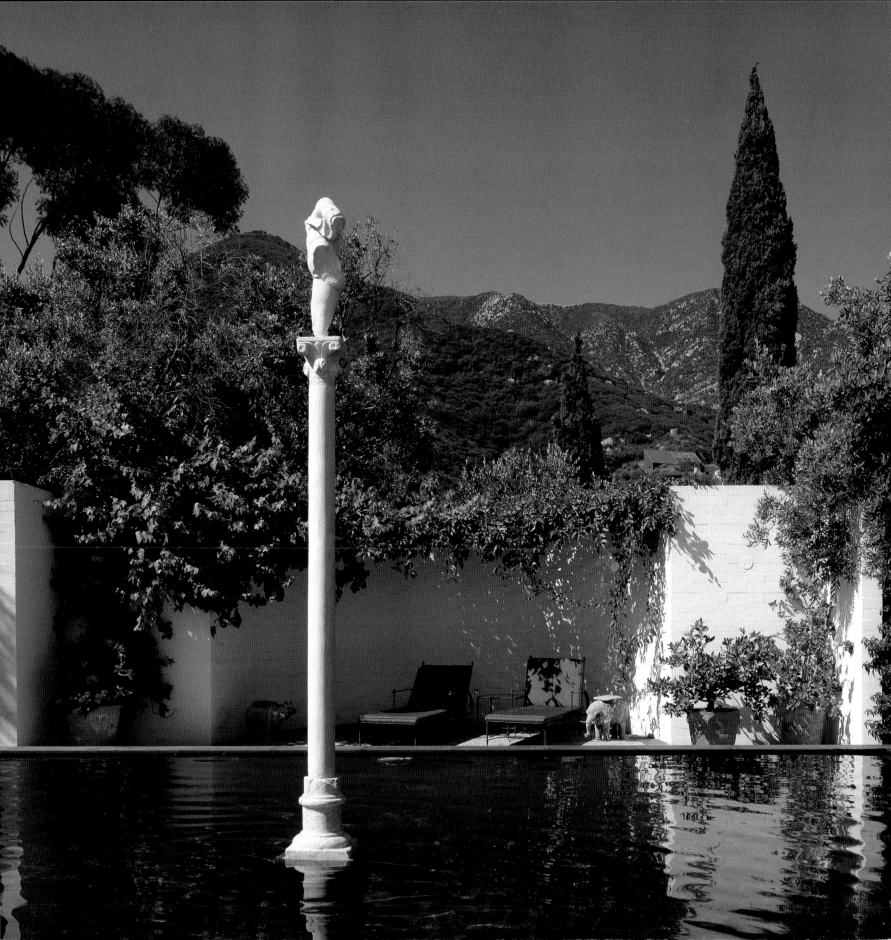

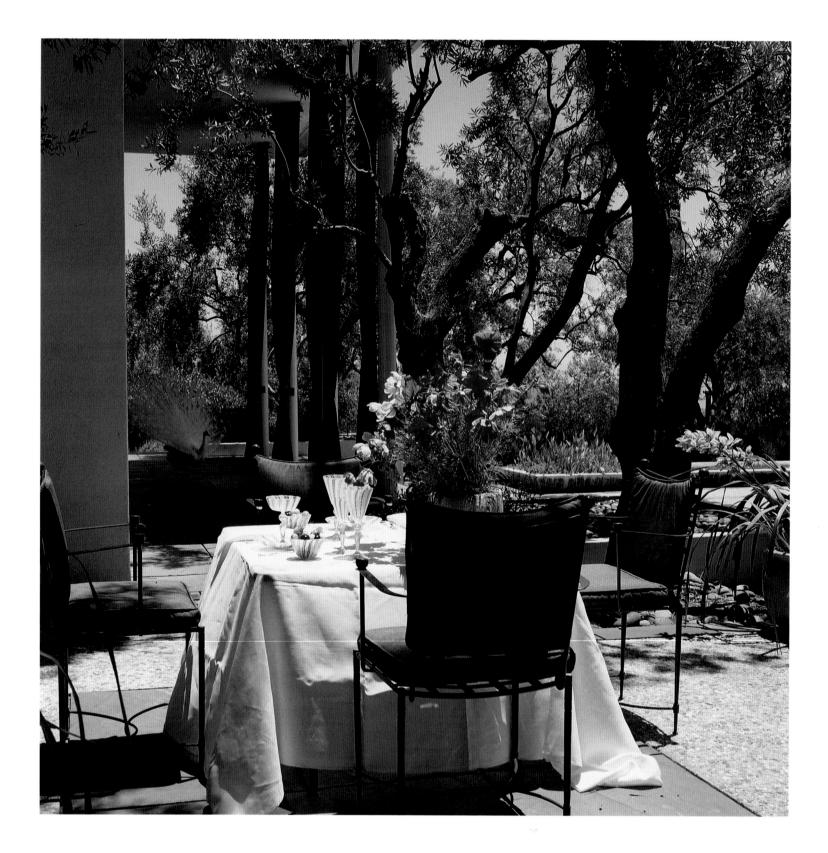

LEFT: "We've always loved Roman marbles, and this is a perfect setting for them," says Don Willfong. This heroic head is actually from the eighteenth century, but it represents a Roman warrior, and it does indeed look perfect perched atop a wall in the garden.

BELOW: A white peacock enjoys a moment in the sun atop a wall in the house's entrance courtyard. There are three peacocks, all named George, and one peahen, named Georgia.

OPPOSITE: The terrace just off the dining room is a perfect spot for an outdoor lunch, which is attended by one of the white peacocks that roam the property.

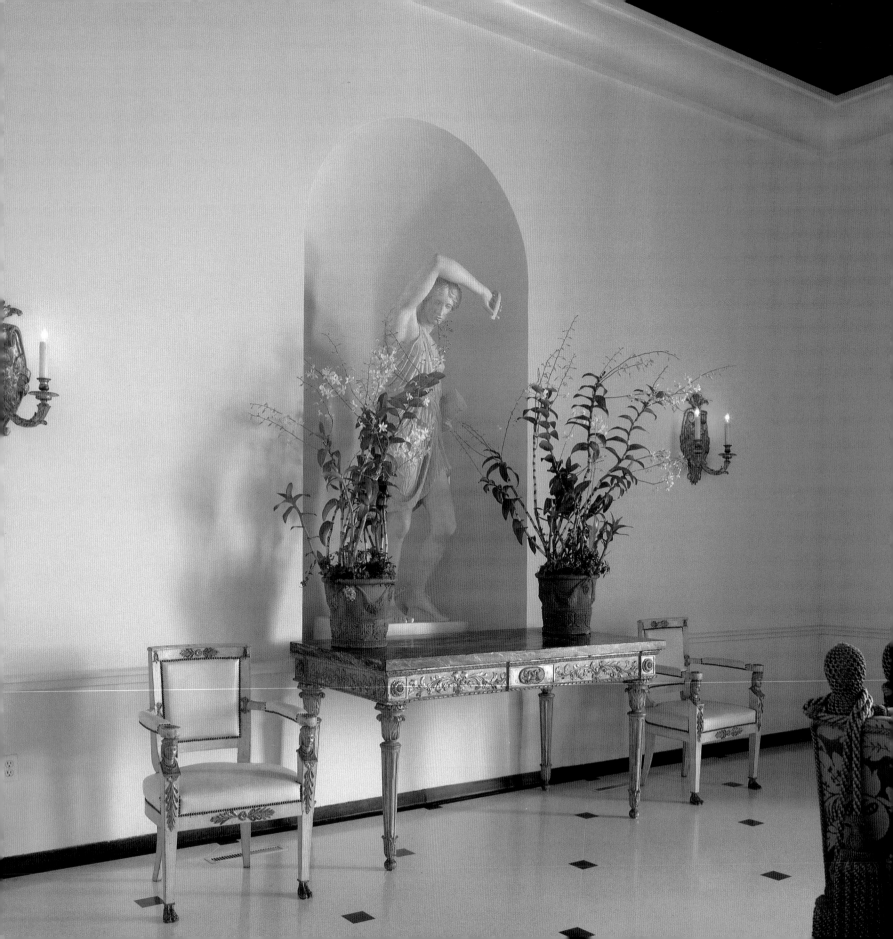

OPPOSITE: Niches in the end walls of the living room contain casts of Roman originals. The chairs and console are all Italian neoclassical, and the *Régence*-style gilt bronze sconces are from Quatrain in Los Angeles.

BELOW, RIGHT: Zeus, the Willfongs' standard poodle, sits in majestic repose in the front doorway, at the end of the long gallery. The armchairs and pilasters are all Italian; the eighteenth-century marble chair is Roman.

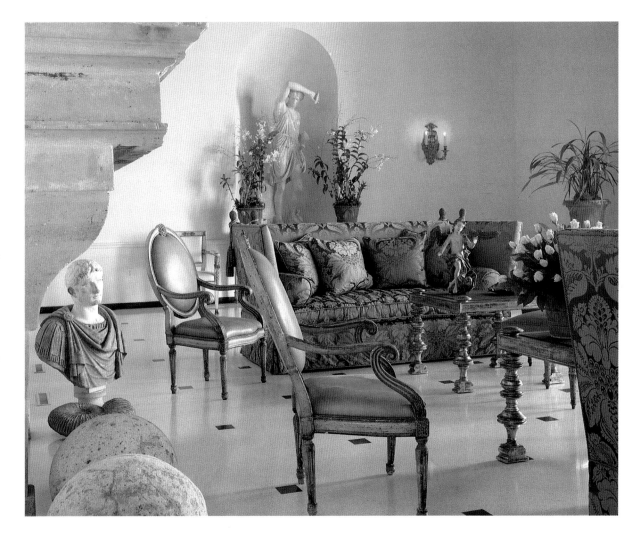

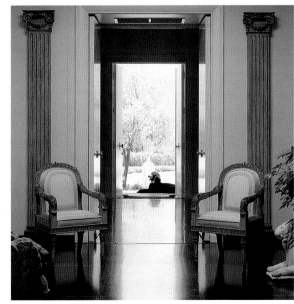

ABOVE: The living room's pale walls and terrazzo floors offset the subtle colors of the Italian neo-classical armchairs, which date from around 1780, and the Knole sofas and Pompeiian-style tables, which are from Quatrain.

RIGHT: In the master bedroom, a gilt bronze gueridon holds an arrangement of objects, among them a Roman marble head and two Egyptian figures.

OPPOSITE, TOP: The eighteenth-century French boiserie in the bedroom was refinished in a darker tone to make it "more Italian, and to reflect the colors of the painted furniture," says decorator Craig Wright. The bed is Italian neoclassical.

OPPOSITE, BOTTOM: Green silk velvet covers the Italian neoclassical chairs in the bedroom; on the gilt console are two blue and white Chinese export porcelain jars. The banquette and pillows are covered in a striped fabric from Scalamandre.

The Willfongs set about restoring the house and gardens with care and vision—and with Los Angeles decorator Craig Wright, with whom they are partners in Quatrain, an antiques and reproductions business. (Don is a silent partner, while Alice takes an active role.) The main rooms were put back to their original designs, and, except for the fact that Ludington's dressing room became the Willfongs' bedroom and his bedroom became the library, the house looked as good as new—and, under Wright's direction, better than ever.

"Obviously, the original spirit of the house was Italian," says Wright, who filled the house with painted Italian neoclassical furniture. "It relaxes the house a bit," he explains. "We tried to buy things that were in scale with the house, and fewer of them—to treat the house more minimally. And we didn't use a lot of color—what's there is non-specific." The gardens were returned to their former glory by Robert Fletcher, the Los Angeles landscape architect who banished the ivy and roses that had been planted after Ludington moved out, and who spent two years nursing the olive trees—which had been "poodled" into balls, cubes, and mushrooms—back into shape. "I did restore Elizabeth Kellam de Forest's original silver-green plant palette, which consisted of the olive trees, pineapple guava, and French lavender—and that's it," says Fletcher. And, although the house has recaptured its former grandeur, its idiosyncratic beauty makes it comfortable. As Alice Willfong explains, "We can recharge here. It's a very serene setting."

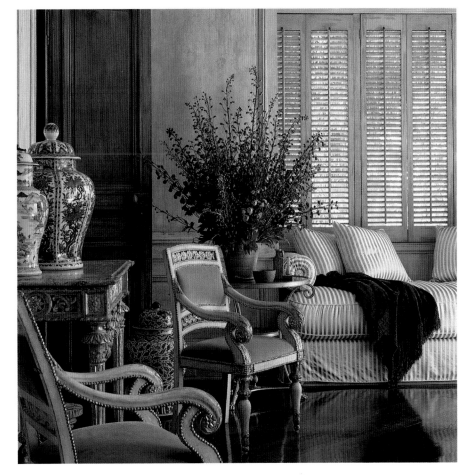

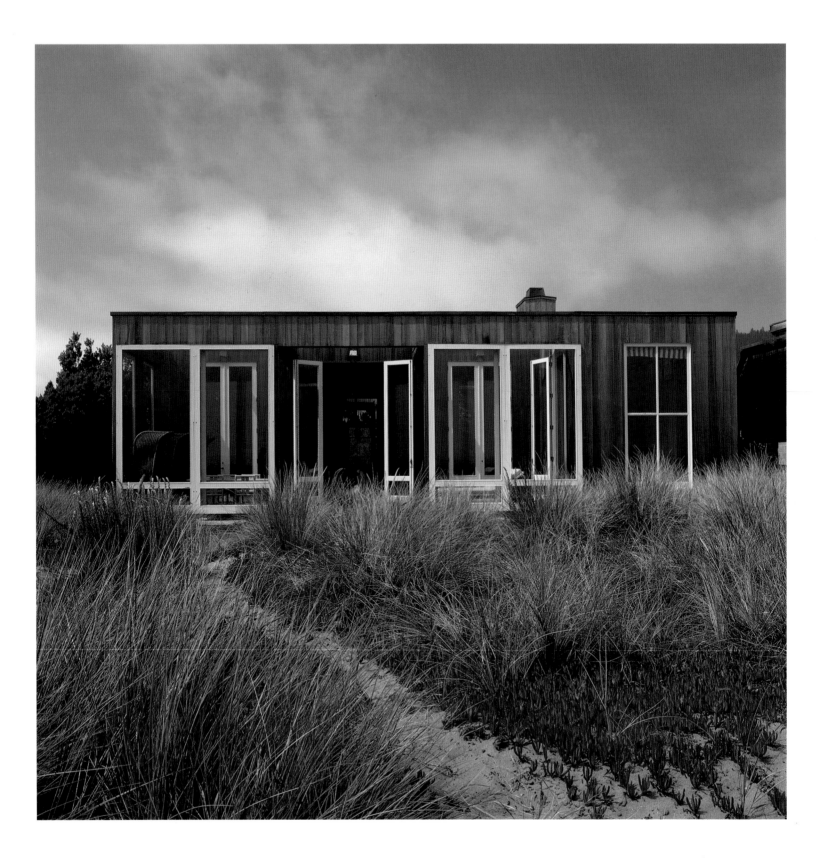

From the street, this house in the Stinson Beach community of Seadrift has an unassuming air, although its suavely proportioned windows hint seductively at what's beyond the facade. But once you step inside, you enter another world, where elegance and informality blend seamlessly, and where the architecture, for all its understatement, is no less striking than the furniture and objects that it contains. Architect Joseph Esherick of the San Francisco firm Esherick Dodge Homsey & Davis and San Francisco designer Andrew Delfino created this year-round week-end house for a couple who are themselves extremely knowledgeable about design; indeed, the collective sophistication of this group—who have known one another for many years—borders on the daunting.

The first thing Esherick considered was the issue of "making a comfortable envelope." He knew that the weather at Stinson Beach—particularly on the ocean side—can be unpredictable, and that the house needed what he calls "several stages of wind protection. You don't want to be stuck indoors all day." So Esherick worked from the beach side of the house inward, designing an open-roofed porch with sliding glass doors for sunbathing on a windy day. For days when even more shelter is needed, Esherick created a square courtyard at the front of the house that is known as the oculus, because of the round opening that is cut into its roof.

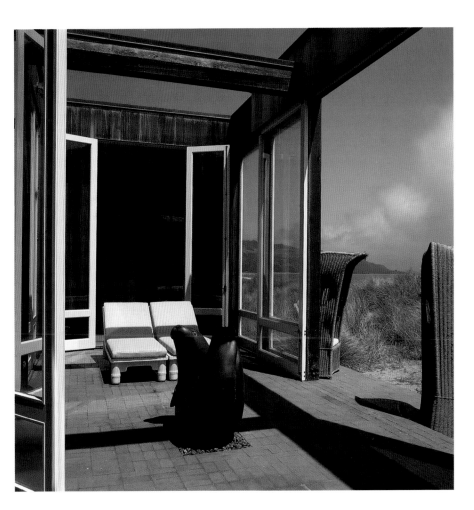

ABOVE: A cast bronze sea lion, by local artist Peter Allen, inhabits the beach-side glass-doored porch.

OPPOSITE: The beach facade of the cedar-sided house is light and open; the porch provides a sheltered spot for sunbathing.

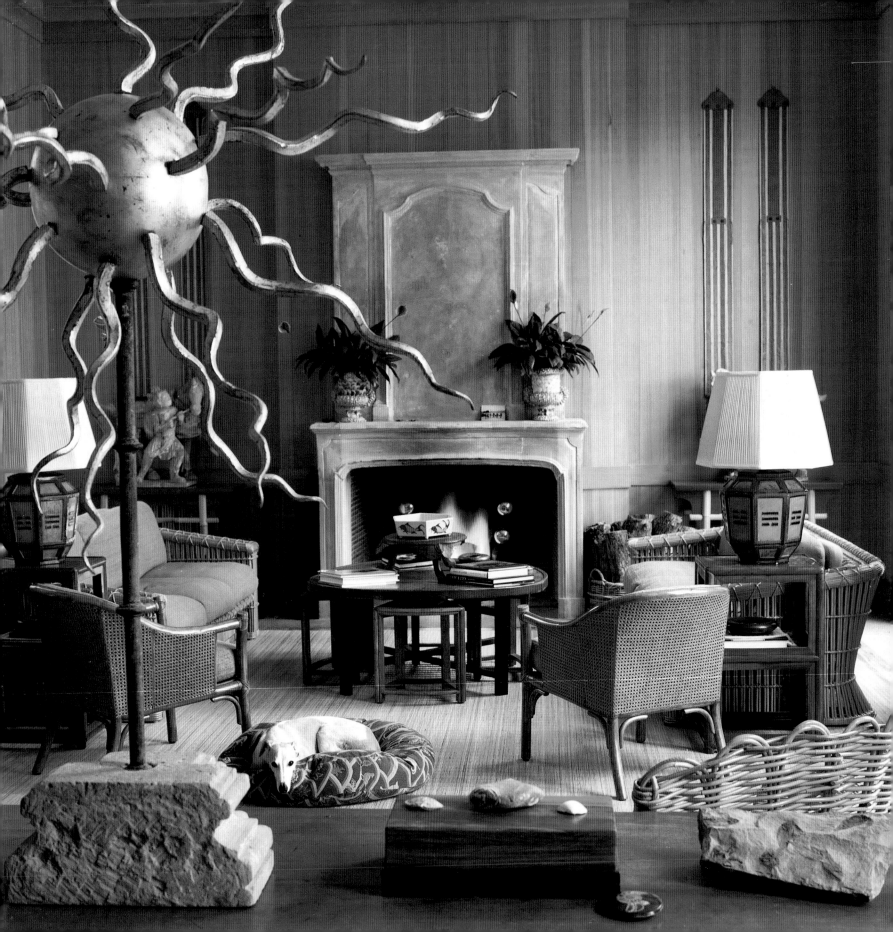

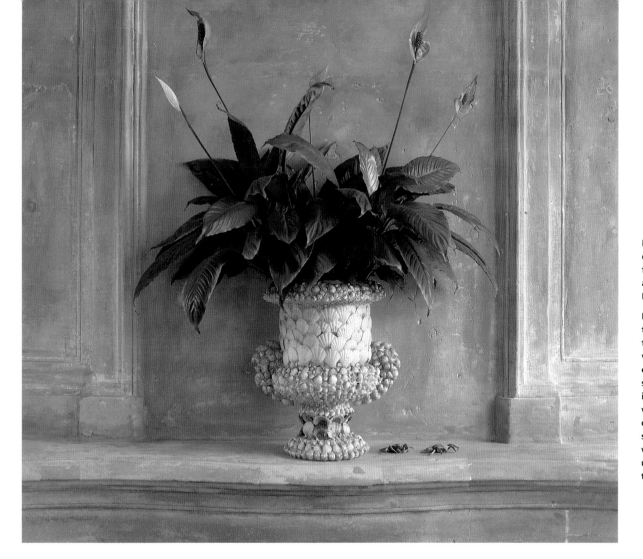

LEFT: A French cachepot covered with shells is framed by the moldings of a seventeenth-century French limestone fireplace.

BELOW: On either side of the fireplace, Chinese temple hangings adorn the walls. One of a pair of carved wood Chinese figures stands on a Chinese-influenced bamboo and wood table that was designed to conceal stereo speakers. The hemlock wall paneling was left unfinished in order to emphasize its grain.

OPPOSITE: A gilt lightning rod from an Italian villa establishes a striking foreground in this view of the living room. The windows facing the ocean are off to the right. The floor is covered with finely textured split-bamboo mats from Indonesia.

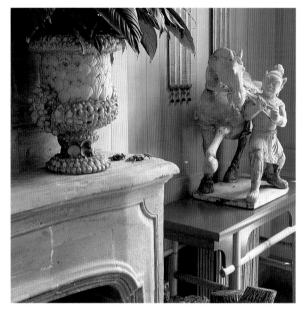

RIGHT: You enter the house through a gallery that doubles as a dining room. Graceful wicker chairs surround a table made from a single width of molave wood from the Philippines. The painted screen is French, and the antique chandelier is from a Venetian theater.

BELOW: A jade-colored Peking glass vase is the perfect compliment to the deep pink of Givenchy roses; the famed couturier, for whom the rose was named, sent the owners several dozen plants.

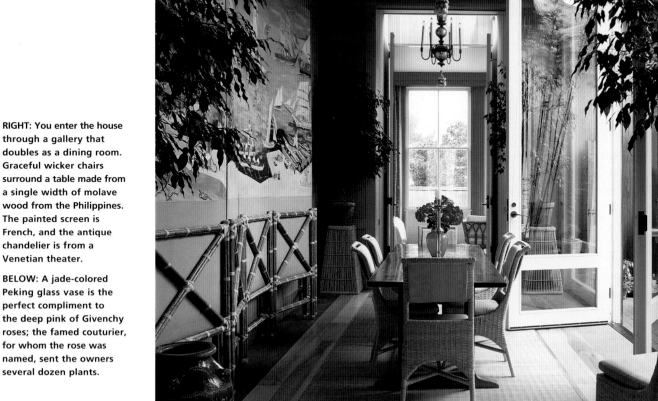

OPPOSITE: The front court-yard is known as the oculus for the round opening in its roof. The brick floor is laid in sand without mortar.

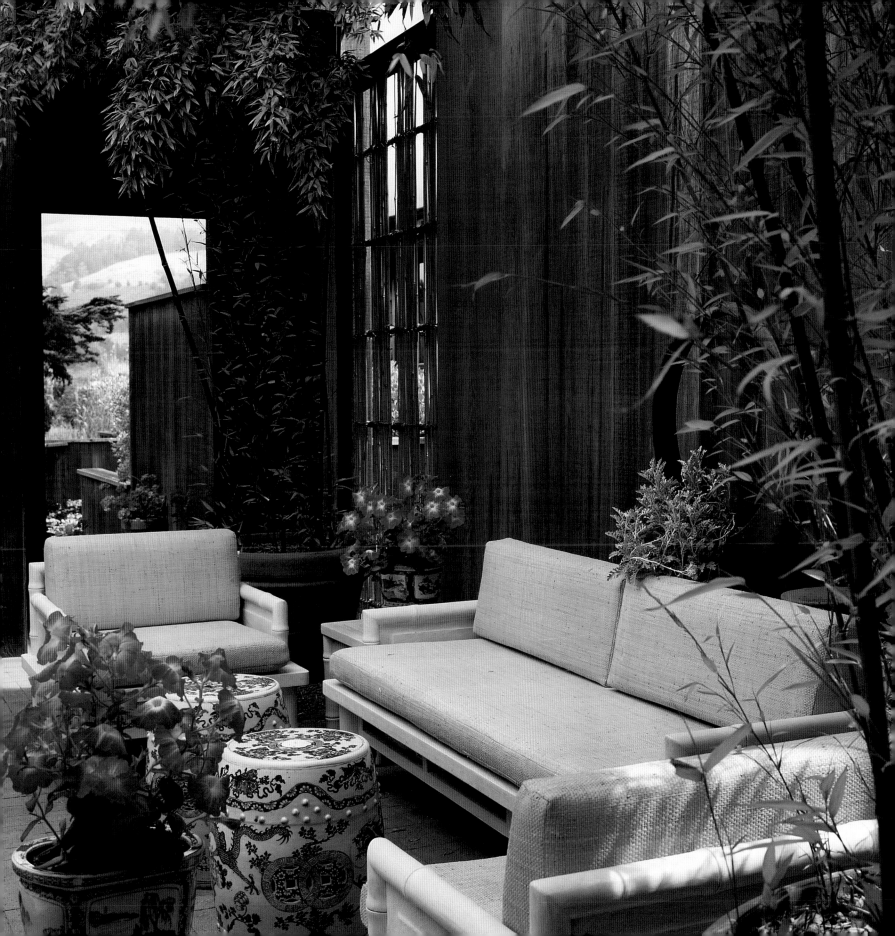

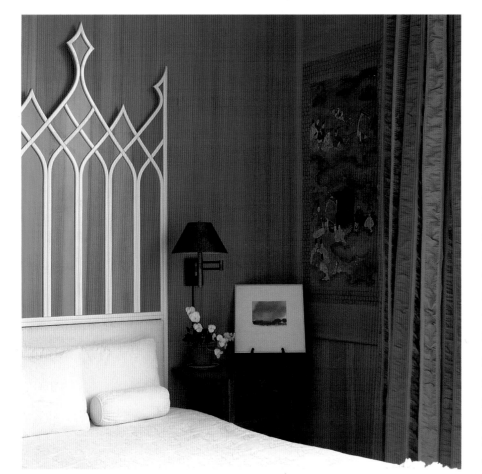

ABOVE: The headboard in the master bedroom was inspired by the English Gothic Revival style. Next to the bed are an antique Chinese table and a Japanese scroll. The seersucker curtain fabric is from Clarence House.

OPPOSITE: The fireplace in the master bedroom is also Gothic-inspired; above it hang a group of four antique Korean scholar paintings. The bamboo furniture is from McGuire.

This courtyard leads into a gallery space (used as a dining room) that links the living room and guest room on the beach side with the master bedroom on the street side. Throughout, the vertical proportions that Esherick finds so pleasing in historical architecture from ancient Greece to Carpenter Gothic—make the rooms both light and expansive. "One of the important things about this house is that it's bright, but the light is balanced," he says.

Both Esherick and Andrew Delfino agreed that natural materials were most appropriate for the interiors—hemlock for the walls and pecan for the floors. This combination of woods creates a warm canvas on which Delfino could go to work—although heaven forbid the work should ever show. "I loathe decorated houses," he emphasizes. "A decorated house is one that is full of superficial detail, where everything is balanced and everything matches. A designed house, on the other hand, should be a more sensitive combination of truly personal things that the owners love." And that is exactly what is here: treasures that the owners have brought back from Europe and Asia, and which are arranged with Delfino's keen eye. "If it's of supreme quality, it doesn't matter what place or period it's from," he says. "It's how it's orchestrated."

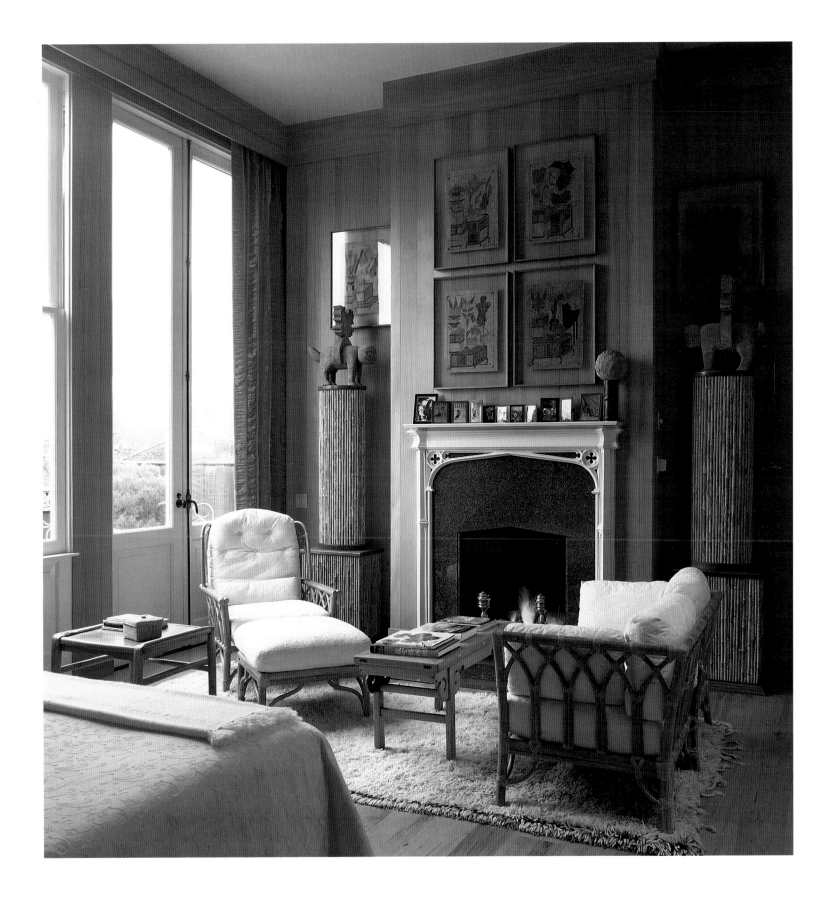

Tisch House, Montecito

ABOVE: Black-and-white-striped awnings shade the terrace off the master bedroom.

OPPOSITE: The poolhouse terrace, shaded by cascades of bougainvillea, provides a cool spot for lunch. The vintage wrought-iron table and chairs are from D. Miller in Los Angeles.

The lure of Montecito has never been disputed, but lately it seems that the lush enclave of Santa Barbara is drawing record numbers of Angelenos looking for a sylvan weekend retreat—or, in some cases, a full-time home. One member of the latter category is Patsy Tisch, who calls Montecito "one of the most beautiful places in the United States. I had been coming up here for years and staying at the San Ysidro Ranch," she says, referring to the luxuriously low-key resort for which Montecito is famous. But not long ago, Tisch decided to leave L.A. in favor of someplace she felt was better suited to raising her two children. She found a spacious Spanish Colonial Revival-style house of fairly recent vintage, which she proceeded to fine-tune (with the help of Los Angeles architect Don Umemoto) by gutting the kitchen, replacing the fireplaces, adding a new master bathroom, and installing hardwood floors throughout. "Basically, I redid all the details," she says. Tisch also installed a pergola over the "too bare and open" terrace off the living room, in order to create a shaded outdoor dining area.

Tisch is a veteran of several major house renovations, and she's a firm believer in working with, rather than against, the existing architectural vocabulary. Her new house is no exception. "I love having a Mediterranean-style house," she explains. "That's the architecture of Montecito; it just goes well with the environment."

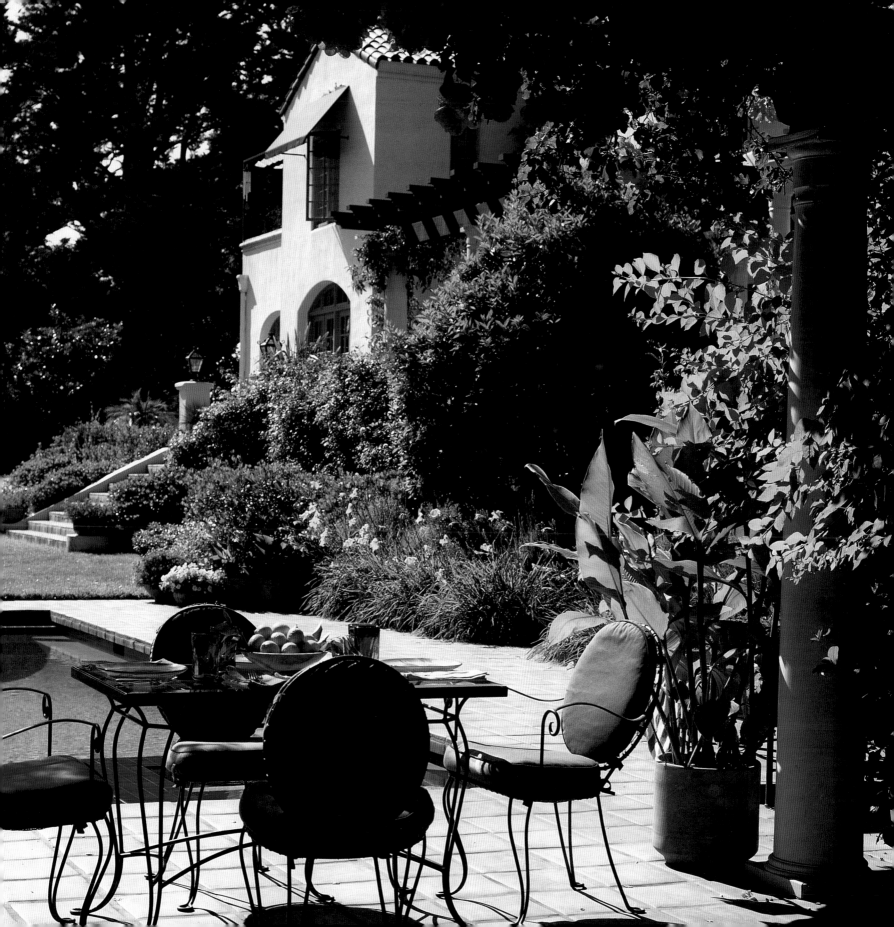

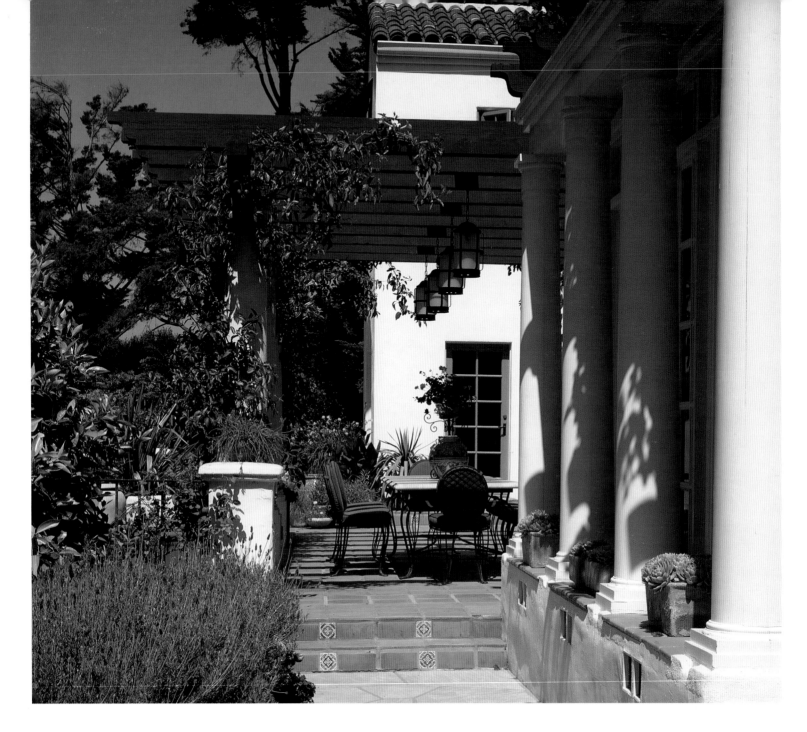

ABOVE: Tisch added a wide
pergola to the terrace
off the living room. When it
is overgrown with vines,
it will provide a shady out-
door dining room. The
exterior of the breakfast
room is visible at right.

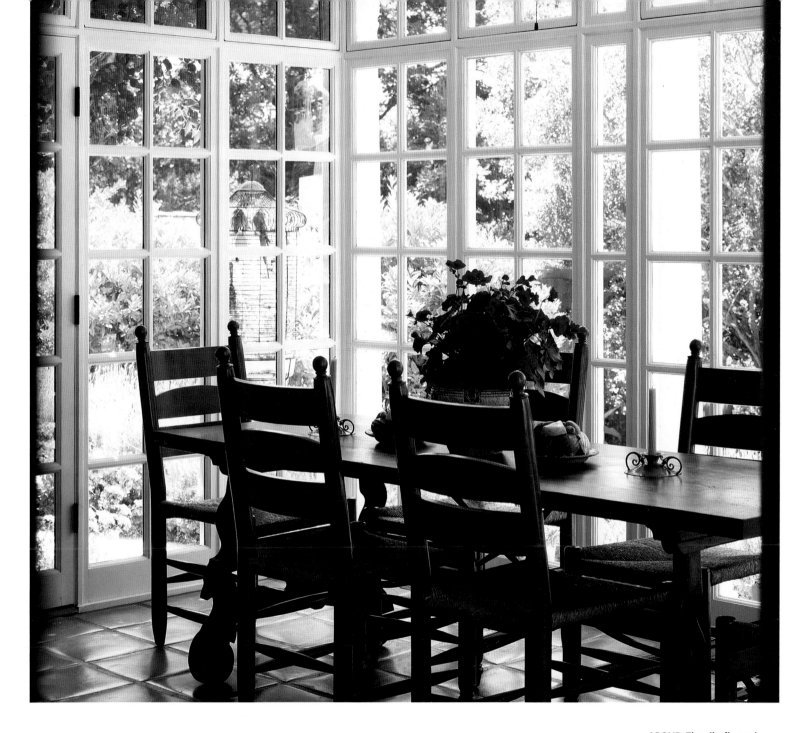

ABOVE: The tile-floored breakfast room offers views of the garden and of the family's two cockatiels. In contrast to the Spanish Colonial table, the slightly overscaled red chairs were designed by Roy McMakin.

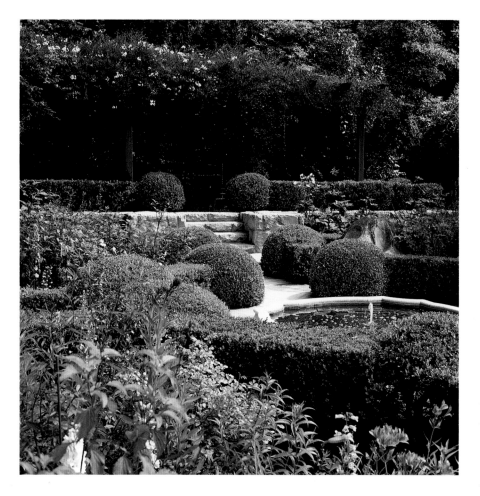

ABOVE: The garden room opens onto a small formal garden, complete with a splashing fountain filled with water lilies.

RIGHT: In the garden room, Tisch designed brackets to hold her collection of Grueby and Teco art pottery.

Therefore, Tisch set about furnishing the house with Spanish Colonial antiques, a smattering of classic modernist pieces, and some of her own designs, interpretations of antique Spanish and French furniture, on which she collaborated with Umemoto.

Tisch further emphasized the Old World feeling of the house by using luxurious fabrics, such as silks and velvets, in deep, jewel-like colors that harmonized with the dark woods of the furnishings. "Santa Barbara is so colorful and sunny outside; I wanted the house to feel cooler and darker on the inside," she explains. What keeps the interiors from looking too "period" is Tisch's inspired use of classic modern furniture designs by twentieth-century masters such as Josef Hoffmann and Marcel Breuer, in places where you'd least expect to see them. Tisch, who studied art in college, nurtured her appreciation of modern design during the five years that she worked for Knoll, the legendary furniture manufacturer. "That's really where my heart is," she adds.

Would she consider moving to a modern house? Yes, she would, if the right one came along. In the meantime, Tisch surrounds herself with her own interpretation of the feeling of old Santa Barbara— a mixture of opulence and austerity that is typically Californian—while at the same time striking some unexpected notes that, with their younger and hipper pitch, ring in the new.

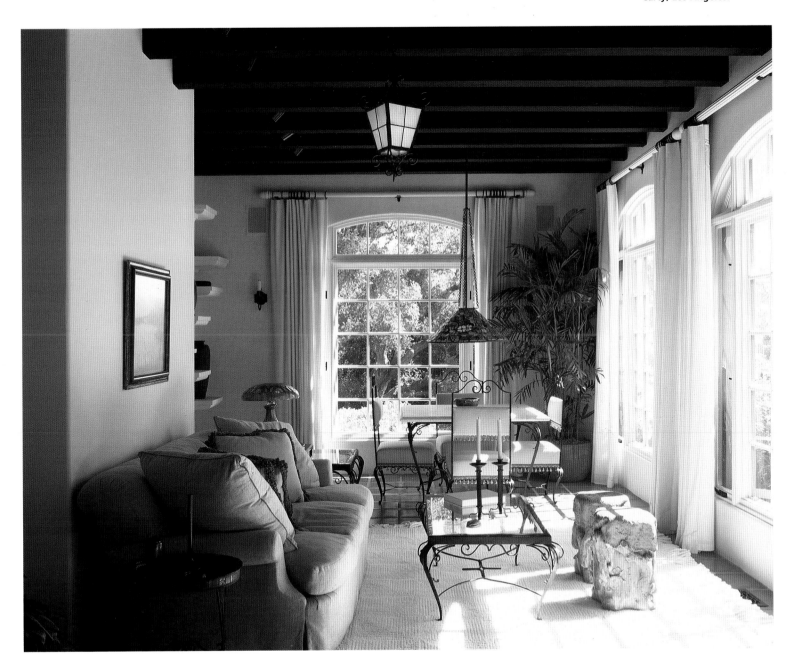

BELOW: Tisch designed the garden room's graceful wrought-iron furniture. The antique French garden stools are from Christianne Carty, Los Angeles.

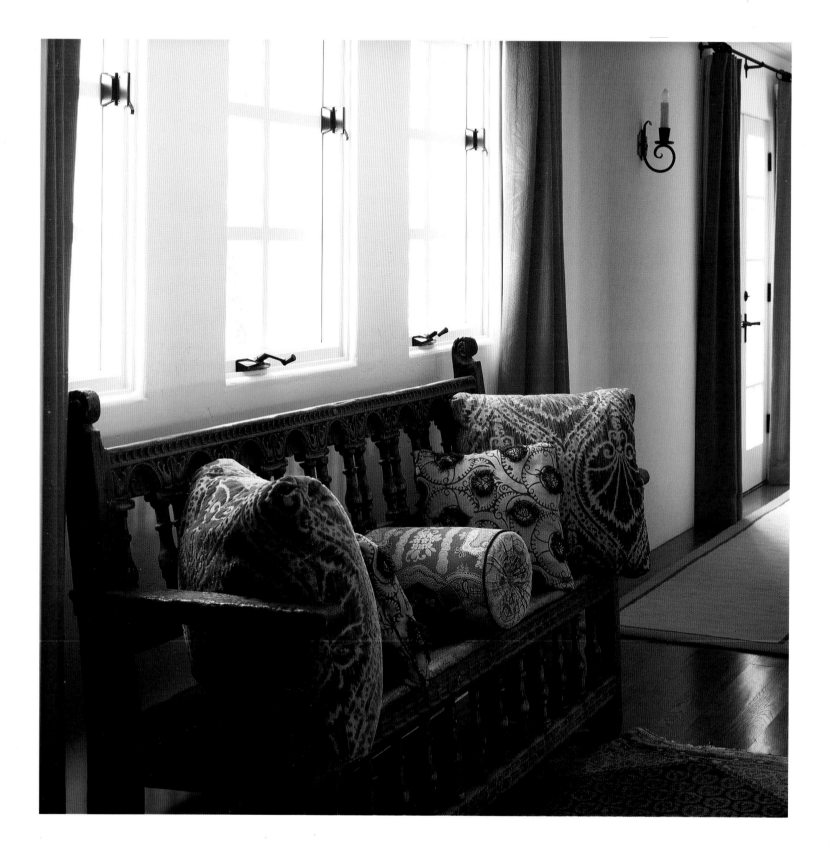

OPPOSITE: In the upstairs hallway, an eighteenth-century Peruvian bench from Michael Haskell in Montecito is piled with pillows in a variety of Clarence House document-inspired fabrics that harmonize with the spirit of the furniture.

ABOVE, LEFT AND RIGHT: In the powder room, the basin, counter, and back-splash are covered in gold glass mosaic tile. In the foyer, an antique Bolivian silver mirror adorned with various fertility symbols hangs above an eighteenth-century Peruvian table.

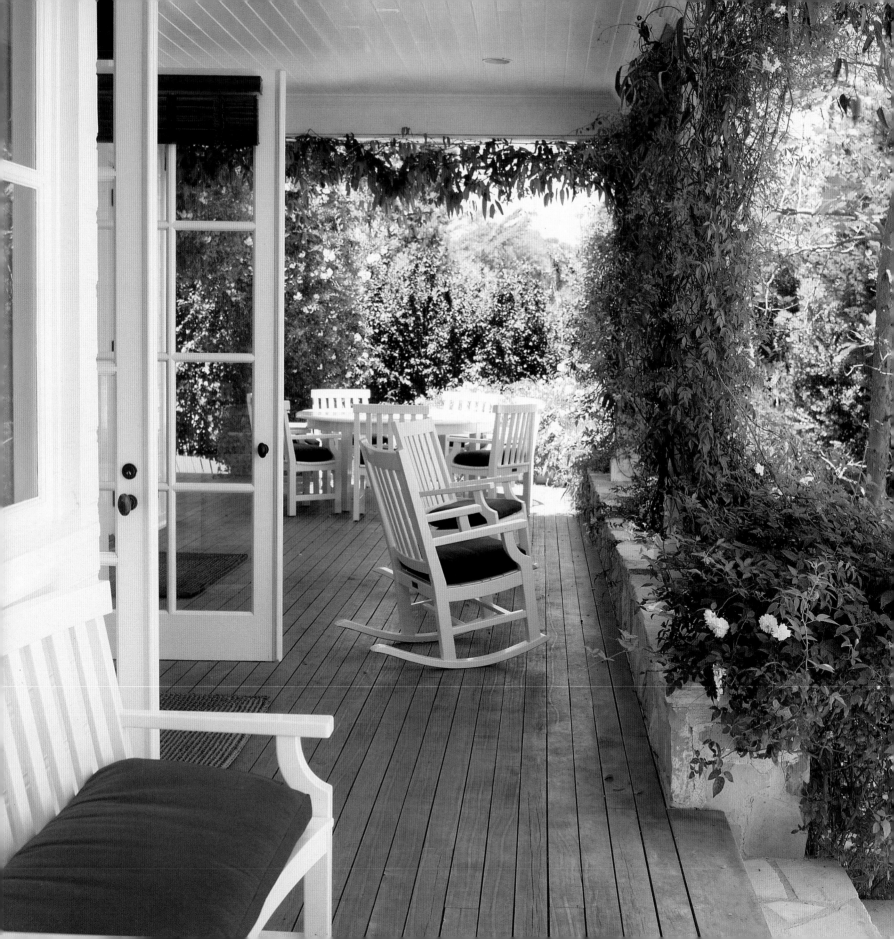

Sandy Gallin manages some of the biggest careers in Hollywood, and he co-owns Sandollar, a film and television production company, with singer Dolly Parton. But when Gallin goes home after a long day at work, he heads not to Beverly Hills or Bel-Air but to Malibu. Gallin bought a spectacular piece of land high above the Pacific, overlooking Paradise Cove, one of the most beautiful beaches in Southern California. There was a small house on the property when Gallin bought it, but he had other plans. Gallin loves the seaside towns on Long Island's South Shore, which are collectively known as the Hamptons, and their houses, many of which have wide, green lawns that roll gently down to the water's edge. And he was particularly taken with the New England–style house in East Hampton that is owned by his friends Calvin and Kelly Klein. So Gallin set about making his vision a reality. "Sandy is like a designer—he can picture a house in his mind," says Bill Lane, the interior designer who has worked with Gallin on about twenty projects over the last two decades. "And he is involved in every design decision, from the foundation up." Los Angeles architect Peter Choate of Choate Associates designed a spacious "cottage" that was built by Albino Martinez, a contractor who has worked with Gallin for years, and whom Lane calls "an artisan." The lush landscape surrounding the house was designed by Mark Rios and Dale Wall of Rios Associates Architects in Los Angeles.

OPPOSITE: Potato vines cover the deep back porch, where Gallin often holds lunch and dinner parties.

ABOVE: The back of the white, wood-sided house overlooks a lap pool and a rolling lawn that leads down to the cliffs above Paradise Cove.

Bill Lane created the house's elegantly casual interiors. A double-height entrance hall is lined with what he calls "low-key" antique furniture on the ground floor; on the second floor is a gallery lined with books. "Sandy loves books," reports Lane, "and there are very cozy reading corners there." The general color scheme is based on a simple contrast of dark and light. The mahogany floors are stained a teak color, and the dark woods typical of antique English tables accent the sofas and chairs, which are all covered in white antique Marseilles cloth, and which were made by Shabby Chic, the Santa Monica–based retailer who made the slightly oversized slipcover a decorating phenomenon. The house feels—just as its owner wished—very East Coast, down to its dark-green shutters, deep back porch, rolling lawn, and white roses framing the front door. Only its West Coast view—which, on a good day, encompasses both downtown Los Angeles to the east and Portuguese Bend far to the south—says otherwise.

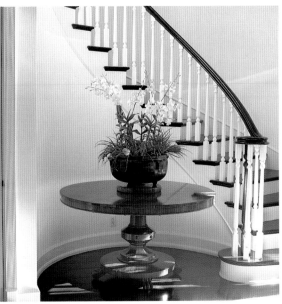

ABOVE: The second level of the double-height entrance hall is a book-lined gallery. The bookcases also hold pottery, art glass, and vintage movie posters.

LEFT: The entrance hall's white walls and dark-stained wood floors offer a neutral backdrop for an antique English table.

OPPOSITE: A flagstone motor court leads to the entrance of the house, which is framed by white roses.

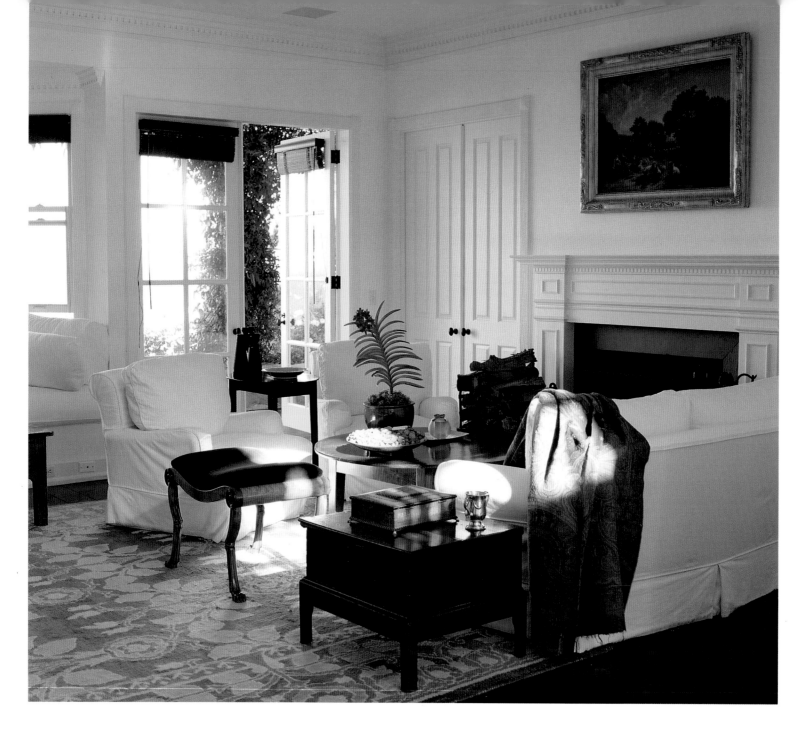

ABOVE: French doors and
bay windows bring
abundant sunlight into the
interiors of the house.
In the living room, chairs
and sofas from Shabby Chic
are slipcovered in white,
and the carpet is based on a
design by William Morris.

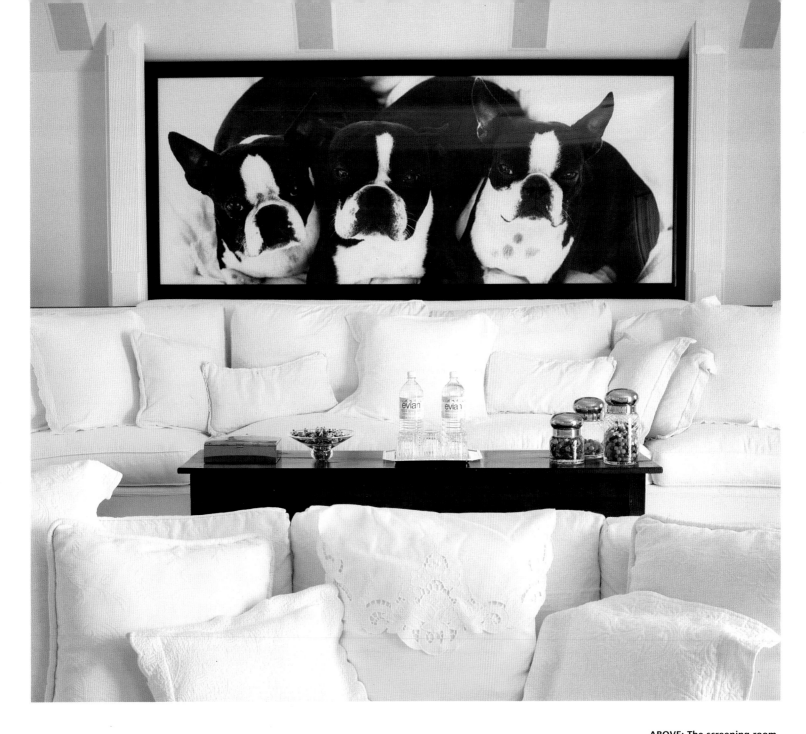

ABOVE: The screening room is housed in a separate building, along with a gym and a guest room. Deep sofas are covered in white; the black-and-white photograph is a portrait of Gallin's Boston terriers taken by Herb Ritts.

RIGHT: The antique Japanese desk in the master bedroom is, says Bill Lane, "the first piece we bought for the house." The French doors at right open onto a balcony that runs the length of the second floor.

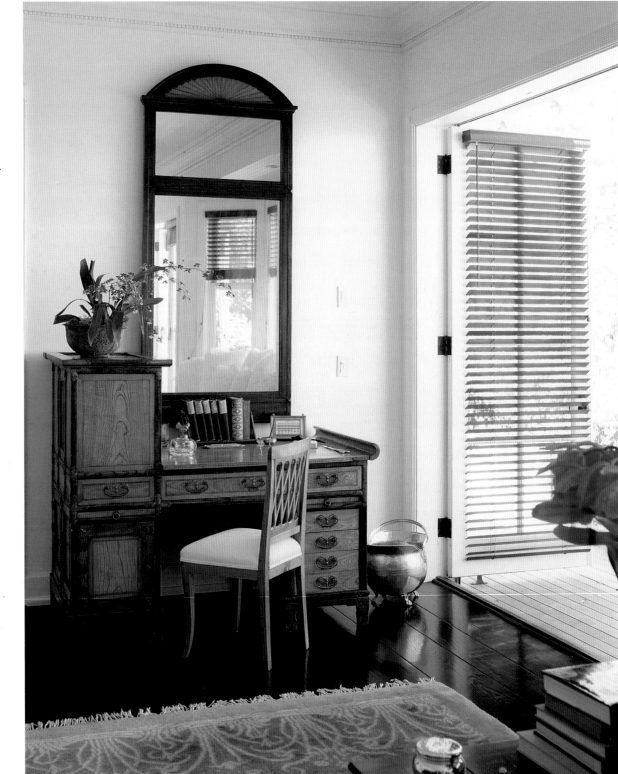

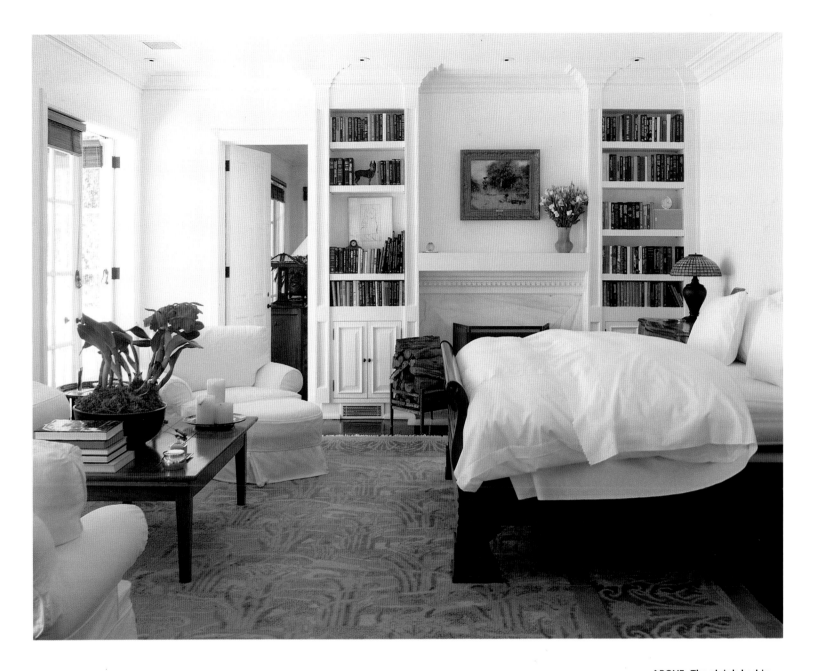

ABOVE: The sleigh bed in the master bedroom has built-up legs to provide a better view of the ocean. A Tiffany lamp is on the bedside table; the antique coffee table in the seating area is English; and the carpet, like the one in the living room, is based on a William Morris design.

Yudell-Beebe House, Malibu

ABOVE: The outdoor "street" ends at the swimming pool, where a tented pavilion offers bathers a shady place to sit.

OPPOSITE: The pool terrace offers a view of the house; the small front lawn is ringed with iceberg roses.

It's hard to believe that Buzz Yudell and Tina Beebe's idyllic home in the Malibu hills was once just an empty strip of land that no one seemed to want, even though it backs up to federally protected parkland to the north and looks toward the ocean to the south. Required clearances—for a streambed on the west side and a fire lane on the east side—effectively made the buildable lot thirty-two feet wide by six hundred feet long. But while others threw up their hands, Yudell, a partner in the Santa Monica architectural and planning firm Moore Ruble Yudell, and Beebe, a color consultant who often collaborates with her husband's firm on building projects, saw possibilities. He wisely decided not to fight the site, but instead made the most of it by designing a house that he calls an "extrusion," a long building with two "streets" that follow the site's north-south axis. The inside street, or gallery, steps down from the entry at the north end of the house to the kitchen and again to the living room, the southernmost room in the house. (The master bedroom, Yudell's studio, Beebe's study, and a library are upstairs.) French doors along the gallery open onto the outside street, which is connected to its own set of rooms—a series of open-air dining pavilions—and which itself steps down to the swimming pool. Thus the line between indoors and outdoors is made wonderfully ambiguous—which was precisely the plan. "We wanted a rural, agrarian feeling for this house," explains Beebe.

RIGHT: The indoor "street," or gallery, with its beamed ceiling, connects the first-floor rooms and links the outdoors and indoors. Yudell made the parchment sconces that dot the gallery wall. Percy, Yudell and Beebe's golden retriever, and a neighbor's dog admire the view from the living room.

ABOVE: Beebe, a superb
cook, also uses the wooden
kitchen table for arranging
the fruits of her gardens
and orchards.

LEFT AND ABOVE: Back-
to-back fireplaces separate
the living room from
the spacious kitchen and
informal dining area.
Flowers and artwork adorn
the mantels in the two
rooms (the kitchen mantel
is shown above). The living
room is furnished with what
Beebe calls "a peculiar mix"
of modern furniture, such
as the leather-covered Cab
chairs by Mario Bellini for
Atelier International, with
older family pieces.

RIGHT: The master bath-
room is a study in soothing
green slate floors and
plaster walls. Beebe mixed
the color for the plaster
herself, and she painted
the small wooden table in
the foreground.

The forms of the house are simple and strong, the product of diverse influences that range from the proportions of Palladian buildings and what Beebe calls "the gutsiness of old Tuscan farmhouses," to the architecture of Bay Area architect William Wurster and even the repetitive, modular architecture of the iconic modern house that Charles and Ray Eames built for themselves in Pacific Palisades. In its distillation of all these influences, Yudell notes that "the issue of style becomes peripheral." The terra cotta–tinted exterior is meant, according to Beebe, to recall the color of an old Tuscan clay pot. On the inside, Beebe mixed pigment into the plaster as it was being applied; these integrally colored walls never need painting. As befits someone whose work is all about color, Beebe is also in charge of the gardens. While "domesticated" plants like roses and sweet peas grow close to the house, more native plants take over toward the site's edges, and most plants are in the silver-gray to dark gray-green range. "I don't like bright lime-green things," she says. Yudell notes that as the gardens mature, "the relationship between the house and the outdoors becomes even richer." For Beebe, arriving home is "a real reward." But it's a gift that seems all the more precious because Yudell and Beebe created it themselves.

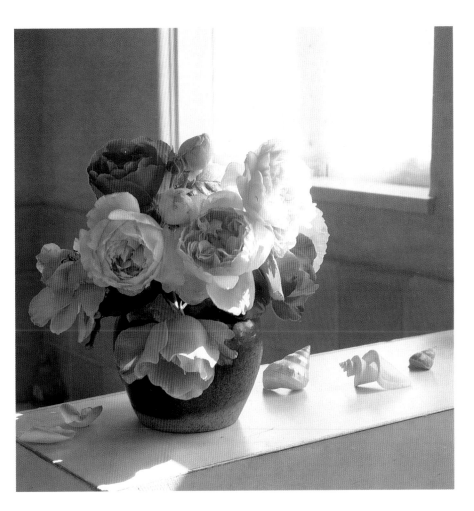

ABOVE: A vase of peonies from Beebe's garden sits on a ledge in the bathroom, which is flooded with east light each morning.

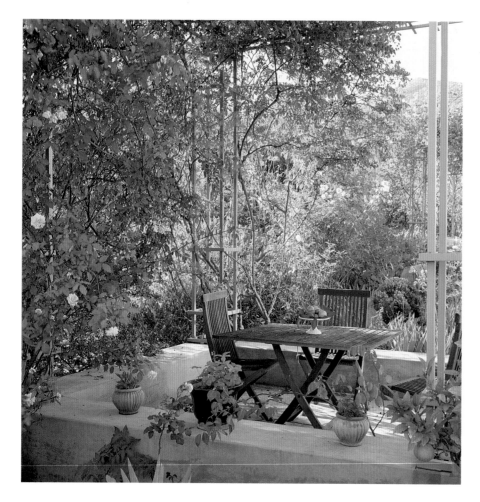

ABOVE: The farther you get from the house, the less "domesticated" and more native the plantings become, as seen here in the Mexican blue fan palms and salvia.

OPPOSITE: A pergola with terra cotta–colored columns provides a sunny spot for a pair of hammocks; beyond is an allée of guava trees.

ABOVE: A series of al fresco dining pavilions (this one is adorned with climbing roses) are located along the outdoor "street" on the west side of the house, providing quiet, fragrant spots for reading as well as for meals.

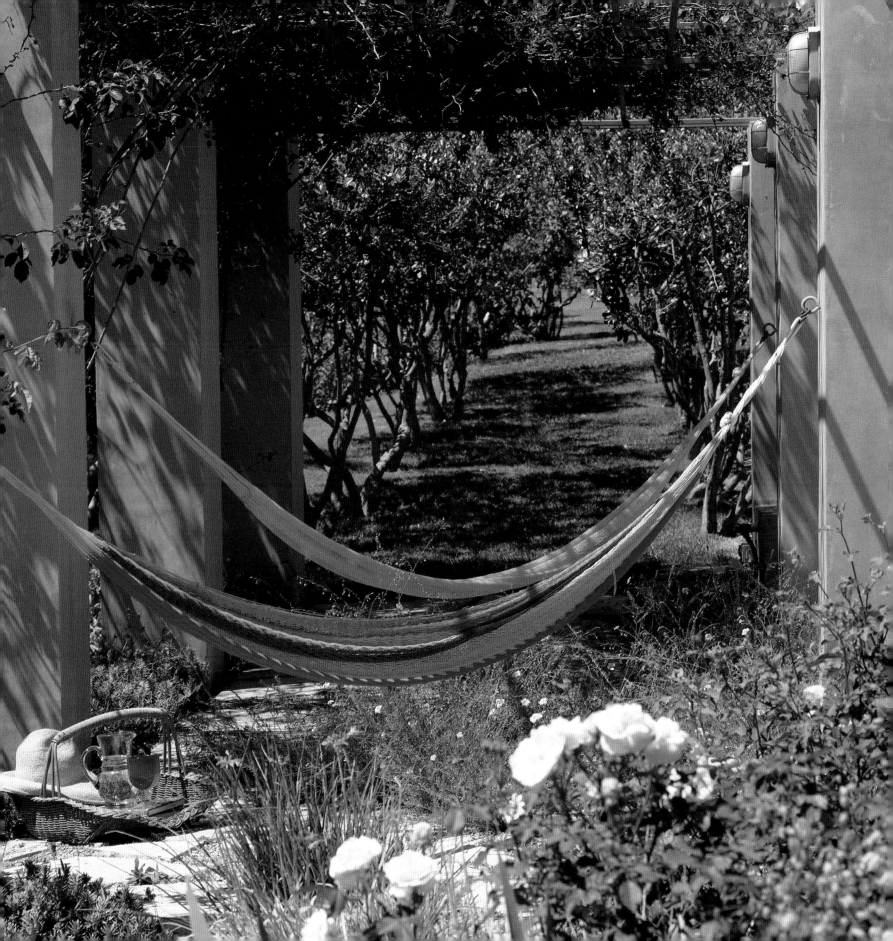

Coast Catalog

San Diego & Vicinity

Metropolis

1003 University Ave.
San Diego, CA 92103
(619) 220-0632

Traditional to hip, an eclectic mix of furniture, lighting, and accessories.

Forma

3741 Park Blvd.
San Diego, CA 92103
(619) 688-9788

Furniture by local artists, as well as ironwork— tables, hardware, finials— custom upholstery, and handblown glass.

Boomerang

3795 Park Blvd.
San Diego, CA 92103
(619) 295-1953

The real thing in modernist furniture, lighting, and accessories: Hard-to-find classics from the 1940s through the 1960s.

Simayspace

835 G Street
San Diego, CA 92101
(619) 544-6444

Cutting-edge fine and functional art by Southern California artists and architects, all well-priced.

Prototype Gallery

5727 La Jolla Blvd.
La Jolla, CA 92037
(619) 459-8490

Two brothers—one designs in wood, the other in metal—collaborate on simple, rational furniture. By appointment.

MPLA Associates

444 S. Cedros Ave.
Solana Beach, CA 92075
(619) 481-9209

Authentic reproduction modern furniture—Wright, Mackintosh, Rietveld, Le Corbusier—in a renovated rocket factory.

Orange County

Durenberger & Friends

31531 Camino Capistrano
San Juan Capistrano, CA 92675
(714) 240-5181

Eighteenth- and nineteenth-century antiques and decorative arts for the home and garden.

Leisure World Consignment Shop

23595 Moulton Pkwy.
Laguna Hills, CA 92653
(714) 770-7626

Quality crystal, china, and silver.

Areo

207 Ocean Ave.
Laguna Beach, CA 92651
(714) 376-0535

Small furniture and home accessories (every size candle imaginable) in a Japanese/Arts and Crafts vein.

Richard Yeakel Antiques

1099 S. Coast Highway
Laguna Beach, CA 92651
(714) 494-5526

A comprehensive array of twelfth- to eighteenth-century furniture and objects of art displayed in a shop reminiscent of those on London's Bond Street. By appointment.

Nicholson's Antiques

362 N. Coast Highway
Laguna Beach, CA 92651
(714) 494-4820

Fine English and Continental period furniture and accessories.

Warren Imports

1910 S. Coast Highway
Laguna Beach, CA 92651
(714) 494-6505

Chinese, Japanese, and Southeast Asian art. Stunning antique stone garden lanterns and Chinese tomb figures.

Roger's Gardens

2301 San Joaquin Hills Rd.
Corona del Mar, CA 92625
(714) 640-5800

The largest outdoor horticulture center in the country; of particular delight are the moss hanging baskets and the collectible Christmas ornaments.

Jefferies Ltd.

852 Production Pl.
Newport Beach, CA 92663
(714) 642-4154

Custom picture framer specializes in French matting and traditional frames; his large showroom also houses the wares of eight antiques dealers.

Tom Stansbury Antiques

466 Old Newport Blvd.
Newport Beach, CA 92663
(714) 642-1272

Seventeenth- through nineteenth-century English, American, and Continental furniture, paintings, and tabletop accessories in a lovely garden setting.

Newport Harbor Art Museum Consignment Shop

333 East 17th St.
Costa Mesa, CA 92627
(714) 645-6426

Antiques, china, crystal, and furniture up to 1944— about where the focus of the esteemed modern art museum (located a few miles away) begins.

Santa Monica

Ireland-Pays

2428 Main St.
Santa Monica, CA 90405
(310) 396-5035

Wonderful English style decorative accessories.

Santa Monica Antique Market

1607 Lincoln Blvd.
Santa Monica, CA 90404
(310) 314-4899

Dozens of vendors under one roof, with furniture and objects ranging from the funky to the fancy.

Hennessey & Ingalls Inc.

1254 Third St. Promenade
Santa Monica, CA 90401
(310) 458-9074

L.A.'s best-known architecture bookstore.

The Blue House

1402 Montana Ave.
Santa Monica, CA 90403
(310) 451-2243

Once carried only blue-and-white transferware, hence the name. Inventory now includes English and French antique furniture and decorative items.

Rizzoli Bookstore

332 Santa Monica Blvd.
Santa Monica, CA 90401
(310) 393-0101

An excellent selection of books on design, decorating, architecture, and gardens.

Malibu

Thee Foxes Trot

23733 West Malibu Rd.
Malibu, CA 90265
(310) 456-1776

A stylish mix of ethnic and contemporary home furnishings and gifts: African masks and twiggy Filipino tables to Bang & Olufsen stereos.

Topanga

Sassafras
275 N. Topanga Canyon Blvd.
Topanga, CA 90290
(310) 455-1933

A great source for perennials and English roses notable for their coloration. Owner Pamela Ingram designs gardens for the stars, as well as for lesser lights.

Ventura

The Calico Cat Bookshop
495 E. Main St.
Ventura, CA 93001
(805) 643-7849

Current and antiquarian books on design, gardening, and California history, all in a converted 1920s hotel.

Santa Barbara County

The Urban Hunter
944 Linden Ave.
Carpinteria, CA 93013
(805) 684-6309

Terrific architectural artifacts: Doors, period paneling, turn-of-the-century iron gates. Treasures from England and France, including unusual chandeliers and garden ornaments.

Summerland Antique Collective
2192 Ortega Hill Rd.
Summerland, CA 93067
(805) 565-3189

Celebrities are onto this place: Twenty dealers group their pieces together in total environments, such as a French-style living room.

Bill Cornfield Gallery
539 San Ysidro Rd.
Montecito, CA 93108
(805) 969-3337

A very high-end selection of English, Continental, and Asian antiques.

Michael Haskell
539 San Ysidro Rd.
Montecito, CA 93108
(805) 565-1121

Spanish Colonial and Latin American art and furniture of the seventeenth, eighteenth, and nineteenth centuries, pulled together with a discerning eye.

Pierre LaFond
516 San Ysidro Rd.
Montecito, CA 93108
(805) 565-1502

A nice assortment of old wood desks, armoires, and hutches from Turkey. Cassis pottery, elegant linens, and kitchen accessories.

William Laman
1496 E. Valley Rd.
Montecito, CA 93108
(805) 969-2840

Lead planters, pottery, French antiques and fabrics, all culled with the helping hand of Chicago interior designer Bruce Gregga.

Turk Hessellund
1255 Coast Village Rd.
Montecito, CA 93108
(805) 969-5871

Extraordinarily well-tended plants from a true plantsman. Old-fashioned, horticulturally based.

Santa Barbara Style
137 E. de la Guerra St.
Santa Barbara, CA 93101
(805) 569-1841

Owner Karen Pope's formula for a great California look is English, French, and Italian antiques mixed with bamboo, sisal, and rattan.

Earthling Bookshop
1137 State St.
Santa Barbara, CA 93101
(805) 965-0926

Books on gardens and design in a cozy atmosphere—the fireplace is especially inviting.

V.L.T. Gardner Books
625 E. Victoria St.
Santa Barbara, CA 93101
(805) 966-0246

The largest collection of garden books on the West Coast encompasses landscape architecture, botany, and horticulture. By appointment.

Cambria

Maison de Marie
768 Main St.
Cambria, CA 93428
(805) 927-7234

For Francophiles: French bed and table linens and decorative accessories; herb plants, topiary, and antique garden furniture.

Valhalla
766 Main St.
Cambria, CA 93428
(805) 927-7376

The architect owner carries finds from his and others' travels; among the most intriguing are Indonesian furniture and statuary.

Home Arts
727 Main St.
Cambria, CA 93428
(805) 927-2781

Furniture from reclaimed shutters, windows, and doors, as well as Shaker-style pieces and a range of accessories. Stylish tableware by young ceramicists Luna Garcia and Kathy Erteman.

Heart's Ease
4101 Burton Dr.
Cambria, CA 93428
(805) 927-5224

A charming Victorian house filled with botanical and herbal products and surrounded by native California gardens, large herb gardens, and a nursery.

What Iz Art?
4044 Burton Dr.
Cambria, CA 93428
(805) 927-0126

Colorful gift shop and gallery featuring whimsical things; among them, a T-shirt that reads, "Good Art Won't Match Your Sofa."

Big Sur

The Phoenix
Highway 1
Big Sur, CA 93920
(408) 667-2347

Antiques, textiles, ceramics, windchimes, and wrought-iron garden gates hold their own with the spectacular view.

Carmel

Trappings
West Junipero
between 5th & 6th
Carmel, CA 93921
(408) 626-4500

One-of-a-kind pieces set against a warm, romantic backdrop. Exclusive lines of hand-painted furniture and luxurious bedding.

Places in the Sun
Dolores
between Ocean & 7th
Carmel, CA 93921
(408) 626-0113

French and Spanish antiques, Portuguese ceramics and cookware. Wonderful old baskets.

Circa Antiques of the Future
7th & Mission
Carmel, CA 93921
(408) 624-4780

New furniture made in the manner of the best antiques: Think wooden pegs.

Axelsson Metalsmith-Viking Forge
The Barnyard
Highway 1
Carmel, CA 93923
(408) 624-3909

Chris Axelsson masterfully forges bronze, copper, and steel into tables, lamps, chandeliers, fountains, and gates that are at once organic and architectural.

Santa Cruz County

Wisteria Antiques & Design
5870 Soquel Dr.
Soquel, CA 95073
(408) 462-2900

California country with a French twist in a rambling, bucolic setting: Antiques, vintage fabrics, accessories.

Giltwood Studios
1531 Pacific Ave. on Plaza Ln.
Santa Cruz, CA 95060
(408) 423-1298

Decorative antiques and antique prints, including beach scenes of the 1800s.

San Francisco

Fillamento
2185 Fillmore Street
San Francisco, CA 94115
(415) 931-2224

Wonderful home accessories and an irresistible selection of items for the tabletop.

Limn
290 Townsend St.
San Francisco, CA 94107
(415) 543-5466
457 Pacific St.
San Francisco, CA 94133
(415) 397-7474

Two sites cover all the bases: The Townsend St. showroom is international in flavor—furniture and lighting by the design icons. Furniture at Limn Pacific takes the softer, more warm-woods approach.

East Bay

Creations From the Sea Driftwood Studio
229 Tewksbury Ave.
Pt. Richmond, CA 94801
(510) 233-9663

Recycling at its most creative: Salvaged barn and boat wood, oak staves from French wine barrels, and driftwood become cabinets, rockers, tables, and birdhouses. By appointment.

Marin County

Imari, Inc.
40 Filbert Ave.
Sausalito, CA 94965
(415) 332-0245

Japanese antiques of the Edo and Meiji periods; known for a superb collection of antique folding screens. By appointment.

Heath Ceramics, Inc.
400 Gate 5 Rd.
Sausalito, CA 94965
(415) 332-3732

Renowned studio potter Edith Heath creates colorful ceramic tiles for the house and garden, as well as beautiful dinnerware.

Eclexion
1 Throckmorton Ave.
Mill Valley, CA 94941
(415) 381-9095

Agathis hardwood—harvested in Indonesia and approved by the Rainforest Alliance—fashioned into unique baroque and sleigh beds. Also, Biedermeier reproductions and Dutch Colonial antiques.

Summer House Gallery
21 Throckmorton Ave.
Mill Valley, CA 94941
(415) 383-6695

Antiques and furniture crafted by English and U.S. artisans; fun lamps and hand-painted furniture in the children's annex.

Pullman & Co.
108 Throckmorton Ave.
Mill Valley, CA 94941
(415) 383-0847

Stylish home furnishings and accessories, including slipcovered furniture.

Salsa
14 E. Sir Francis Drake Blvd.
Larkspur, CA 94939
(415) 925-1810

Original designs and Spanish Colonial–style handcrafted furniture and home accessories.

Gardenside
999 Andersen Dr.
San Rafael, CA 94901
(415) 455-4500

Plantation-grown teak garden furniture: steamer chairs, benches, tables—and a good assortment of market parasols.

Sonoma County

Hendricksen Natürlich Flooring & Interiors
7120 Keating Ave.
Sebastopol, CA 95472
(707) 829-3959

The emphasis is on natural flooring—wool carpeting, hardwood, real linoleum—and even the window coverings and upholstery are low-toxic.

Christopher Queen Galleries
John Orr's Gardens
Duncans Mills, CA 95430
(707) 865-1318

The paintings of early-California realists.

Back to Entertaining
John Orr's Gardens
Duncans Mills, CA 95430
(707) 865-1155

Antique furnishings and custom linens; creative tablesettings incorporating unusual glassware, especially jewel-toned Depression-era collectibles.

Mendocino County

Golden Goose
45094 Main St.
Mendocino, CA 95460
(707) 937-4655

Fine European bed, table, and bath linens in just the kind of great old Victorian you'd expect to find in these parts.

Adirondack Designs
350 Cypress St.
Ft. Bragg, CA 95437
(707) 964-4940
(800) 222-0343

All-redwood outdoor furniture, specializing in Adirondack chairs—but the loveseats, swings, and potting benches have equal appeal. ∎

Designers

Designer & Architect Listings

The following is a list of designers and architects whose work is featured in this book.

Tina Beebe
933 Pico Boulevard
Santa Monica, CA 90405
(310) 450-1406

James Bischoff
49 Alcatraz
Belvedere, CA 94920
(415) 435-8492

Geoffrey E. Butler Architect
435 Brannan Street
San Francisco, CA 94107
(415) 541-0668

Choate Associates
1808 Sawtelle Boulevard
Los Angeles, CA 90025
(310) 477-1547

Steven Ehrlich Architects
2210 Colorado Avenue
Santa Monica, CA 90404
(310) 828-6700

Edward W. Engs Design
10414 Troon Avenue
Los Angeles, CA 90064
(310) 838-8012

Esherick Homsey Dodge & Davis
2789 25th Street
San Francisco, CA 94110
(415) 285-9193

Frederick Fisher & Partners Architects
12248 Santa Monica Boulevard
Los Angeles, CA 90025-2518
(310) 820-6680

Waldo Fernandez Waldo's Designs
620 N. Almont Drive
Los Angeles, CA 90069
(310) 278-1803

Michael W. Folonis AIA & Associates
1731 Ocean Park Boulevard
Santa Monica, CA 90405
(310) 450-4011

G.G. Green Interior Design
18 Mirabel Avenue
Mill Valley, CA 94941
(415) 381-2659

Interim Office of Architecture
10 Heron Street
San Francisco, CA 94103
(415) 864-7226

Jo Ann James Interior Design
1120 Westfield Drive
Menlo Park, CA 94025
(415) 321-3097

Bill Lane & Associates, Inc.
926 North Orlando Avenue
Los Angeles, CA 90069
(310) 657-7890

Jerrold E. Lomax, AIA
225 Crossroads Boulevard
Suite 320
Carmel, CA 93923
(408) 659-7502
4223 Glencoe Avenue
Suite B115
Venice, CA 90292
(310) 306-7722

Linda Marder
8835 Wonderland Avenue
Los Angeles, CA 90046
(213) 656-8844

Moore Ruble Yudell Architects & Planners
933 Pico Boulevard
Santa Monica, CA 90405
(310) 450-1400

G.K. Muennig Architect
P.O. Box 92
Big Sur, CA 93920
(408) 667-2471

Brian Murphy BAM Construction & Design
150 West Channel Road
Santa Monica, CA 90402
(310) 459-0955

Lorcan O'Herlihy Architects
1715 California Avenue
Studio F
Santa Monica, CA 90403
(310) 453-1915

Rob Wellington Quigley, AIA
434 West Cedar Street
San Diego, CA 92101
(619) 232-0888

Ivy Rosequist
P.O. Box 410507
San Francisco, CA 94141
(415) 728-7877

Stanley Saitowitz Office
1022 Natoma Street
San Francisco, CA 94103
(415) 626-8977

Michael S. Smith, Incorporated
1454 5th Street
Santa Monica, CA 90401
(310) 656-5733

E. Tarkington Steele
835 Shan Creek Road
Grants Pass, OR 97527
(503) 479-8804

Umemoto Associates
8380 Melrose Avenue
Los Angeles, CA 90069
(213) 852-1624

Walz Design
37 West 57th Street
New York, NY 10019
(212) 355-9078

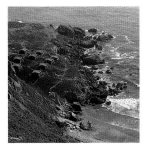

Richard Warner Architects
1523 6th Street, Suite 6
Santa Monica, CA 90401
(310) 394-5733

Wormser + Associates Architects
644 Broadway
New York, NY 10012
(212) 505-6962

C.M. Wright Incorporated
700 North La Cienega Boulevard
Los Angeles, CA 90069
(310) 657-7655 ∎

Index